American Jukebox

American Jukebox
A PHOTOGRAPHIC JOURNEY

CHRISTOPHER FELVER

Forewords by David Amram and Lee Ranaldo

Indiana University Press
Bloomington and Indianapolis

This book is a publication of Indiana University Press

Office of Scholarly Publishing

Herman B Wells Library 350

1320 East 10th Street

Bloomington, Indiana 47405 USA

iupress.indiana.edu

Telephone: 800-842-6796

Fax: 812-855-7931

Library of Congress Cataloging-in-Publication Data

Felver, Christopher, [date]- photographer.
 American jukebox : a photographic journey / Christopher Felver ; forewords by David Amram and Lee Ranaldo.
 pages cm
 Includes index.
 ISBN 978-0-253-01402-3 (cloth)
 1. Musicians—Pictorial works. I. Amram, David, writer of preface. II. Ranaldo, Lee, writer of preface. III. Title.
 ML87.F45 2014
 780.92'273—dc23
 2013049890

1 2 3 4 5 19 18 17 16 15 14

This book is dedicated to all the wonderful spirits who gave me a moment,

and to my mom, who always told me,

"You have friends out there you haven't met yet."

Plug into this jukebox
and see the faces and
figures behind the
greatest American music!

— Lawrence Ferlinghetti

CONTENTS

ONE HEART MANY VOICES

Christopher Felver's *American Jukebox* is to the eye what a perfect jukebox is to the ear: a treasure chest to enable the reader to have a feast anywhere that he or she opens to any page of this stunning collection of photographs. By stopping and taking a good look at *American Jukebox,* we can all pause long enough to see the outstanding musicians of all genres who have made the world listen more closely to music that is built to last.

The American landscape has always been as challenging as it has been inspirational for novelists, poets, painters, and playwrights to understand and to document, even after they have spent years of travel and endless work.

Our musicians have a way of documenting this landscape through sound, capturing the flavors of the places they have adopted as their own in their endless travels on the road. Their songs and performances are as unique and varied as the endless miles they continue to travel throughout their lifetimes.

An accomplished guitar player and singer himself, Chris has somehow found a way to document an astonishing variety of innovators from every genre of music, capturing their personalities and spirits in this unique collection of photographic studies. *American Jukebox* celebrates the spirit of music that comes from the heart and transcends category or commerce. Like the work of the musicians themselves, Felver's photographs tell a special story in a way that words can never equal. His pictures put you right on the bandstand as he releases the creative genie from each bottle, allowing us to see the music as well as hear it.

The soul of each performer and composer shines through Felver's photographs, and their work comes alive. Once you start to look through it you won't want to put it down.

– DAVID AMRAM, composer
Putnam Valley, New York, July 2012

Inside this book you'll find the sounds of things to come.
Each image illuminates a road map to the future.

That basic, fundamental thruuummm—terrestrial drone of the Earth in rotation—it consists of all the music that's ever been, since the beginning of time—can be heard between these pages if you just listen. But this is not some *memento mori*, no. Music moves through time, from the past into our present, and further on out from here. The faces in Chris Felver's photos look to the horizon, and just beyond, as if to say, "There, that's where we're going."

Music moves us in ways both simple and complex. We want to see the faces of the women and men who make the music. They who provide us with the voices, the melodies, and the sounds in our heads. Here's a Jukebox full of them.

The things that draw folks to make music are usually simple, elemental, less complex. It doesn't begin or end at the edge of the stage, oh no. It's combusting constantly in backrooms and bedrooms, in open fields and on the tongue. Music tastes good. Sometimes a little salty, sometimes a bit sweet. Our music can be heard within these frames: the open rolling tones of six-string symphonies that can't stand still for a minute. The chords and melodies, clangs and bangs of horn or drum, songvoices, the bleating soft lips of truth. What does the room sound like after the music stops? There is no void, the music goes on forever, it hides under the eves while the audience files out.

What is an eye? Glass of water with a hole punched through? Steel plate with silver coating? Cave where rain gets in? What can it hear? Just-created tone poem? Ancient weathered rocky shore? Bells in ancient towers? Flickering wings on the wind? What is an ear? Overgrown vineyard, full of fruit?

Our music is unintelligible, inexplicable, flying sometimes low under the radar. Hella loud then almost silent. Keeping secrets, some new and some of ancient origin, only partially audible. Sometimes our music seems to encompass everything, more than words can tell; sometimes it's a radiant throwaway pop song, showing off for the crowd, waiting to be discovered, to thrust a fire up into the night.

These photos are silent. The faces that turned to Felver's camera are silent here, facing the future, listening for the next thing, still unheard, and wondering what the camera can hear of it? Rest assured, the music is just out of the frame, the next sounds that we'll hear, right after the shutter clicks shut.

How not to get played on the radio.
How to keep a good thing quiet.
How to roll with the punches and keep on keeping on.
Further on up the road.
C'mon take me to the Mardi Gras.

I'm goin' up the country,
Devil at the crossroads,
Deep in the woods,
Goin' down the road,
Keeping it real.

—LEE RANALDO, founder of Sonic Youth
New York City, March 2013

ACKNOWLEDGMENTS

To everyone who offered generous contributions to the making of *American Jukebox*,
I offer heartfelt applause.

I'm indebted to my wonderful friends for their support: Eliza Twichell, Helen MacLeod,
Joyce Jenkins and Mark Baldridge at *Poetry Flash*, Eric Christensen, Barry Kaiser,
Craig Bishop, Wavy Gravy, Susan Johnson, Doug Brinkley, Hugh McCracken, Hamer Mainwaring,
Ron Whitehead, Michael Salerno, Chuck Statler, Colin Birdseye, Peter Maravalis, Steve Dalachinsky,
Christian de Boschnek, Suzanne Shelhart, Marsha Bellavance, Robert Berman, Rita and Tom Bottoms,
Josh Romberg, Jack Hirchman, Matt Carlson, Peter Frank, David Shapiro, Tom Crawford, Bob Edmundson,
Erin White, Kim Rea, Charlie Knight, George Krevsky, Jessie Block, David Fahey, James Crump,
Marshall Virello, Alan Woll, Melton Magidson, John LeBow, Thomas J. Dillon, John Yau, Tony Cragg,
Eva Reitspiesova, and Jay Daniels/Black Cat Studios.

Special thanks to Raina Polivka and the staff at Indiana University Press.

Bravo to Kirk Anspach's for his photographic prints and Jack Darrow for always giving me the right camera.

And especially to Linda Johnson for keeping it all together.

American Jukebox

A MUSIC BOOK FOR EYES
and memories. —A keyboard
of photos.

— Michael McClure

If music be the food of love, I've been honored to be a guest at many a banquet. I've found love, joy, and heart in these encounters with American musicians. Much like Walt Whitman's poetic expression, "containing multitudes," *American Jukebox* celebrates the colorful tapestry and immense diversity of styles that make up the American sonic landscape. I wanted to catch authentic, unguarded moments with performers and transport the viewer into the musician's world. The resulting portraits are a culmination of my personal journey through the late-twentieth-century music community.

American Jukebox is rooted in my early influences growing up in Akron, Ohio. My grandmother, Esther Keenan, the first beautiful force in my then very young life, awakened me to the sound of music. She had studied Gregorian chant in New York City in the 1920s and could play everything in *The Great American Songbook* on her Steinway. My earliest memory of a live performance was going with her to hear George Shearing play his classic "Lullaby of Birdland" in 1953 at the Maramor Restaurant in Columbus.

When I was a teenager in the '50s, local DJ Alan Freed became internationally known for promoting a mix of blues, country, and rhythm and blues on radio stations in Akron, Cleveland, and New York City. Freed's understanding of the emergence of this new American music led him to coin the phrase "rock and roll." Everyone I knew turned their radios on when this sensation went viral in the American consciousness. There was a musical convergence beaming every night from the radios in Detroit, Chicago, New York, Nashville, West Virginia, and, on a clear evening, even Texas. This constellation of jazz, pop, rock, blues, and country left a loud and clear impression.

In 1960 Ray Charles came to Akron University with his hot Raelettes, and their soulful performance left "Georgia on My Mind" forever. As Detroit's Motown sessions were giving us Marvin Gaye, the Supremes, and the Temptations, we were "Dancing in the Streets" with Martha and the Vandellas. In Cleveland, Dave Brubeck was playing "Take Five" with Paul Desmond at the Carousel Theatre. My gang was either rockin' with Elvis, Jerry Lee Lewis, and Chuck Berry or eager to "Walk the Line" with Johnny Cash. We got into folk music with the

Kingston Trio and Peter, Paul and Mary, while Dave Van Ronk was singing Reverend Gary Davis's version of "Cocaine Blues." Another Greenwich Village folkie named Bob Dylan signaled "The Times They Are a-Changin'." He was right, and his prophetic lyrics accompanied me to the University of Miami in 1964.

I landed in Coconut Grove, the artist community off Key Biscayne, a few miles from campus. The lifestyle in Miami at that time revolved around sunshine, sailing, jai alai, horses, and a funky musical nightlife—perfect for an incoming freshman! There was only one traffic signal in town and two bars, the Hamlet and Nick's Grove Pub. The Florida Pharmacy lunch counter was the center of the town's daytime social life and everyone would go there on Sundays for brunch to see and be seen. The Dinner Key Auditorium promoted lineups ranging from Stevie Wonder and the Motown Review to the Doors' historic censored concert. Gaslight South, the only music club, is where I first heard Odetta, Ramblin' Jack Elliott, Tom Paxton, and Fred Neil, who was always the talk of the town when he wasn't in New York City. He and his singing partner, Vince Martin, had become legendary on the folk circuit.

About the time David Crosby sailed his schooner *Mayan* into Biscayne Bay, you could spot musicians on just about every corner. Joni Mitchell, Rick Danko, Paul "Oz" Bach, Bobby Ingram, John Sebastian, Phil Everly, and Eric Andersen all checked in. Visionary John Lilly was researching dolphin communication and Ric O'Berry was training Flipper at the Sea Aquarium, where Fred Neil hung out and was inspired to write "The Dolphins" with the popular refrain, "I keep searching for the dolphin in the sea. And sometimes I wonder, do you ever think of me?" Over the next few years, more small clubs opened and the Grove was so alive with artists and all-night music sessions that the annual art festival became an international event. I knew I was living in a magical time and place.

In Miami, Aretha Franklin was recording her *Respect* album at Criteria Studios where the Bee Gees were soon to record their disco hits. On Seventy-ninth Street Causeway, the Barn featured Wayne Cochran, "The White Knight of Soul," wailing his hit, "Goin' Back to Miami." Over at the university I was majoring in

history and trying to avoid the draft, but in the end, the whole mess caught up with me and soon after graduation I found myself in basic training at Fort Leonard Wood, Missouri.

That summer I was stationed at Fitzsimmons General Hospital in Denver. At five o'clock when my shift was over, I would go to work tending bar at Your Father's Mustache on Larimer Square, where the banjo bands soothed the horrors of the war casualties I was witnessing on a daily basis. Fortunately, after ten and a half months, the commanding officer discharged me for being "untrainable."

Liberated from the war machine, I made my way to Stockbridge, Massachusetts, in the Berkshire Mountains, where an alternative lifestyle was in full bloom. My first stop was Alice Brock's restaurant. Arlo Guthrie's famous anti-war song, "Alice's Restaurant," inspired Arthur Penn's movie about the scene. People who came to Stockbridge thought they could get anything they wanted, just like in the song. The restaurant became "in" and Alice had to move to a bigger place on Route 183 to accommodate all her new fans—the power of a hit song!

Stockbridge was a lively cultural center at that time—celebrities were posing for Norman Rockwell (I saw John Wayne in full cowboy regalia strolling down Main Street after a session); Jacob's Pillow, the oldest international dance school, held performances and workshops throughout the year; the Music Inn featured intimate outdoor concerts, and nearby Tanglewood was the summer home of the Boston Symphony Orchestra. Everything was hoppin', so I decided to stay for the summer. I bunked down in Lenox at the Music Store, owned by my friend Tom Everett, who played bass with the group Children of God. During the all-night jams, I started fiddling around on the guitars and mandolins for sale in the studio. Up the street, at David Silverstein's The Bookstore, I hung out reading what I missed in college and listening to everything, especially Joni Mitchell's hot new album, *Blue*.

David would go down to New York City every Monday to see his shrink and I'd tag along to see my friends and meet a whole new colorful gang of creative souls. This was my first taste of New York living, and all that energy reinforced my thinking that anything was possible. It wasn't long before, like the Cat Stevens song, I was on the road to find out, just as so many had before me. From then on I was busking with my guitar on street corners, in cafés, and in wild little clubs across America singin' for my supper.

By the spring of '74, I was ready for the "busman's tour" of Europe. Traveling by caravan, trains, and hitching rides, I savored the highlights and lowdowns of Western civilization from Athens to Madrid. When you're a freewheeling troubadour anything and everything happens. Jamming with musicians of every stripe, I played for tips with bouzouki players in Greece, flamenco guitar-ists in Spain, and classical violinists on the steps of Sacré Coeur in Paris. My magical musical tour kept right on movin'.

After six months of non-stop travel, I went back to New York City and stayed with filmmaker Jim Szalapski in his loft at 154 Spring Street. Jim was working on *Heartworn Highways*, a film profiling the "outlaw" Nashville music scene. One day at the Eighth Street Bookshop I picked up the book *Eight Directors*, a compendium of stories by international film directors, which sent me in another direction altogether.

Within a few weeks I was studying filmmaking in England at the London College of Printing (LCP), hoping my musical background might provide a natural segue into cinema. Bob Morgan was the program director and let me join the class, telling me he needed an American presence. Four days a week we shot on location and on Fridays we screened the dailies and a few films. I suggested we watch *Pull My Daisy*, the rarely seen Robert Frank film with David Amram, Larry Rivers, Allen Ginsberg, and Gregory Corso. Little did I know how intimately involved I'd become with these characters down the road.

After the screening, an ambitious fellow student, Phil Davey, asked what I knew about the Beats and Jack Kerouac. I showed him a 1971 *Time* magazine article on the changing times in American writing. "Poetry Today: Low Profile, Flatted Voice" contained excerpts from poems and portraits of the new generation of wordsmiths. Phil got excited and convinced me to immediately begin writing a screenplay—so I did. *The Last Time I Saw Neal* was thirty minutes long and produced by LCP the next season. The film turned out to be the first of many focusing on the relationship between Jack Kerouac and Neal Cassady.

While at the LCP, Rosalia Perahim, an Israeli colleague, and I were working on a short film based on D. H. Lawrence's "The Rocking-Horse Winner." I shot the production stills and one day she took me into the darkroom on the fourteenth floor to develop my first roll of film. My reaction to that alchemical process and those emerging images was so profound I've been hooked on the magic ever since. That seminal semester in London would prove to be the inspiration behind many new directions I explored when returning to the States.

I returned to New York in '76, and popped into Art d'Lugoff's Village Gate in Greenwich Village where Rahsaan Roland Kirk was sharing the bill with Dick Gregory. Roland was making his way from the greenroom to the bandstand for his third set of the evening when I spotted him. He was exhausted and grumbling but wanted to give the patrons what they came to hear. As he passed I caught a picture of him; little did I know I was making the first photograph for *American Jukebox*.

For a couple of years I made the rounds from New York City to Miami and then to Los Angeles looking for any kind of film work. Several different production companies hired me as assis-

tant cameraman/editor on commercials and low-budget films. In Miami I was Joe Adler's assistant on his feature *Convention Girls*, and in Los Angeles, I worked with Larry Savadove, who was making "shake & bake" catastrophe films narrated by William Conrad. My stellar moment, however, was working as assistant for BBC Australia cameraman David Sanderson at the American Film Institute. We documented film legends reliving their performances and triumphs on the silver screen—Lucille Ball, Henry Fonda, Jack Lemmon—all basking in the limelight of their legendary careers.

Working on all of these projects as a hired hand finally got to me. There was always a paycheck but never the personal satisfaction of fulfilling my vision. I started thinking about what was most meaningful to me and decided to head to San Francisco.

In the words of Ezra Pound, "one wanted the word and tune, one wanted great poetry sung, one wanted to get something more extended than the single lyric." Those words exactly described the poetry of Scottish poet Robert Burns, and poets I had long admired—the Beats. I wanted to seek out Lawrence Ferlinghetti, who I had met in 1966 on my first trip to City Lights Bookstore. He was the paterfamilias of San Francisco's literary community. In college I was uplifted by the poems in his book *Coney Island of the Mind* and admired the courageous First Amendment stance he took by publishing Allen Ginsberg's *Howl*.

Driving from Los Angeles to San Francisco was spectacular as I headed up the coast to Santa Barbara, then on to Big Sur and Carmel. I knew I was making the right move. My first day in San Francisco I stumbled upon Cab Calloway at a book signing in Union Square. Cab turned the event into a real happening, "struttin' his stuff" and scattin' a bit of "hidee hidee hidee ho" from "Minnie the Moocher" for us. There was only one showman like Cab. Being with him for just that wonderful, brief moment made me positive I was on track.

The last vestiges of Jack Kerouac's San Francisco could be found in North Beach, the artistic and cultural vortex of California in the 1950s. The community of bards and artists that knew Kerouac still congregated at the Café Trieste on Grant Street, around the corner from City Lights Bookstore. Poets Lawrence Ferlinghetti, Allen Ginsberg, Gregory Corso, Bob Kaufman, Jack Hirschman, and the surrealist Philip Lamantia were regulars and kept the Socratic tradition alive. Just two blocks away, Keystone Korner was hosting the giants of jazz and the occasional collaboration with poets. Every night was exciting! This atmosphere inspired me to take a class with André Breton's friend, surrealist poet Nanos Valaoritis, at San Francisco State University. Portable video recorders had just come out, so it was easy for me to document San Francisco's unique poetic congregation. Editor Joyce Jenkins of *Poetry Flash* offered to publish my early portraits—I'd found the coterie I was looking for.

That September, I attended my first Monterey Jazz Festival and snapped a few shots of Big Joe Williams. Capturing his oversized personality and presence seemed a tall order to fill. Looking back, I was just testing the waters with photography and documenting my experiences without having a particular series or project in mind. It was a kick making those early photos, but I discovered what really turned me on was meeting such iconic personalities, and if I could make a portrait, all the better. I was taken by what Frank O'Hara wrote about living in the moment in his marvelous poem "In Favor of One's Time." With camera in hand, I had my introduction and from then on, like they say, I was on my way.

In the summer of 1980, I was invited to teach a video workshop at the Sun Valley Center for the Arts. The theme was "Awesome Space," a perfect subject for artists and writers to mull over. The word "awesome" wasn't a cliché yet and John Baldessari, Jim Turrell, Christo, Mary Frank, and Terry Allen were exploring that notion in the rugged Sawtooth Mountain Range. Mark Klett and Ellen Manchester ran the photography program and spearheaded the Rephotographic Survey Project. As they attempted to duplicate the historical photographs of William Henry Jackson, Timothy O'Sullivan, and others, I filmed them working in the field. We trekked to Shoshone Falls, Idaho; Green River, Wyoming; and Mount of the Holy Cross, Colorado, in search of the exact locations where these great American landscapes had been photographed on glass plates over a hundred years before. Spending a summer with this diverse group of visual artists made me realize how completely focused I'd been on poetry, ignoring the other disciplines of creativity.

When I returned to San Francisco that fall, I started work on *West Coast: Beat & Beyond*, a film centered around thirteen writers who intimately knew Jack Kerouac. Lawrence Ferlinghetti, Allen Ginsberg, Gregory Corso, Jack Micheline, Ken Kesey, Joanne Kyger, Jan Kerouac, and others reminisced about the influence Jack had on them. In 1983 the piece was sewn together and narrated by Kerouac's biographer, Gerald Nicosia. The film aired on PBS in San Francisco and Boston. Right out of the box we scored.

In the spring of '84, Ferlinghetti asked me to join him at the Rubén Darío Poetry Festival in Nicaragua. It was the height of the Sandinista revolution, and poet Ernesto Cardenal, the new minister of culture, invited Lawrence to read and meet with members of the junta. They were all poets in their own right and fascinated with Ferlinghetti, this North Americano poet and publisher. President Daniel Ortega, whose athletic appearance led you to believe he had just gotten off the soccer field, drove his own jeep to meet Lawrence in the guarded Samosita house where we were staying. We toured the war-torn country, from prisons and battlefronts to artist union meetings. Thanks to

Lawrence, I was able to document this critical moment in history. We flew back to Florida, where Lawrence was teaching at the Southeastern Center for the Arts, put our notes together with my snapshots, and *Seven Days in Nicaragua Libre* was published by City Lights Books that fall.

At a *Poetry Flash* reading in Berkeley, I made a portrait of poet Jerome Rothenberg and showed him my portfolio. His great anthology *Shaking the Pumpkin: Traditional Poetry of the Indian North Americas* was being published in New York, and he suggested I contact Alfred van der Marck. So I made my way back to the East Coast and met with Alfred, who accepted the photos and handwritten texts for publication the following year. I had been in New York only two weeks and just couldn't believe I was walking down Fifth Avenue with a contract in hand. *The Poet Exposed,* my first book of portraits, had become my raison d'être.

In the heart of Greenwich Village I found a studio at 38 MacDougal, just down the block from the famous Gerde's Folk City and New York's premier jazz joints, the Blue Note and Village Vanguard. My first week in town, Larry Fagin gave me a list of poets and artists I had to meet–Kenneth Koch, John Ashbery, Larry Rivers, and Noguchi were all in front of my camera in no time. This was my introduction to New York's vibrant art scene. Allen Ginsberg invited me to events and readings and introduced me to the St. Mark's Poetry Project, a crucial venue for new and experimental poetry, where I met Ron Padgett, Jim Carroll, Clark Coolidge, Eileen Myles, Bob Holman, and Anne Waldman.

One night at Terry Allen's art opening I bumped into Laurie Anderson, who invited me to her flat the next day for a quick portrait–quick being the operative word. I was learning to take big personalities and squeeze them into my camera, seizing the magic of their essence in no time at all.

Surrealist poet Ted Joans, who was crashing on my couch, announced one day that we were going to the Brooklyn Museum to meet composer and pianist Cecil Taylor. We connected in the gallery of African art, a subject both of them were extremely knowledgeable about. Afterward, Cecil invited us to his Fort Green pad for champagne. I made a few photographs and, later that afternoon, Cecil decided to practice. From the first note he played, I was mesmerized by the distinctive quality of his sound– "tone clusters." This was new music to my ears.

There is no place quite like New York. Live music is the sound of the city. As New Yorkers are always a familiar scene standing at the bar for an entire set, I fit right in. On a cold snowy January evening, it was a thrill to warm up at Fat Tuesdays, a little club in the Village, and listen to pouch-cheeked Dizzy Gillespie play "Salt Peanuts" and other Afro-Cuban rhythms. At the Lone Star Café on Fifth Avenue, I caught Rick Danko playing solo guitar. Over beers after the gig he got right up in my face to remind me how

"one man's courage can move the world." I'll never forget Rick or his quest; it became my inspiration.

John Cage was sitting at the first computer I'd ever seen when I met him at his Sixth Avenue apartment. While he was printing out his latest composition, "Etcetera 2/4 Orchestras," John showed me his extensive rock and mushroom collections. This was my introduction into his Buddhist world of "chance operations" and the beginning of our friendship.

Van der Marck Editions published *The Poet Exposed* in the fall of '85 with introductions by Gary Snyder and Robert Creeley. The book party/exhibition was at Gotham Book Mart, Francis Steloff's cultural landmark and literary sanctuary for the avant-garde on 47th Street in the Diamond District. The sign over the front door read "Wise Men Fish Here," and I'm forever in their net!

Serendipitously, when I returned to San Francisco, John Cage was working on etchings at Crown Point Press and preparing for a performance of his composition "One/Seven" at the Art Institute. I interviewed John about Black Mountain College and his relationship with Zen master Suzuki Dysat and put a short film together entitled *John Cage Talks About Cows.* The title refers to Black Mountain College having no money in its final days and the students having only the prized cows to eat.

Around the same time, Cecil Taylor was sharing the bill with Sun Ra at the Paramount Theatre in Oakland. After his set, Cecil invited me backstage where Sun Ra was being dressed in the most elaborate of costumes. When Sun Ra hit the stage I listened from the wings while he and his "cosmic jazz" Arkestra kept interplanetary possibilities alive.

In the spring of 1988, sculptor Manuel Neri hosted a party in his Benicia studio for Jim Melchert, director of the American Academy in Rome. Jim and I hit it off and he invited me to be a visiting artist that fall. The day before leaving, I checked in with Leo Castelli at his gallery on West Broadway in New York and showed him my American artists series. He was excited seeing "his" artists and wanted ten of my photographs on the spot. With Leo's blessing and stipend I was on my way again.

Arriving in the Eternal City, I wasn't quite sure in which direction to head. By accident I ran across an exhibition of portraits by Ugo Mulas that kickstarted my next move. I looked up Mario Schifano, an artist who was represented by Leo Castelli and a friend of the American poet Frank O'Hara. Before I left San Francisco, poet Bill Berkson had given me a photo of Ezra Pound reading in Spoleto, which I offered to Mario. From then on Mario had big plans for me. I started right in, photographing the artisti Romani as Ugo Mulas had done. Schifano insisted on providing me with a troupe so I could start filming every Friday. That was the beginning of *Taken by the Romans* and I started living *La Dolce Vita* at the American Academy!

After filming Paolo Cotani in his Piazza Del Popolo studio, he suggested we go to his gallery L'Arco di Alibert near the Spanish Steps. The director, Daniela Ferrari, knew what I was up to and offered to show my prints. Her idea was to match the pictures I was making of Roman artists with portraits of their American contemporaries and to call the exhibition *Ritratti di Artisti*. Opening night was a Felliniesque scene—all of the artists arrived with their entourages and preened while standing by their portraits. For the after-party, over a hundred people were invited to a villa in Piazza Navona for a catered dinner. The next day, there was a review in the Communist paper *La Repubblica* and I got to wondering who picked up the tab for the night before. That's when I learned how ingrained art is to Italians—you never ask where the money comes from! Jim Melchert loved the excitement and asked if I'd like to come back to the American Academy for a winter residency, which meant I could finish the film. It was just before Christmas when I booked a ticket back to the States. The agent asked if I wanted to leave on the twentieth or the twenty-first. Off the top of my head I said "Tuesday." Had I said the twenty-first, I would have been on the Lockerbie flight that tragically went down in Scotland. I learned a long time ago when I was a kid playing golf that "I'd rather be lucky than good."

After the holidays, I returned to Rome and the Academy to finish filming *Taken by the Romans*. Just as my winter residency was ending, I bought a VW bus. At that same moment, Berlin's preeminent gallerist Rudolf Springer called to say, "Georg Baselitz will see you." That was the beginning of a year living in the van and meeting every artist I could on the continent—but that's another story.

That summer the Venice Biennale was in full swing. It seemed as though every international artist was there either installing work or just hanging out. I photographed the festivities that week before the opening, meeting artists I'd only read about—James Lee Byars, Yayoi Kusama, Francesco Clemente, and Yoko Ono. Of course Leo Castelli was there and brought a pensive Jasper Johns for me to photograph outside the American Pavilion. Meanwhile, sculptor Tony Cragg was setting up his show in the British Pavilion. We shared an interest in poetry, especially the American poets. He suggested we walk to a little café in the Giardini where he introduced me to all the artists who were having their afternoon espressos. It was amazing how open they were to my documenting them and how they genuinely enjoyed collaborating with me. Later that summer, I went to see Tony at his studio in Wuppertal, Germany, and we began preliminary work on his documentary, *Tony Cragg: In Celebration of Sculpture*. He was headed to San Francisco a few months later for a residency at the Headlands Center for the Arts in Marin County and to make etchings at Crown Point Press. Timing is everything and this was the perfect time to continue our collaboration.

I brought the videotapes back from Rome and began editing *Taken by the Romans*. Italy's foremost art critic, Giovanni Carrandente, had recorded the film's narration in Rome, profiling each artist and movement since World War II in historical perspective. Annamaria Napolitano, the chair of Stanford's Italian department, helped with translation, and I recorded Italian-born San Franciscans for the voice-overs to maintain the film's cultural identity. Rick DePofi composed the perfect soundtrack, weaving together the various jazz styles I'd heard in Rome—a combination of Astor Piazzolla's Argentinian tango and the airy jazz tones of Gerry Mulligan. The film debuted as part of my exhibition *The Italian Face of Art* at the Museo Italo-Americano in San Francisco.

During the summer of '92, I made a quick run to Marfa, Texas, primarily to make a portrait of sculptor and architect Donald Judd. It happened to be his sixty-third birthday, and luckily he allowed me to interview him, which was the start of yet another documentary, *Donald Judd's Marfa Texas*. Judd's Scottish ancestry and love of tradition made it easy for bagpiper John Pedersen to play traditional Celtic tunes, fingering the chanter for the score. This was a fortuitous and wonderful occasion. The reclusive founder of minimalism and its theoretician would be dead a year later.

In the summer of '93, the Centre Pompidou in Paris finally called to schedule my exhibition *Regards Sur La Generation Beat*. Three years earlier I had met with Blaise Gautier at a cafe in front of Niki de Saint Phalle's "Stravinsky Fountain." He was the director of *La Revue Parlée* section of the museum and in charge of cultural exhibitions. After two bottles of champagne, Blaise assured me the Pompidou was indeed interested in the Beats and that he would get back to me. It took a while but was worth the wait. In January 1994, the show opened in the lower salon of the Pompidou, and Robert Creeley came to give a poetry reading at the vernissage. *West Coast: Beat & Beyond* was the centerpiece of the show, surrounded by over a hundred photographs of the era and vitrines filled with holographic scripts and ephemera. I stayed in the "City of Light" for the entire run of *Regards Sur La Generation Beat*, and met many of the twenty thousand international visitors who seemed genuinely fascinated by America's outsider movement, the Beat Generation.

Allen Ginsberg's dream of achieving academic acceptance for the Beat Generation came true that fall. Anyone who had a connection with Allen attended "The Beat Generation Legacy and Celebration," a weeklong conference organized by New York University's School of Education. The Beat Generation's visual art exhibition featured photographs, drawings, and paintings at NYU's Grey Gallery on Washington Square. I contributed my first grid of photographs—thirty individual portraits of Beat bards, which the New York Public Library snatched up. The week of celebration ended at Town Hall, with performances

by David Amram, Cecil Taylor, Philip Glass, Ray Manzarek, Michael McClure, and the Fugs, featuring Tuli Kupferberg and Ed Sanders. That night, curator Lisa Phillips was in the audience and began to plan an even bigger event two years later at the Whitney Museum.

David Amram and Cecil Taylor were the two musicians most closely associated with the Beat Generation. I first met David in 1982 at the twenty-fifth anniversary *On the Road* celebration at Naropa Institute in Boulder, Colorado. I knew a little of Amram's impressive career, but meeting him at this conference was the start of what would be a lasting and meaningful friendship. His encouragement and ideas never waned—he's always believed everything's possible.

During the Beat celebration in New York, Douglas Brinkley, a scholar from the Eisenhower Center for American Studies at the University of New Orleans, introduced Hunter S. Thompson and moderated the panel discussions. He invited me to join him the following fall as photographer for his second Magic Bus Tour. I figured being in an "on-the-road" adventure was just the ticket. Twenty-seven students were chosen from various universities and met in the Crescent City that August for a week of music and lectures before the tour. We attended performances by Ramblin' Jack Elliott, Townes Van Zant, Irma Thomas, Bo Diddley, Alex Chilton, and Clarence "Frogman" Henry at famous New Orleans clubs—Tipitina's, House of Blues, Maple Leaf, Howlin' Wolf, and, of course, Margaritaville.

Prototype natural gas Penske engines were put in two regular street buses that were painted by the YaYas, a local art group. As we began the trek across literary and cultural America the buses broke down constantly. Penske's mechanics would overhaul them every night, but they seemed to need more and more attention as we made our way across the American landscape. We visited with Jimmy Carter in Americus, Georgia; B. B. King in Atlanta; George McGovern and Kinky Friedman in D.C.; Kurt Vonnegut in Sag Harbor on Long Island; Arthur Miller in Connecticut; Studs Terkel at his office in Chicago; Chuck Berry at Blueberry Hill in St. Louis; Hunter Thompson at his Woody Creek pad near Aspen. The bus slowly hiccuped its way to the West Coast, then back to New Orleans. This semester-long journey gave the students an unforgettable peek into contemporary American history and earned them nine college credits.

After my pictures were developed, Doug called to say Louisiana State University Press was interested in publishing them. I flew to New Orleans, and while we were driving to Baton Rouge, Doug offered to write the introduction. We arrived at LSU, and to my surprise, everyone had already agreed that my picture of Abbie Hoffman would be the cover of their fall book list. It was now official—*Angels, Anarchists & Gods*, featuring over two hundred "cultural revolutionaries," had a life and would be in bookstores by the fall of 1996. I still had time to make a few more pictures.

When Patti Smith returned to New York City from Detroit she was greeted by an enthusiastic overflow crowd at her *Coral Sea* book signing. Allen Ginsberg introduced us after her reading, while she was autographing books. Patti said she was laying down tracks for her next album *Gone Again* at Electric Lady Studio on 8th Street the following day. In the morning I called to find the schedule and the engineer said the session was set for noon. I got there a little early and sure enough she arrived with Lenny Kaye and her entourage right on time. Patti gave me the high sign and said she'd be right out after they dropped off the equipment. In a minute or two she came around the corner in a white Gotham Bookstore tee shirt. She was no model. Way better than that—she had the wild energy of real talent, authenticity.

I took the MTA train north from Grand Central Station to Beacon on the Hudson for Pete and Toshi Seeger's annual Corn Festival. On the ride up, I kept thinking about how Pete's Clearwater projects had helped restore the river. The "Beacon Sloop Club," where Pete hung out, was right next to the station. I caught up with him just as he was about to perform another civic duty—taking the waste from the port-o-lets to the dump before everyone arrived. His first words were "Wanna help?" I wouldn't have missed this opportunity for anything. As we headed out I flashed on the film *Alice's Restaurant* which starts with the infamous dump run on Thankgiving. Driving in his pickup, we talked about everything—Woody, the Clearwater sloop, politics, and music in that order. He was completely down to earth—just as I'd expected. I felt like I was getting a lesson in Buddhist practice. By the time we got back to Beacon, the afternoon glow of the Hudson River was starting to work its magic. There were craft tents, farmers markets, corn was being shucked and cooked—all while local musicians were performing, including David Amram with his whole family. At the end of the afternoon Pete took the stage and joined all the performers, singing "Where Have All The Flowers Gone." It was getting late when I asked Pete if we could make a portrait. "We sure can, let's get to it." I thought it would be authentic if he played at the shore of his beloved Hudson. He walked onto a rock, smiled and began singing Woody Guthrie's "Goodbye [Chris] It's Been Good To Know Yuh." It was pure "Americana"!

With *Angels, Anarchists & Gods* off to LSU press, I went to work finishing *The Coney Island of Lawrence Ferlinghetti*. Soon after, the Venice Film Biennale 1996 called asking to screen my documentaries at their sidebar event on the Beat Generation. They sent me a round-trip ticket and I was off to Venice again. Almost every film made about the Beats was shown that week and there was an extensive catalog containing many of my photographs. Roman Polanski was the omnipresent artistic direc-

tor, actively involved in keeping things running smoothly and introducing most of the films. Here I was dining with Robert Altman, watching the paparazzi chase Nicole Kidman, having drinks with Anjelica Huston—and getting the chance to meet Jean-Luc Goddard. No one throws a party like the Italians!

In 2000, Peggy Parsons of the National Gallery of Art in Washington, D.C., hosted a retrospective of my films. The series was billed as a Roster of America's Mid-century Avant-Garde. I attended the screenings, and seeing them all together on the big screen made me realize that my immersion in poetry is what tied all of the work together. Then music entered my life again.

I started working with photographic printer Kirk Anspach in the '80s. He printed for iconic music photographer Jim Marshall. When I was first introduced to Marshall's incredible body of work, I thought, "What's left to photograph?" Jim's pictures spanned from the '50s with Coltrane and Miles right through to the heady '60s and '70s. Being around Jim was a non-stop music history tutorial—there was no separation between who he photographed and the man himself. Guns, drugs, and fast cars were as much a part of Jim's life as photography. He had made all the pictures and lived all the stories.

One evening Kirk threw a party for Jim in his studio, the "Soma Print Room." The esteemed fraternity of photographers Kirk worked with came by for a drink: Ed Kashi, Baron Wolman, Robert Altman, and Michael Zagaris. Toward the end of the party I showed Jim my recently published book, *Ferlinghetti Portrait*. He paused as he was paging through it and categorically said, "You gotta see Fahey, *now*." This was a golden opportunity. David Fahey was the distinguished photographic dealer in Los Angeles. The next day Jim called to set up an appointment and within a week I was in LA with Fahey, who said, "I want to see every portrait you've made." Since I'd taken over eight hundred, that was a real assignment. When I finally did get all the pictures together, Fahey introduced me to Santa Fe publisher James Crump of Arena Editions. After looking over the portfolio, James said he would publish *The Importance of Being*, and the game was on.

I began making as many portraits as possible, spending loads of time in New York. Right about then Jim Szalapski moved out of his Spring Street loft and I started couch surfing at Rick DePofi and Craig Bishop's New York Noise (NYN) studio on Gansevoort Street in the meatpacking district. Rick was the musical director and composer at NYN, a music production company specializing in composing original music for commercial TV and advertising. He and longtime musical partner John Leventhal produced Grammy Award-winning albums and hits with Shawn Colvin, Rosanne Cash, and Marc Cohn. I was just a fly on the wall when Elvis Costello, Kris Kristofferson, Rodney Crowell, and Carly Simon all came by the studio to sit in.

When not making pictures, I had time to catch up with old friends, especially Cecil Taylor. He lived in a brownstone next to the Brooklyn Academy of Music and was rather reclusive. Sometimes he didn't leave his house for weeks on end, often practicing six hours a day. Cecil played with and knew the entire jazz world and had all the anecdotes. I was just the cat who wanted to hear them all. He'd worked with Baryshnikov and Mary Lou Williams, played at the White House, and been on the historical Smithsonian record. His influence is monumental among the musicians who followed, especially those playing in the free jazz idiom. I loved where he was coming from and hoped that by collaborating with him, gates to the deeper dimensions of jazz would open. With all that in mind, I started filming *Cecil Taylor: All the Notes*.

I'd bring over a bottle of Veuve Clicquot champagne and a pack of American Spirit cigarettes and that was enough fuel to get Cecil talking for days. Sometimes I would get only a minute or two of usable footage, but Cecil didn't care and was never in a rush. He wanted most of all to have fun and I was on the same page. That meant talking 'til all hours of the morning about everything—the Boston Conservatory, the first time he saw Billie Holiday, the architect Calatrava, the Bolshoi dancers, Margot Fonteyn, Art Tatum, Lennie Tristano, John Coltrane; and the list goes on.

We'd go into the city and hang out at his favorite spot, the 55 at Sheridan Square. I filmed him at a Lincoln Center gig, in New York at the Iridium with his big band, in Royce Hall at UCLA, at Yoshi's in Oakland, and during his residency with students at Mills College. I got the feeling Cecil never wanted me to finish the film; he was having too much fun. After his incredible performance at the San Francisco Jazz Festival we went back to his hotel suite where he sat perched on the corner of his bed, sharing yet another bottle of Veuve Clicquot with me. After an hour or so, he fell into a sweet nostalgic moment, reminiscing about his parents and inadvertently saying exactly what was needed to finish the film. *Cecil Taylor: All the Notes* first screened at Lincoln Center and then became part of the traveling exhibit, *Blues for Smoke*. Jazz critic Gary Giddins reviewed the film in *JazzTimes*, saying, "Felver leaped into the breach to penetrate the mist surrounding Cecil Taylor."

In the spring of 2002, I drove to Santa Fe, New Mexico, with all the photographs for *The Importance of Being*. When the designer Elsa Kendall showed me the cover, a grid with many of the pictures I'd recently made, it hit just the right note. Seeing the book come together made all the energy that had gone into it worthwhile. Introductions by George Plimpton, Andrei Codrescu, Luc Sante, and Amiri Baraka set the tone for the 436 portraits that followed. The omnibus celebrated the international cadre of artists, writers, and activists I had been fortunate to meet. The *Wall Street Journal* reviewed the book, saying,

"The best specimens of the human animal show up in *The Importance of Being*." That spring, Fahey/Klein Gallery had a double exhibition with portraits from my book and photographs of Warhol by all the photographers who associated with Andy. Opening night was a madhouse–it seemed everyone in Los Angeles was there.

Mills College, just east of San Francisco Bay, has been a center of musical creativity and innovation for the past century. The school's heritage is famous for performers and composers who have led the evolution of new music. While in Rome, I had photographed composer Luciano Berio, not knowing he had been a professor at Mills. He suggested some musicians I might be interested in following. While working on *All the Notes* with Cecil at Mills, Berio's advice struck a chord. I hadn't realized that as far back as the late 1930s, Henry Cowell, John Cage, and Lou Harrison began the tradition of experimental music at Mills. As it turns out, many of the composers I've photographed–Dave Brubeck, Meredith Monk, and minimalists Terry Riley and Steve Reich–all graced the Mills concert hall with their avant-garde compositions. There was synchronicity in my musical meanderings!

Late one night David Amram called while I was in Akron saying, "Let's go to Farm Aid." Whenever they were in the same vicinity, Willie Nelson always asked him to sit in with the band. At that time, David was guest-composer-in-residence with the Richmond Symphony Orchestra in Richmond, Indiana. He was invited by Guy Bordo, their music director, to teach workshops for young people and to hear a performance by the symphony of his cello concerto *Honor Song for Sitting Bull*.

I attended the concert, then we drove all night, arriving at the performance space in Tinley Park, Illinois, just in time for the 2005 Farm Aid opening ceremonies with Neil Young, Dave Matthews, Willie Nelson, and John Mellencamp. David spoke about being brought up on a farm and voiced his concern for today's family farms. I hadn't been to an event like this in years, so I didn't know what to expect. There were gorgeous custom buses, food galore, massage tents, and a contagious excitement in the air.

Featured performers appeared with all the bands. Neil Young played "Walkin' to New Orleans" with a full choir to honor Hurricane Katrina victims, Arlo Guthrie played "Alice's Restaurant" with his son Abe, and Emmylou Harris joined Willie for "Pancho and Lefty." During my ramblings I caught the eighteen-wheelers pulling up to the loading dock behind the stage to unload sound equipment, instruments, and props for each performer. After the show, the entire stage was loaded back onto the truck and they headed out for the next gig–a far cry from troubadour life.

David knew almost everyone and was having a blast being in his element. I met the Calhoun Brothers, who actually manufac-

tured the interiors of the star's buses and were formerly famous singers in their own right. We strolled around as they stopped and gabbed with all the entertainers, even then-Senator Barack Obama. When we walked over to Willie's bus he was coming out to greet some fans. I wanted to make just one picture that day and after the Calhoun Brothers' introduction I got my moment with the "Red Headed Stranger." That evening I went behind the scrim, backstage with Willie's entourage, and watched his wonderful performance with David joining the band playing pennywhistles, French horn, and dumbek.

After twenty-five years of being intimately involved with the Beat Generation, I thought it was time to create an homage to those gentle souls and characters. I rounded up all the drawings, poems, broadsides, newspaper clippings, and posters I'd collected, and added all my photographs of Allen Ginsberg's "extended family." Logically, I called my scrapbook and memento *Beat*. My designer, Linda Johnson, and I laid out the maquette during the magic of Fiesta in Santa Fe. Back in San Francisco, filmmaker Eric Christensen was the first to see it. He presented the book to pioneering counterculture publisher Ron Turner who apparently thumbed through five pages and said, "Yes!" Last Gasp added *Beat* to their eclectic collection of releases and I joined the pantheon of Last Gasp authors, which included R. Crumb and Robert Williams.

We celebrated the *Beat* book party in Los Angeles at the Robert Berman Gallery. It was a natural fit because Robert had organized the historical exhibitions *Man Ray: Paris—LA*, as well as *William S. Burroughs Paintings 1987 to 1996*. John Colao helped me "salon style" mount over 120 photographs in the gallery, and David Amram flew in to perform with Buddy Helm, making sure with their music that "the beat goes on."

Bruce Ricker loved jazz films and once said to me, "A film is a great thing to make if you have the money." I thought that was a riot because that is exactly opposite to the way I make films. He distributed Jim Szalapski's *Heartworn Highways* in the '70s and I knew of his association with Clint Eastwood. Bruce worked as an advisor on *Bird*, Clint's film about Charlie Parker. I asked him if he could arrange a photographic session with Clint. "We'll be at the Monterey Jazz Festival working on the Brubeck film and you can come by then," he said. Over the years, Ricker collaborated with Eastwood on jazz and blues documentaries, including *Tony Bennett: The Music Never Ends, Johnny Mercer: The Dream's on Me,* and *Thelonius Monk: Straight No Chaser.* When I got to the fairgrounds, a ticket and golf cart were waiting for me. I was whisked to the rehearsal hall where Dave Brubeck was having a run-through with his orchestra. Just as I was getting oriented, Bruce came out of nowhere with Clint. The "high plains drifter" had charisma. He was cool, calm, and collected, immediately treating me like one of the crew. I recalled the many films he'd composed music for–*Mystic River, Million Dollar Baby, Flags of*

Our Fathers, and *Changeling.* When making his portrait, I didn't ask "Dirty Harry" to smile, but for some reason he gave it up.

With Clint's endorsement, I wandered about the festival all weekend free to look, listen, and photograph the amazing lineup of talent. Bruce always told me, "We can get to anybody." In this case, "anybody" included the likes of Ornette Coleman, Charles Lloyd, and Kenny Burrell. Standing in the wings, I caught the performances of Terence Blanchard, Sonny Rollins, James Moody, and Dave Brubeck with his orchestra performing *Cannery Row Suite,* a tribute to Steinbeck's classic novel set just down the road from the Monterey Fairgrounds.

Music in Monterey has a rich tradition. The stage comes alive when you imagine all the artists who've performed there. Even the ghosts of Joplin and Hendrix still haunt the place from the iconic Monterey Pop Festival in '67. On Sunday evening my final picture was of Clint, Elvin Jones, and Oscar Petersen beaming together, which seemed to sum up the vibe of the entire weekend.

One of Jim Marshall's favorite stories was when he went to Hawaii with the Jefferson Starship to make some pictures for them. A young kid guarding the stage door gave him a hard time and, Jim being Jim, just got on the next plane back to San Francisco. Episodes like this made me reluctant to dive into photographing the music scene. I knew that unless you have the "all access" pass, there will always be someone between you and the artist. That's just the way it is! What I learned at Farm Aid was that music photographers usually have ties to magazines and get passes, as do friends of the artists. I saw what it was like to be in the photo pit with photographers struggling to get their shot during the first two songs of a set. It seemed like a battlefield with managers, publicists, agents, stagehands, security, even overactive volunteers taking their roles way too seriously, but I was getting drawn again into this capricious world.

The next festival I attended was the never-ending 2007 Summer of Love Celebration in Golden Gate Park with Eric Christensen, who needed help making his film on album covers, *The Cover Story.* I shot interviews for him and made portraits of Taj Mahal, David Nelson of the New Riders, Dan Hicks, and Canned Heat, who all came around to be filmed after they performed.

A month later Eric wiggled us into Golden Gate Park again for the Hardly Strictly Bluegrass Festival. This was a biggie. There were six stages with more than eighty acts. Over a million people attended the free, three-day affair sponsored by philanthropist and banjo player Warren Hellman. When Steve Earle was interviewed on KQED radio, he called the event "pure hillbilly."

After filming Eric's interviews, I would invite the musicians into my "studio," a little shaded area with an airplane blanket taped to the side of a generator. I'd ask if I could take a couple of pics, and meant it—never more than three because this was certainly a fast crowd. Here were the greatest acts in country music, all performing at the same venue on a perfect September weekend, artists I had only dreamed of meeting—Doc Watson, Earle Scruggs, Charlie Louvin, Hazel Dickens, Emmylou Harris, T Bone Burnett, and Ricky Skaggs. As Marty Stuart once observed, "It was like being set in the middle of the Old Testament of country music."

Then film work called again. It isn't often you can go back and revisit a film. In 2007, Ferlinghetti showed me a picture that had never been seen before. It was sent to him by photographer Dale Smith and taken in 1965 on the historic day Dylan, Ginsberg, McClure, and Robbie Robertson were hanging together in the alley next to City Lights Bookstore. This photograph was the only record of Lawrence being with them. A few months before, Lawrence played me a tape of Dylan introducing him on Dylan's Sirius radio program, which featured baseball as the theme. Lawrence read his poem "Baseball Canto," which inspired me to tackle another go-round with the Ferlinghetti documentary. I included many of his aficionados that weren't in the first film. Michael McClure, Allen Ginsberg, Billy Collins, Robert Scheer, Dave Eggers, Dennis Hopper, Gary Snyder, and of course Bob Dylan all "weighed in" on Lawrence and City Lights Bookstore and Publishers. Rick Depofi composed the main themes and transitions. David Amram added his unique compositions on flute and piano, tying all the segments together just as he had for *Pull My Daisy, Manchurian Candidate,* and *Splendor in the Grass. Ferlinghetti: A Rebirth of Wonder* had an auspicious premiere in his hometown at the 2009 San Francisco Film Festival. *New York Times* critic Daniel Gold wrote, "He was not just present at the creation of the Beat Generation, he was also one of its midwives."

Barry Kaiser worked at Your Father's Mustache with me in Denver and was the first photographer I'd ever met. He lives in New Orleans and was always telling me to come to Jazz Fest. So in 2011, I put a call in to the director. After he looked at my website, he welcomed me in real Southern style, "Come on down." Jazz Fest is a whole other kettle of catfish—seven days of music over two weekends and parties all night long. Twelve music stages and tents are scattered in the infield of the New Orleans Fair Grounds Race Course. It wasn't hard to get caught up in the Mardi Gras Indians, the second-line dancers twirling their umbrellas, the excitement, the music, and of course the steamin' heat.

Security enforced the two-song rule—that's all the time they gave you to make your picture. Some performers and headliners wouldn't let you shoot at all. Only a few photographers from the big agencies got a crack at the main stage, but there's still plenty going on. Such a smorgasbord of music is being presented—gospel, jazz, blues, zydeco, and Dixieland—that the colorful crowds migrating back and forth had a hard time figuring out which venue to attend.

After the first three days I was running out of film and asked someone in the "photo pit" for a roll. He laughed, "You're the only one here not shootin' digital." With that, I ordered another fifty rolls to be sent down from New York for the second weekend. The music stirred up so much feel-good energy that you never wanted to leave—hence the battle cry, "Laissez les bons temps rouler." Jazz Fest in the Big Easy is one huge gumbo party before the summer heat wave. Everyone celebrated like there's no tomorrow. I took many pictures of performers I'd never seen in person—Jimmy Buffet, Allen Toussaint, Aaron Neville, Kid Rock, Pete Fountain, and James Cotten. Despite all the challenges in the photo pit, I felt there was a story to tell and that what I was capturing might very well fit into a book.

One of the best storytellers I know is silver-tongued Buffalo Benford Standley, a visionary with a heart of gold and a longstanding friendship with Merle Haggard. For fifteen years Benford has been documenting the stories of the early pioneer troubadours and even had a hand in bringing the Haggard/Dylan tour together. He's putting together the first documentary on legendary Jimmie Rodgers, known as "the man who started it all" and the "Father of Country Music." Benford let me know that Kris Kristofferson and Merle were playing at the Greek Theatre in LA and wondered if I wanted to tag along. I got to LA and we met up at noon, just as the buses arrived. Kris came in this sleek silver Prevost while Merle's three-bus entourage arrived just moments later. Early in the afternoon, Benford and I were having lunch with Frank Mull, Hag's longtime tour manager, and I said I wanted to get a portrait of Merle. "You and about two hundred other people," Frank shot back, and we all just fell off our chairs howling. About four o'clock, during sound check, it all came together. Kris was working out a new song, "Feeling Mortal," when Merle came onstage playing his Fender, and then he took a turn on the fiddle. There were no distractions and it was pure joy making those pictures.

New Orleans gets in your blood. The next year I called the director at Jazz Fest and was informed of their new policy—everyone had to apply online for a photo pass. I knew right then and there the whole production had gone corporate.

After filling out the form, I called to talk to the media consultant. She told me I had to have a magazine affiliation or no dice on the pass. I proposed that poet Andrei Codrescu and I do an article for the *New York Times Magazine*. She thought about it and asked for the number of the editor at the *Times* to follow up. I told her to call Andrei, who was game and said he would be signing his new book, *Biblio Death: My Archives*, during the second weekend of the festival. With that, she gave the okay, and I booked a ticket to the Crescent City again.

At the same time, Scott Edwards called to say he'd just opened New Orleans's newest photo gallery and offered to show some of my pictures, which sounded great! When I arrived I went straight to the gallery and found that Scott had hung twenty of my music portraits in a grid on the back wall. Everything was perfect and I settled in. The next day at the festival, it all seemed like déjà vu. I was back running between stages, in the photo pits making pictures, and reconnecting with old friends. It was the same event, different year. On my way back to the gallery one night, I took a wrong turn on Ramparts Street and a cop ordered me into a cab because there was a punk running loose wielding a gun. Everyone knows New Orleans can be tricky, but you just keep swingin' and roll with it.

I made wonderful pictures of Zac Brown, Esperanza Spalding, Dr. Lonnie Smith, David Sanborn, Mavis Staples, Herbie Hancock, and Al Green. The last day everyone wanted a picture of Bonnie Raitt. For whatever reason, she didn't want photographers shooting during her performance, but that's when the real "groove" of New Orleans kicks in and things have a way of working out. The last performance of Jazz Fest on the Gentilly Stage was the Preservation Hall Jazz Band with guest artists Bonnie Raitt and Allen Toussaint. The Preservation Hall performers are "hometown favorites" and give everyone, even photographers, full access. So, at the end of the day, everyone got their chance to take a picture of Bonnie as she played a slide guitar solo with Toussaint during their tribute song.

The next day as I was leaving for New York, Charmaine Neville rounded the corner headed to her weekly gig at Snug Harbor Jazz Bistro. We had been trying to meet up, so this was perfect. When you're in New Orleans you're in Neville country, and how wonderful it was that my last portrait on Marigny Street would be Ms. Neville, the radiant sister of the Crescent City's first family of song.

Like Odysseus, my journey was to envelop myself in "the music of the spheres." This was the siren song that led me to document those in harmony with the muses. Every photograph tells a story and right now there's just not enough time to tell them all. I'd like to thank the many people who helped open doors, giving me the opportunity to be in the right place at the right time. How lucky I've been to find myself in jazz clubs, greenrooms, sound checks, and backstage at wonderful events along America's "heartworn highways." I found what I was looking for—a true generosity of spirit and downright soulful aura glowing from all of these gypsy songsters, composers, instrumentalists, troubadours, and performers. The sound of their music echoes in me and I hope in you as well. Robert Earl Keen's lyric sums it all up: "The road goes on forever and the party never ends."

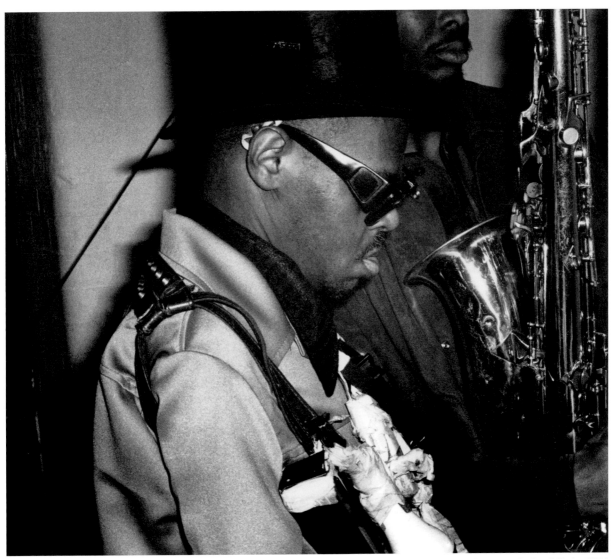

Rahsaan Roland Kirk, 1976

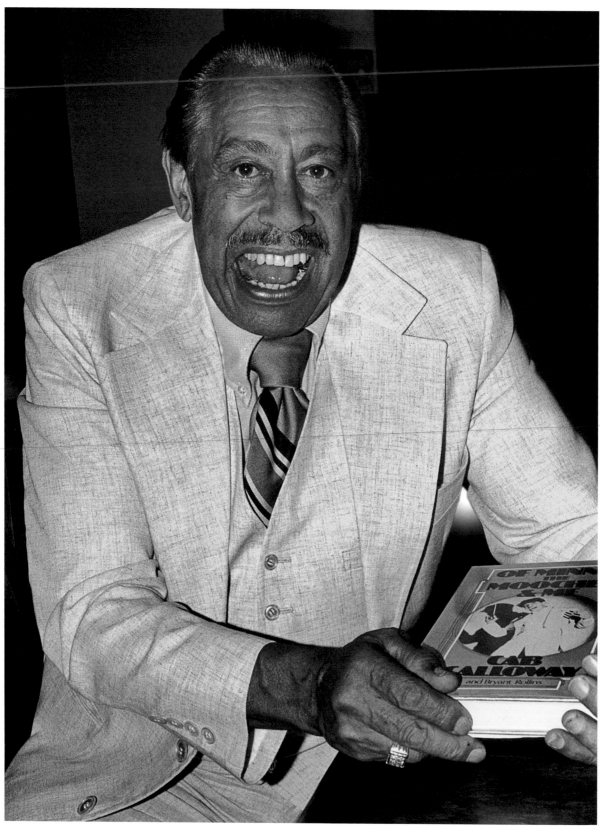

Cab Calloway, 1978

Big Joe Williams, 1978

Steve Goodman, 1980

Ned Rorem, 1982

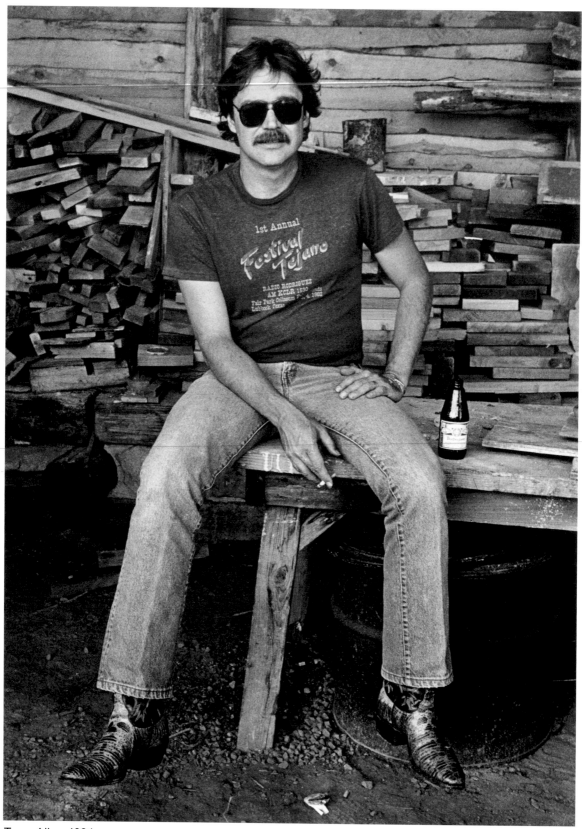

Terry Allen, 1984

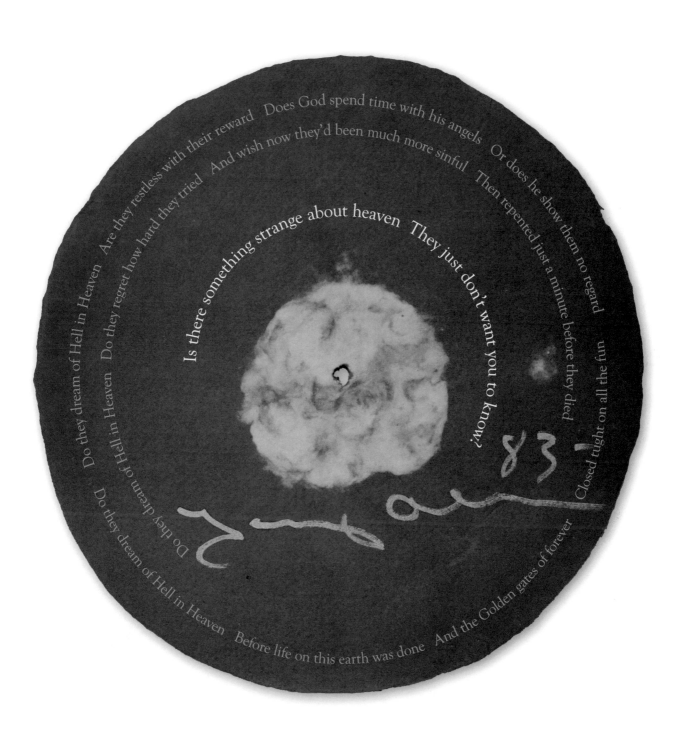

Do they dream of Hell in Heaven · Are they restless with their reward · Does God spend time with his angels · Or does he show them no regard · Then repented just a minute before they died · Closed tught on all the fun · And the Golden gates of forever · Before life on this earth was done · Do they dream of Hell in Heaven · Do they dream of Hell in Heaven · Do they regret how hard they tried · And wish now they'd been much more sinful

Is there something strange about heaven · They just don't want you to know?

Do They Dream of Hell in Heaven
© Terry Allen, 2007, Green Shoes Pub, BMI

Rick Danko, 1984

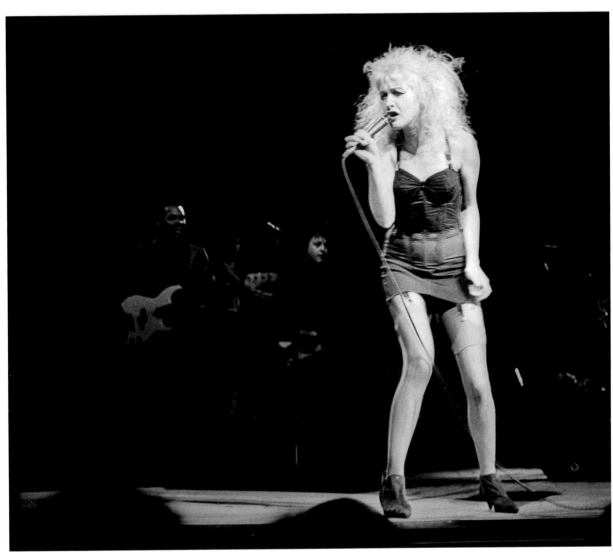

Cyndi Lauper, 1985

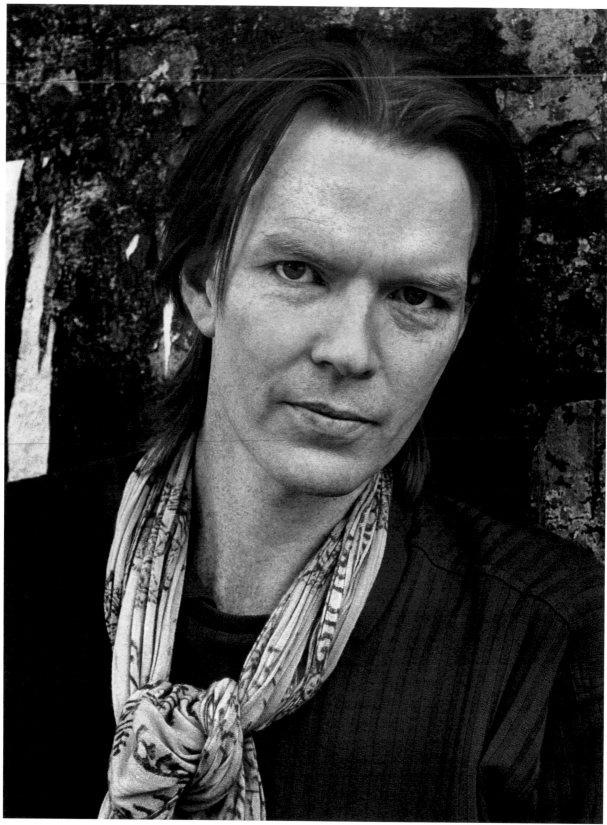

Jim Carroll, 1985

Note for Song
(the)
On my minor she wrote,
 "Vaya con Dio"
Next to my photo of
 Delores del Rio

 Jim Carroll
 '85

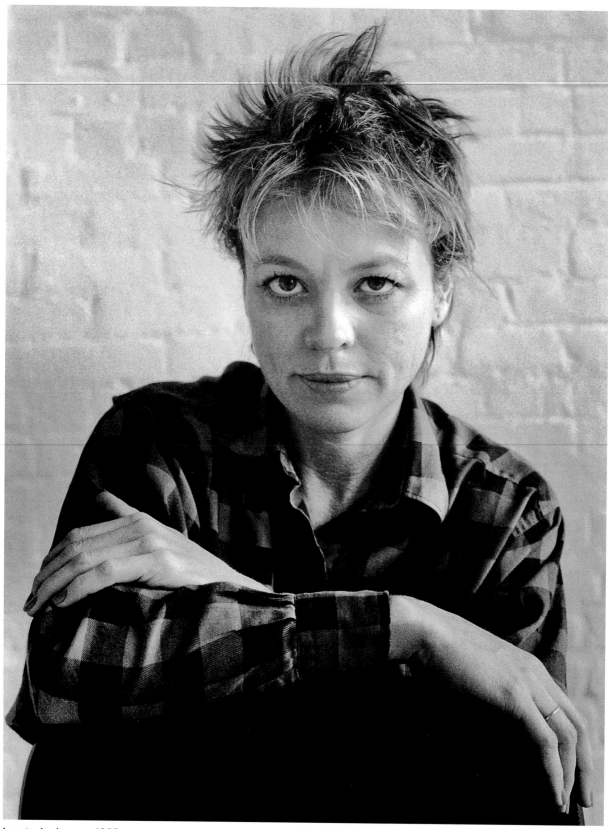

Laurie Anderson, 1985

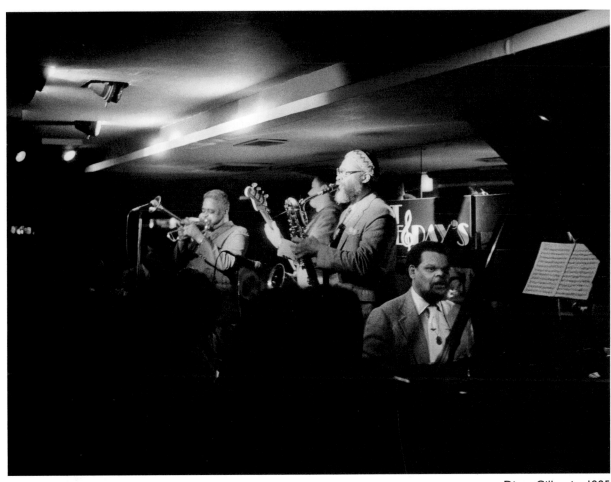

Dizzy Gillespie, 1985

Charm chuckle)
bewy by E
Rim-Rhyme O//
to Reason
Mortars Ragged
.GuttenTail (c(sce)
beG 1st step
Roil f super-
-imposeD DETRiTus

Brine AST Porticullus
Slam Donk pust
Chisel STAIN grown
INWARD Phase As
Altcenative sloche-
Slur, Ashen To Roseate
Prowl legs ApaRT
How sweet it all
is was, one or——

C E C I L T A Y L O R

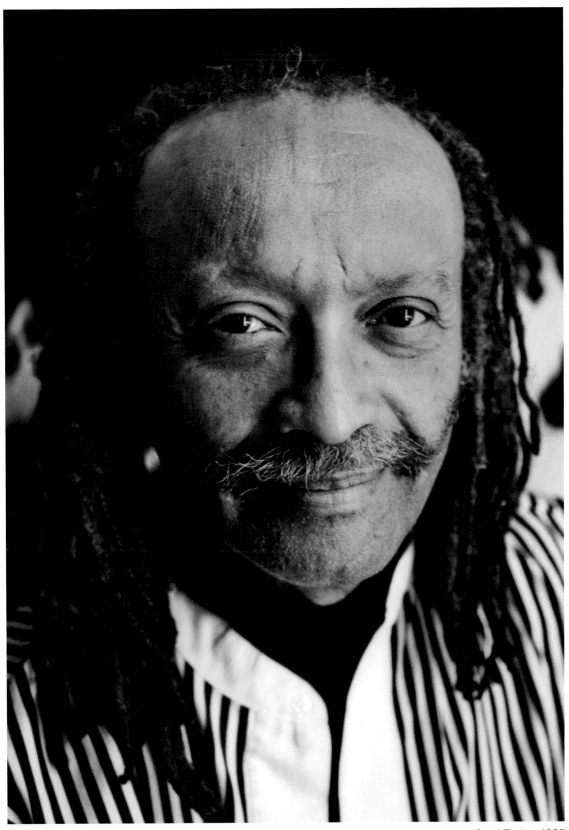

Cecil Taylor, 1985

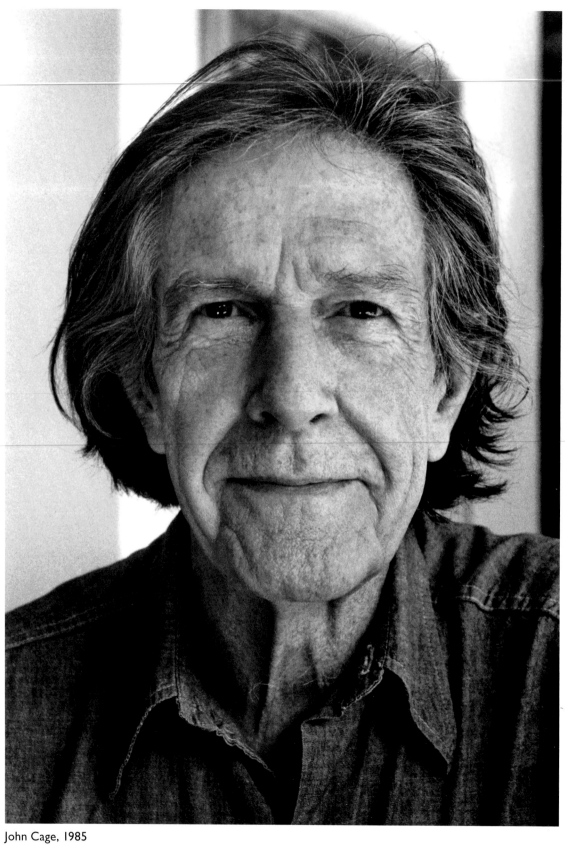

John Cage, 1985

As a result of studying Zen Buddhism with D. T. Suzuki in the early '50s, I started working with "chance operations" when I first went to Black Mountain College.

I spent two summers at Black Mountain and taught composition of experimental music, but no one studied with me. Black Mountain had a very distinguished student body and almost everyone in it became an active artist in society. What was important was not the classes but the fact that the faculty and students ate breakfast, lunch, and dinner together. It was at those meals and during the conversations with them that the life of the college took place.

It was there that I was able to give what is now considered to be the first "Happening." It was a group of activities to each of which I'd given a time bracket so that Charles Olson, the poet, for instance, was free to climb a ladder between certain times. M. C. Richards [poet, writer, and potter] also used the ladder, so that there had to be some kind of traffic considerations. Bob Rauschenberg was active in it with his white paintings and black paintings and he played one of those old-fashioned Victrolas that the dog listens to. David Tudor played the piano and a small radio, while Merce danced. I gave a lecture that had both sentences and silences from the top of another ladder. The audience, instead of facing the stage, was facing itself, the apexes of which were toward the center so that the audience saw itself rather than looking at a stage and the activity around it. I remember in particular Mrs. Yoliphant came in quite early because she wanted to have the best seat and I said they are all equally good. On each seat was a coffee cup and at the end of the performance was the filling of those cups with coffee, which meanwhile had been—not all of them, but many of them had been—filled with cigarette butts. People were still smoking a great deal in the early 1950s. I think we were just becoming aware then of oriental philosophy and it was about that time that I first heard the term "overpopulation."

It was there at Black Mountain that Bucky Fuller put up his first geodesic dome and it collapsed and he was delighted, because he said he learned more from his failures than his successes. It was a great place, but people now who'd like to revive it didn't support it, no one at that time helped to support it. So the end of Black Mountain was the killing of the cattle and the cutting up of the flesh of the cattle as payment for the teachers. There was no money and meat was one of the most highly prized things. Now I wouldn't prize it, but at that time I was still eating steak.

My music is concerned with sounds, not with my self-expression, but with my becoming more open to all the sounds that there are to hear. One of my pieces is called "4'33"" and in that I make no sounds; I listen rather to the sounds of the environment. What happened most recently is a growing enjoyment of sounds that don't vary but that are constant like drones, steady sounds of many of the machines that give us so much comfort. I've made an effort by means of "chance operations" to make my work open to the world outside me.

—Excerpted from Chris Felver's film *John Cage About Cows*, 1986

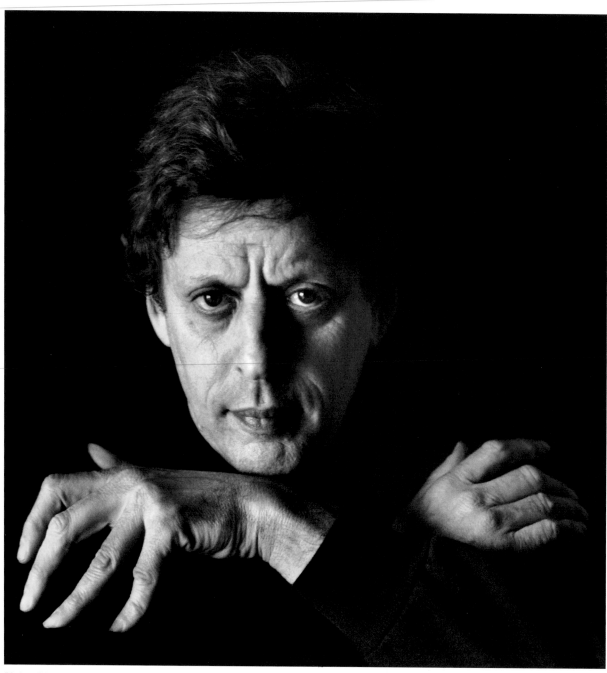

Philip Glass, 1991

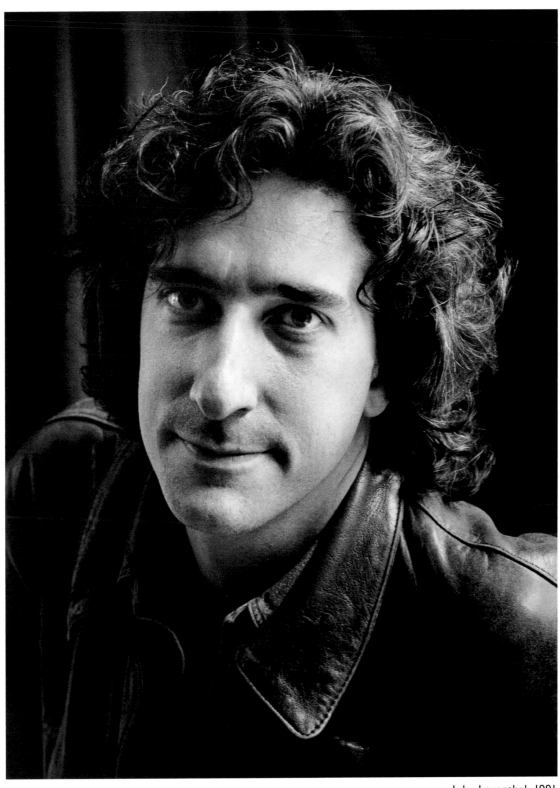

John Leventhal, 1991

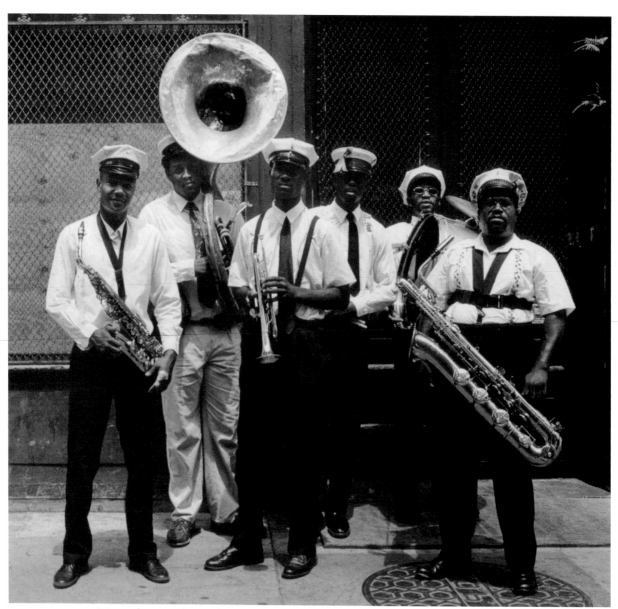

New Orleans Street Band, 1991

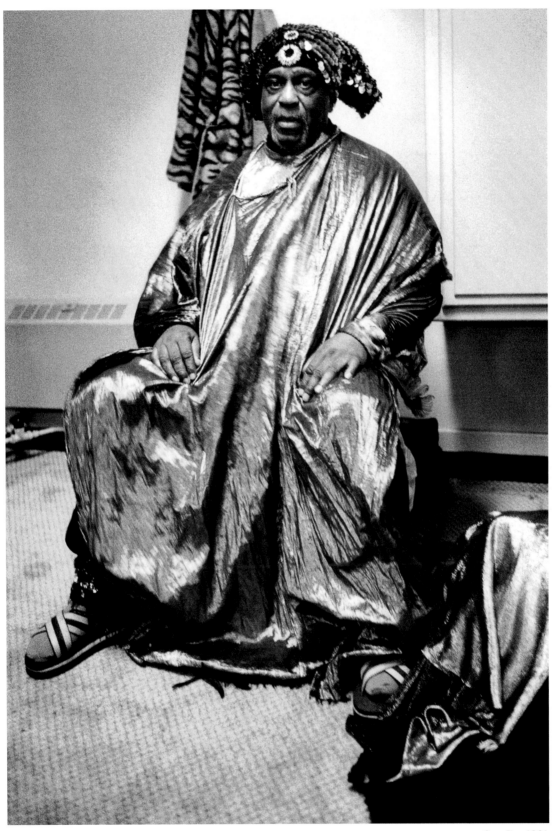

Sun Ra, 1991

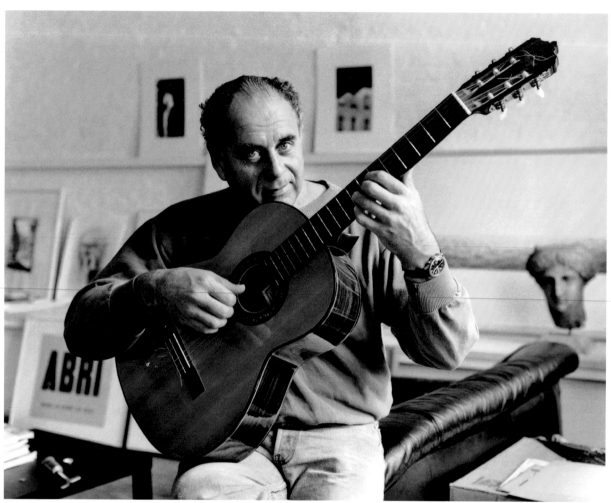

Ralph Gibson, 1992

TIMBRE TENOR TONE

There I was, a 19-year-old photographer's mate second class in the U.S. Navy, hiding in the ship's darkroom with a classical guitar, a portable turntable with Bach's Bourrée playing, and some sheet music, which I barely understood. But reading and playing along with the record helped . . . slowly I built a repertoire of ten or twelve classical pieces.

Upon discharge in 1960, I headed straight to the San Francisco Art Institute for more photography and more classical guitar. A student friend, the painter Bill Wiley, invited me to play in a bar on Sundays, a sing-along in exchange for pizza . . . at least one meal a week guaranteed. About this time I was offered a job on a cruise line to play in the lounge . . . ten or twelve classical pieces . . . and very well paid. I immediately declined the offer, recognizing that I had come to a fork in the road. Photography easily won.

But I never abandoned the guitar entirely. Moving to New York in 1967, I joined friends at St. Mark's Theatre on the Bowery and met Sam Shepard. Sam liked to play and sing and he loosened me up a bit.

But the real breakthrough came when Larry Clark and I formed the Sex and Drugs Band in the mid-'70s . . . we were truly primitive but could absolutely rock the room. Big loft parties were hot events when we showed up, and it was great for a while. But I could only take three chords so far . . . maybe that's why they call it the blues.

I made zero as a musician until about ten years ago. I began to study theory and harmony with Brandon Ross, the avant-garde guitarist and co-founder of Harriet Tubman. With his help I was able to deconstruct a fifty-year-thick wall of defense against studying the real architecture of music. The music began to just flow out and at the same time I questioned the relationship between photography, music, and video. I make short films on open-ended subjects such as typography and perform composed loops in front of the projections. These performances occur a few times a year at some festival or venue devoted to experimental concerns. In recent years I have been collaborating with Jon Gibson, the superb wind instrumentalist. We resonate in harmony and share tacit notions of sound and motion. We have performed at the Stone, Roulette, and similar spaces. I have given solo performances in Korea, Brazil, France, Australia, and Canada and will debut a piece in spring of this year in Beijing.

The response has been great but nobody knows what to think.

I harbor the belief that reality is to photography as melody is to music, wanting to linger on the cusp of both media, neither here, nor there, nor in between. Sound turns to texture turns to melody seen . . .

There is a kind of internal acoustic space that configures shapes not unlike those heard in photographs or moving gestures as the camera floats before an object . . . the lens vibrates and the string sheds light. Something is born.

—RALPH GIBSON
New York City, February 2013

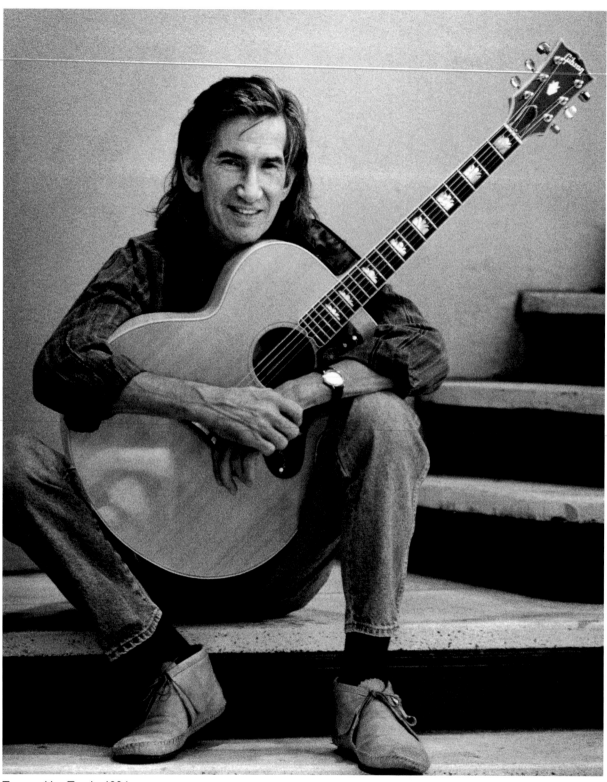

Townes Van Zandt, 1994

Kinky Friedman, 1994

Zion Harmonizers, 1994

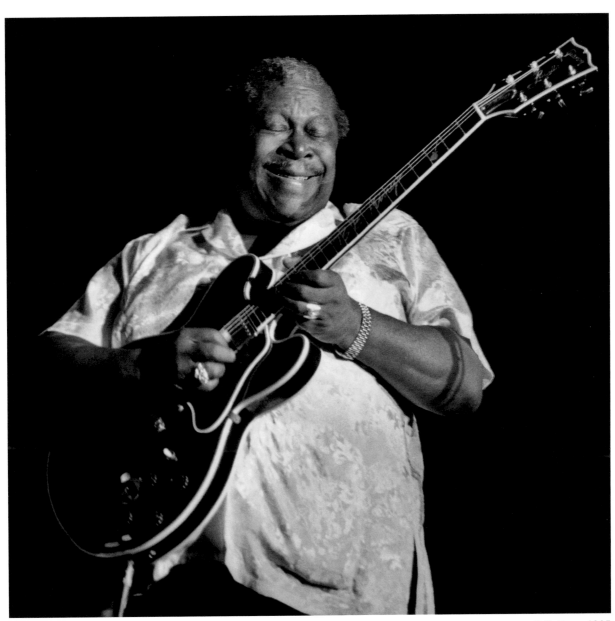

B.B. King, 1995

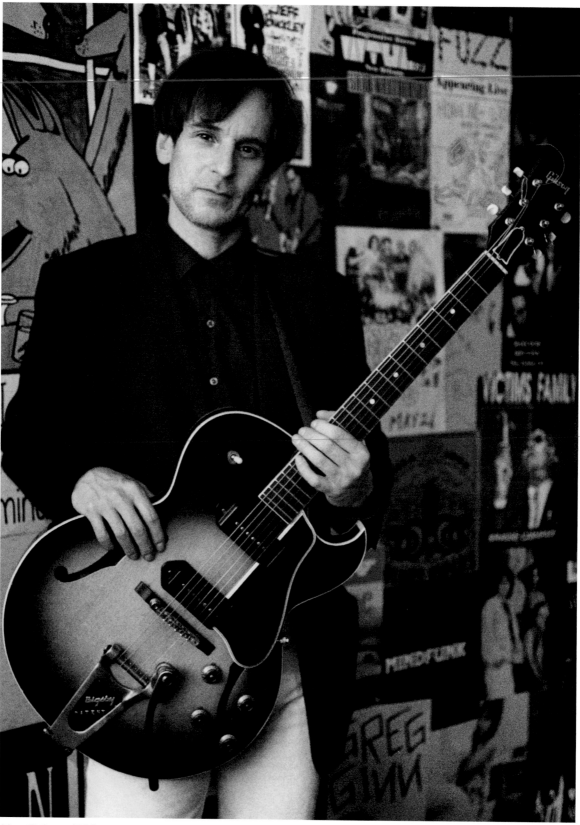

Alex Chilton, 1994

Clarence "Frogman" Henry, 1994

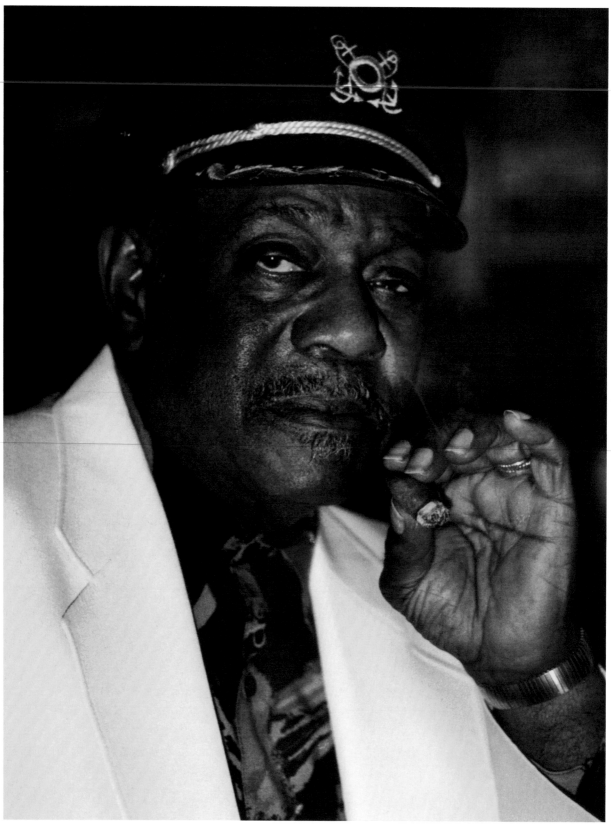

Johnnie Johnson, 1994

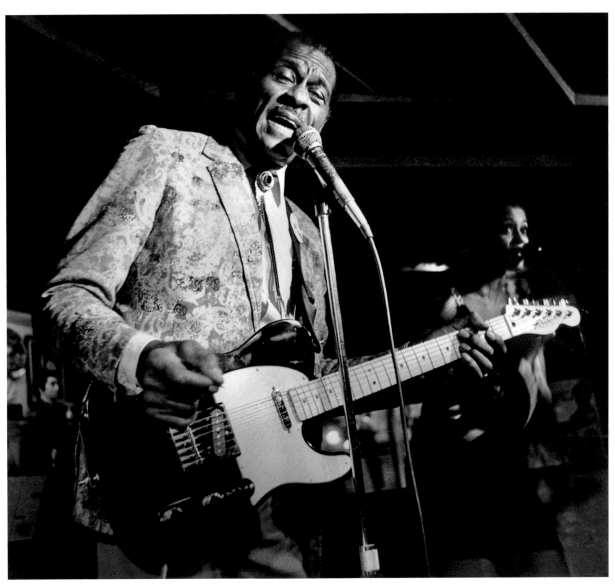

Chuck Berry, 1994

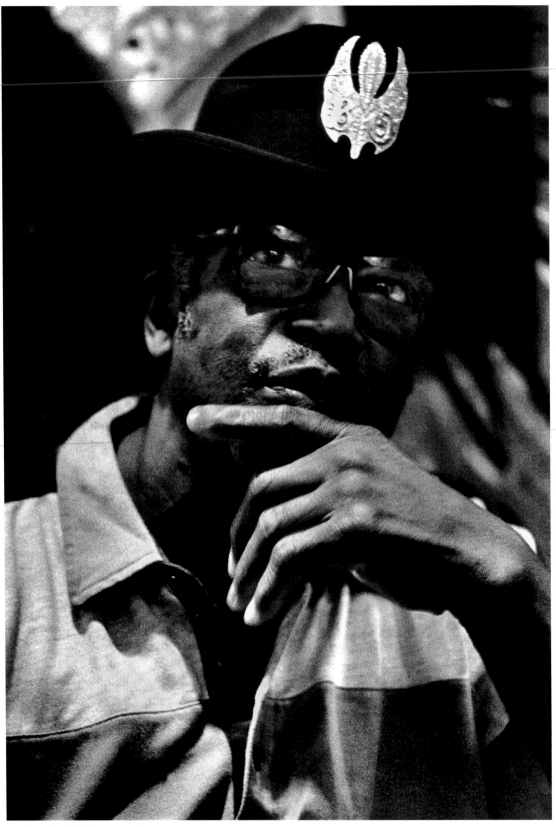

Bo Diddley, 1994

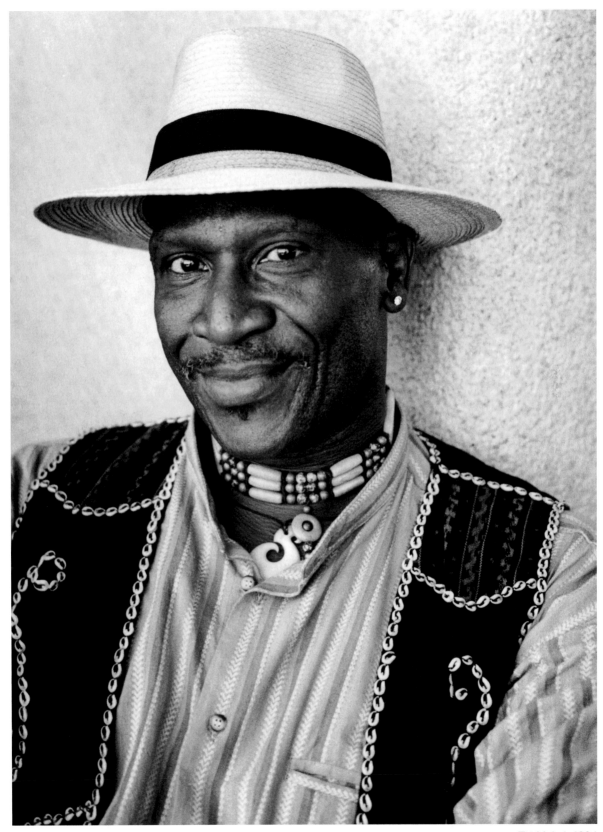

Taj Mahal, 1994

THE FOUNDING OF the FUGS

Much of the '60s had to do with what to do about the American flag, emblematic of Jack Kerouac folding up a flag thrown across a couch at a swanky New York apartment in the fall of 1964. Ken Kesey had purchased a six-acre farm near La Honda, California, from the money he'd made from *One Flew Over the Cuckoo's Nest*. It was the time that Kesey and his pals, called the Merry Pranksters, began holding Acid Tests. The Pranksters arrived in New York City in the wildly painted bus named Further, driven by none other than Neal Cassady. It meant something that *On the Road*'s Dean Moriarty–Neal Cassady–was Further's driver.

Allen Ginsberg went to see Neal, then Neal and Allen drove in the psychedelic bus to pick up Jack Kerouac at his house in Northport, Long Island, and the bus, sporting the banner "A Vote for Goldwater Is a Vote for Fun," brought him back to meet Kesey at a Park Avenue apartment. The Pranksters had put an American flag on the back of the living room couch in Jack's honor. However, Kerouac, spotting the flag in the hectic apartment full of Merry Pranksters, some making home movies, disconcerted him, and he carefully folded the American flag and set it aside.

The Pranksters had placed the flag on the couch deliberately, referring to Kerouac's character Sal, in *On the Road*, who as part of his duties working as a guard in a military barracks accidentally puts an American flag upside down on a sixty-foot pole. "Do you know you can go to jail for putting the American flag upside down on a government pole?" a fellow guard warned him. Sal replied, "'Upside down?' I was horrified; of course I hadn't realized it."

What to do about the flag–an archetypal '60s question.

Right around the time that Kerouac was folding the American flag in a swank Park Avenue apartment, I was busy looking for a storefront to rent in the Lower East Side. I wanted to open the Peace Eye Bookstore. I was a new father, had family obligations, and needed to have a source of income beyond the Times Square cigar store where I worked weekends, plus whatever my rare book catalogs engendered. Selling books and literary relics was remunerative enough that I decided on opening a bookstore and "scrounge lounge." I could put my mimeograph machine there and create a cultural facility as well.

I found a perfect store at 383 East Tenth Street, between Avenues B and C, and just a few hundred feet away from my favorite bars, the Annex and Stanley's. It had been a kosher meat market. I signed a two-year lease for Peace Eye on November 10, 1964. The first year was $50 a month, which went to $60 for the second year. The owner was something called the "Sixth Street Investing Corporation." I went to its offices at 405 Lexington Avenue to sign the lease. I must say, the owner rarely intervened, however controversial the Peace Eye Bookstore became during its two years on East Tenth.

Tuli Kupferberg, Beat hero, lived next door, above the Lifschutz Wholesale Egg Store, with his longtime mate (later wife), Sylvia Topp. I had met Beat hero Tuli outside the Charles Theater on Avenue B back in 1962. He was selling his magazine, *Birth*, to those who were attending the screening of one of Ron Rice's films. He offered to let me publish a poem. I'd seen his picture in a number of books.

I learned a little bit later that he was the guy who'd "jumped off the Brooklyn Bridge" as listed in *Howl*. (It was actually the Manhattan Bridge.) I later asked him why. He replied, "I wasn't being loving enough."

He didn't like to talk about it. Later he commented in the book called the *Annotated Howl*: "In the Spring of 1945 at the age of 21, full of youthful angst, depression over the war and other insanities and at the end of a disastrous love affair, I went over the side of the Manhattan Bridge. I was picked up tenderly by the crew of a passing tug and taken to Gouverneur Hospital. My injuries were relatively slight (fracture of a transverse spinal process) but enough to put me in a body cast. In the hospital wards I met other suicide attempters less fortunate than me: one who would walk on crutches and one who would never walk again.

"Throughout the years I have been annoyed many times by 'O did you really jump off the Brooklyn Bridge?' as if that was a great accomplishment. Remember I was a *failure* at the attempt. Had I succeeded there would have been 3 less wonderful beings (my children) in the world, no Fugs, and a few missing good poems & songs, & some people (including some lovely women, *hey!*) who might have missed my company."

We were very glad he failed at the jump. The world would have missed such poetic classics as "Nothing," "The Ten Commandments," "Morning Morning," "CIA Man," "Einstein Never Wore Socks," "When the Mode of the Music Changes," and many others.

Tuli as a child liked the music he heard at his parents' social club: "They had klezmer music at these things. I would go as a little kid, that high maybe [motions with his hand]. Five years old, I remember. I remember the music, and I would stand watching the musicians; that was the best part of the wedding. There would be, like, one every week. The music really fascinated me.

The Fugs, 1995

They were mostly dance melodies. There was a huge—there was Yiddish radio that I listened to up until my early 20s, which came on every Sunday, which had a wide variety; like the *Jewish Daily Forward* had these Jewish intellectuals analyzing—they had an intellectual program, they would analyze the news, then there were advertisements, and then [laughs] there was a clothing store—I remember some of the advertisements on it. I'll sing one of them for you." He sang:

> "'Joe and Paul Estora Bargain Niggen
> Joe and Pal Minkenna Bargain kriegen
> A Suit a Coat a Gabardine
> Bringt deine kleinen zing.'

Then there was one that went:
> 'Marshak's Malted Milk, it's good for kleine kinder
> Planters peanut oil it good for backen cake.'"

He claims to have received his sense of fun and joy from his mother. "I realize that my father was a very isolated, stern person; not a happy camper; he was one of sixteen children. But my mother was a very lively woman; had a lot of humor, and she loved country things, and she loved society. And I realize this is a kind of Russian–Ukrainian characteristic, so whatever I have of conviviality, I think, came from her."

He graduated from New Utrecht High School in Brooklyn and got a degree from Brooklyn College. "At Brooklyn College, I belonged to the jazz club, and I saw Charlie Christian play with a battery-operated guitar, at some black bar near Brownsville." He wrote poems and short stories and later moved to Greenwich Village where, in the 1950s, he met his lifelong mate, Sylvia Topp. I originally knew of Tuli from his appearance in Beat Generation anthologies, such as *The Beats,* and from his poetry published in the *Village Voice.* During the last few years we had become friends.

This was the poet, publisher, and songwriter whom I later described as commingling his anarcho-Hasidic musical roots with my midwestern country and western, '50s rock and roll, Kansas City jazz heritage to form the band called the Fugs.

As for the Peace Eye Bookstore on East Tenth, there were three rooms, and a courtyard in the back, plus a basement that featured huge water bugs on the posts. The walls were white and the metal ceiling I painted red. My friend the artist Bill Beckman made a sign out of the glass door of a library bookcase, which I hung on the inside of the front window. It had the words "Peace Eye Bookstore." On each side of the words was an Eye of Horus. The outer window had the words "Strictly" and the Hebrew letters for "kosher." I decided to leave both in place.

Meanwhile, after the weekly poetry readings at the Le Metro Café, on Second Avenue near Ninth Street, poets began to congregate at Stanley Tolkin's dance-bar, called the Dom, located in the basement of the Polish National Home building on St. Mark's Place between Second and Third Avenues. (Stanley owned the bar called Stanley's, on Avenue A at Twelfth Street, which during the 1960s was a favorite spot for artists, civil rights workers, writers, poets, and filmmakers.)

1964 was the year of "Oh, Pretty Woman," by Roy Orbison, the Drifters' "Under the Boardwalk," "Leader of the Pack," by the Shangri-Las, and the Animals' "House of the Rising Sun," in addition to "I Want to Hold Your Hand," which had spent seven weeks at the number one position on the charts.

When I was in high school, I followed rock and roll and country and western tunes as if they were sacred chants, but by '64 I was more attuned to civil rights songs and jazz. Inspired by poets dancing at the Dom, I began paying attention to jukeboxes for the first time since '56 and '57 and wondering about the possibility of fusing poetry and this new generation of pop tunes. I was getting the urge to form a band.

During those years, we sang together a lot. There was often a guitar in apartments in the Lower East Side along with a water pipe and collections of folk music and jazz LPs in milk crate storage boxes. Singing together was one of the glories of my youth. One of my favorite lines on civil rights marches was:

> "I've got a home in Glory Land
> that outshines the sun!"

I recalled how we began singing "Down by the Riverside" when members of the Klan surrounded our church in Tennessee and began pelting it with rocks during the Nashville–Washington Walk for Peace back in the spring of 1962.

One night after a poetry reading at Le Metro Café, Tuli Kupferberg and I visited the Dom, where we watched poets such as Robert Creeley and Amiri Baraka (then still known as LeRoi Jones) dancing to the jukebox. Tuli and I retired to another bar on St. Mark's, where I suggested we form a musical group. "We'll set poetry to music," I suggested. Tuli was all in favor of it.

We drew inspiration for the Fugs from a long and varied tradition, going all the way back to the dances of Dionysus in the ancient Greek plays and the theory of spectacle in Aristotle's *Poetics,* and moving forward to the famous premier performance of Alfred Jarry's *Ubu Roi* in 1896, to the *poèmes simultanés* of the Dadaists in Zurich's Cabaret Voltaire in 1916, to the jazz-poetry of the Beats, to Charlie Parker's seething sax, to the silence of John Cage, to the calm pushiness of the Happening movement, the songs of the civil rights movement, and to our concept that there was oodles of freedom guaranteed by the United States Constitution that was not being used.

At first we didn't have a name. One early one I came up with was "the Yodeling Socialists." Tuli was too anarcho for that, and, while I am the only Beatnik who can yodel, he wasn't

into the Great Yod. Another early name for the Fugs was "the Freaks."

Our first duty was to create some songs for our new band. I already had four Blake poems, inspired by Allen Ginsberg, set to music. Two songs, "How Sweet I Roamed from Field to Field" and "Ah, Sun-Flower, Weary of Time," would appear on our first album. I had a Wollensak tape recorder already, by our bed on East Twenty-seventh, and on it I composed a bunch of tunes, "Comin' Down," for instance, and other ditties such as the falsetto "Toe Queen Love," which, alas, never was recorded anywhere but in my mind.

Tuli dashed off tunes such as "Jack Off Blues," "Hallucination Horrors," "That's Not My Department," "The Ten Commandments," "Kill for Peace," and "CIA Man." And I whipped up "Coca Cola Douche," "Swinburne Stomp," "The Gobble," "The I Saw the Best Minds of My Generation Rock," and many others. Tuli and I wrote, in a matter of four or five weeks, around fifty tunes that became the repertoire of the Fugs.

One of Tuli's most popular and lasting songs was "Nothing," written to the melody of a Yiddish folk song. It may have had part of its origins in Louis Aragon's Dada manifesto:

No more painters, no more writers, no more musicians, no more sculptors, no more religions, no more republicans, no more royalists, no more imperialists, no more anarchists, no more socialists, no more Bolsheviks, no more politicians, no more proletarians, no more democrats, no more armies, no more police, no more nations, enough of these idiocies, no more, no more, NOTHING, NOTHING, NOTHING.

Once Tuli told me how he got the idea for "Kill for Peace." He had spotted the sentence "Pray for Peace" on a letter, and then, in his noggin, sprouted the idea for a modification, leading to a Fugs classic tune. We heard over the years that soldiers in Vietnam were known to sing it.

Tuli and I decided to invite a young man named Ken Weaver, who had been staying in the back of Peace Eye, to join us in our new rock and roll/poetry adventure. (The term "folk rock" had not yet been invented.) Weaver had been a drummer with the El Campo, Texas, Rice Birds marching band when in high school, and he owned a large buffalo hide drum. He had been tossed out of the Air Force for smoking pot and proudly displayed his discharge papers on the wall of his pad. He had been a volunteer typist for various Fuck You Press projects, and, with his drumming skill, was soon an eager participant in the unnamed group with the very tentative title "the Freaks." One night in Peace Eye Ken Weaver began jotting some lines for his "I Couldn't Get High" in a notebook. We got excited, and I took over to continue putting some of his lines into a notebook.

I told Israel Young, head of the Folklore Center in the West Village, about my plans to form a band. (I'd sometimes used his mimeograph machine to print some of the F.Y./Press publications.) His advice was, "Don't do it." As for the name, my main ideas, "the Freaks" or "the Yodeling Socialists," were set aside when Tuli Kupferberg came up with "the Fugs," named after Norman Mailer's euphemism for "fuck" that he utilized in his World War II novel, *The Naked and the Dead*.

The Fugs began rehearsing at the Peace Eye Bookstore, and to my surprise the rehearsals themselves started to attract an audience. Peter Stampfel and Steve Weber, a duo known as the Holy Modal Rounders, decided to join us in our early incarnation. We had our world premiere at the Folklore Center and then began performing at galleries and small theaters in the East Village, gradually became more and more skilled at performing, and began to release albums.

Thus we strutted forth into a thrilling decade.

—ED SANDERS
Woodstock, New York, 2013

Lou Harrison, 1995

Meredith Monk, 1995

David Byrne, 1995

Rosalie Sorrels, 1995

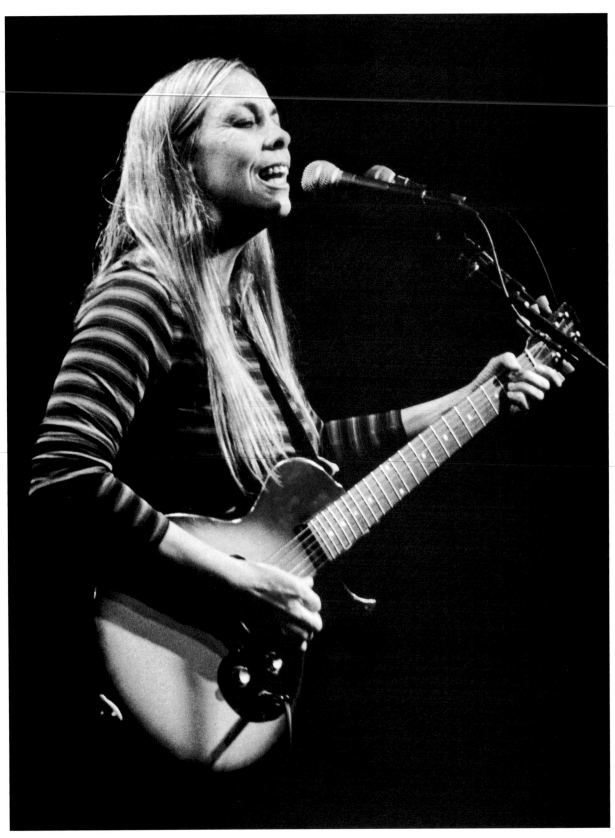

Ricki Lee Jones, 1995

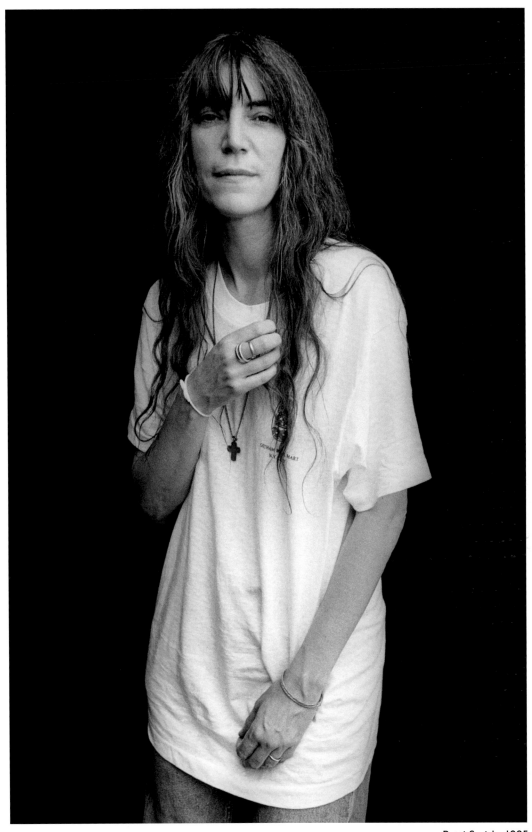

Patti Smith, 1995

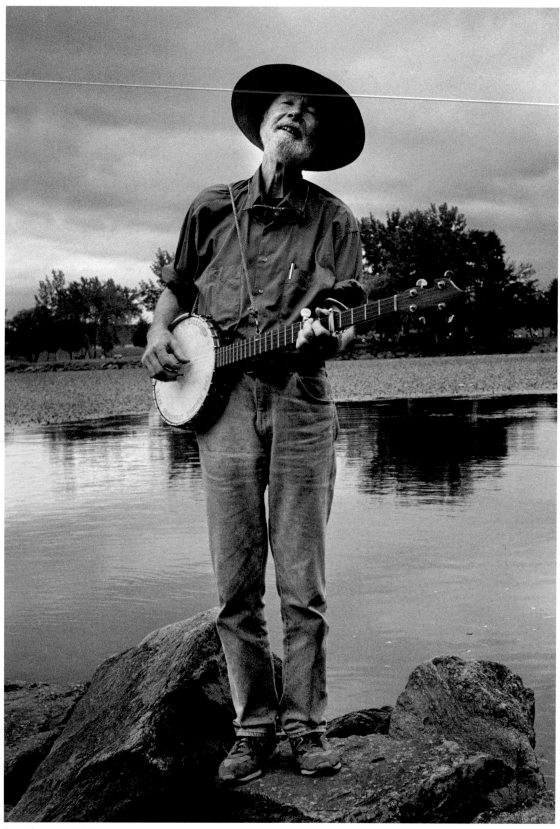

Pete Seeger, 1995

Arlo Guthrie, 1995

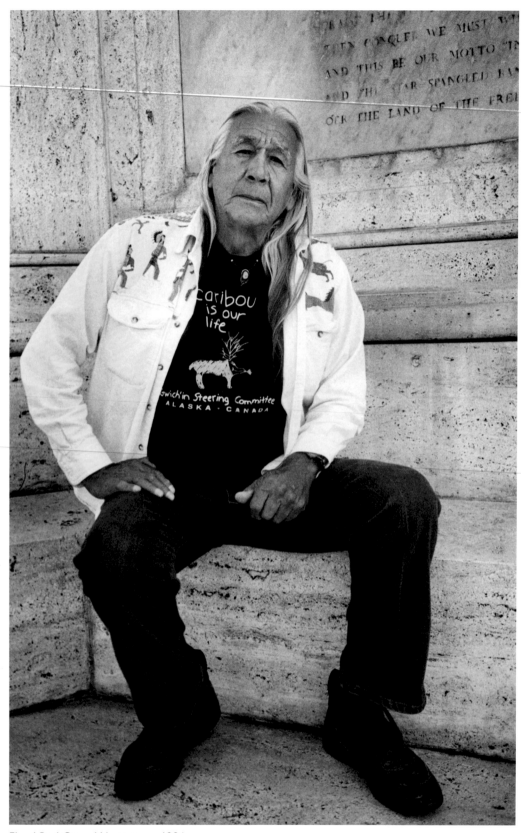

Floyd Red Crow Westerman, 1996

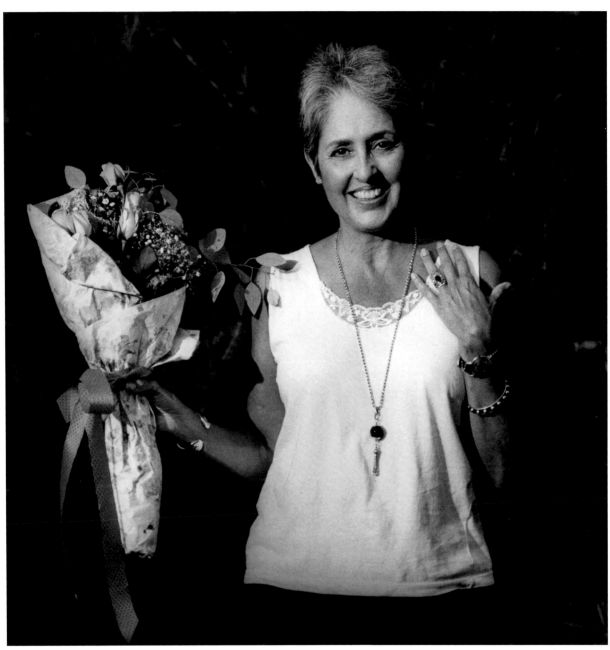

Joan Baez, 1996

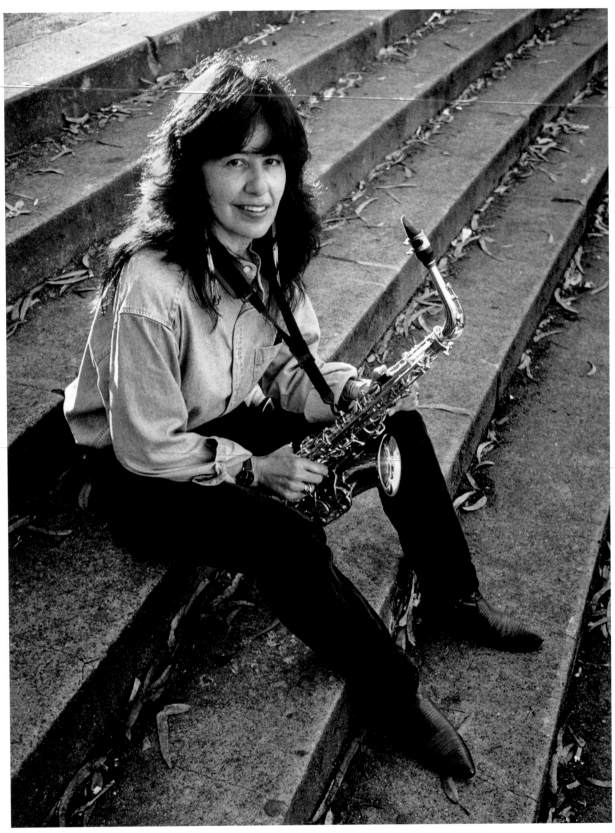

Joy Harjo, 1996

In the Mvskoke tradition,
as I was told by my cousin, the animals gave humans songs.
That's how we got started.

When I am shaking shells at the ceremonial grounds in the thick of summer, I feel the process of how all of the dancers, male and female, become one person. The turtle shells or can shells filled with river stones make the percussive rhythm. The men are singing. The leader calls out. The men respond. We circle the fire-heart counterclockwise. There are layers of insect singing that blend right in and inspire the feet of the dancers. There is the earth upon which we are dancing. Plants are swaying to various winds. The stars move through the sky in an arc.

We remember that we are one person.

I always feel circles within circles. One circle includes our ancestors, who are happy to see us dancing, and they like to join us. I imagine that at the time of Cahokia and the great mound cultures the circles were immense.

And, because I am who I am, I can often hear the saxophone calling out and answering. It makes perfect sense to me. There's a sweet swing rhythm with the one-and-a-two-and-a-three-and-a, blue note lacing the song weave. The leader improvs to the beat and feel and responds to the memory of the music inside the Mvskoke soul. And there we are, being the music.

When you hear southeastern stomp dance music then you understand that there is a larger story of American music. When you discover that Congo Square, the mythic and very real navel point of the blues and jazz, an original American music, was a southeastern tribal stomp ground, then you know without a doubt that we were part of the origin of jazz and blues. We are part of the story. Yet there is great resistance to including indigenous people in this American story.

We were there; we are here, and we are still dancing and making music.

I walked away from music at the age of 14. Then when I was nearly 40 I took up the saxophone (or, it captured me!) and I did not look back at all the lost years. The saxophone is so human. Its tendency is to be rowdy, edgy, talk too loud, bump into people, say the wrong words at the wrong time, but then, you take a breath all the way from the center of the earth and blow. All that heartache is forgiven. All that love we humans carry makes a sweet, deep sound and we fly a little.

—JOY HARJO
Mvskoke/Creek, Glenpool, Oklahoma,
April 2013

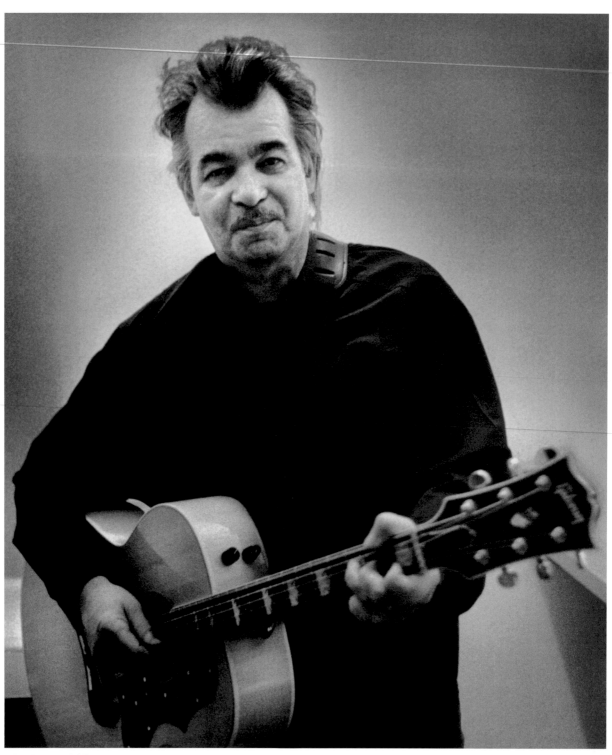

John Prine, 1997

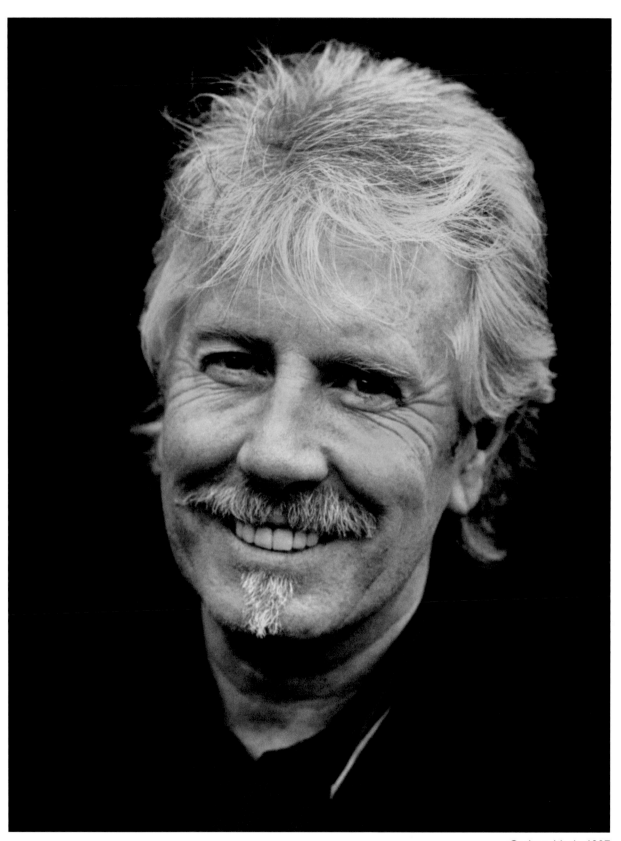

Graham Nash, 1997

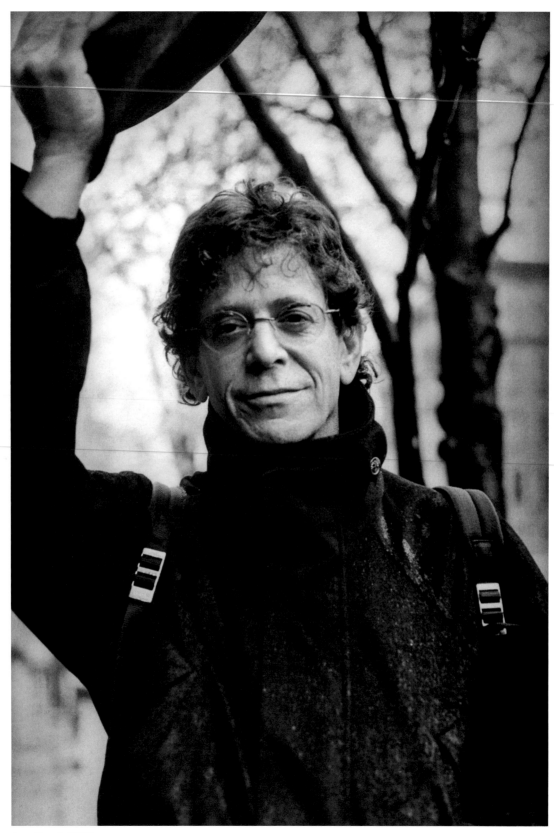

Lou Reed, 1997

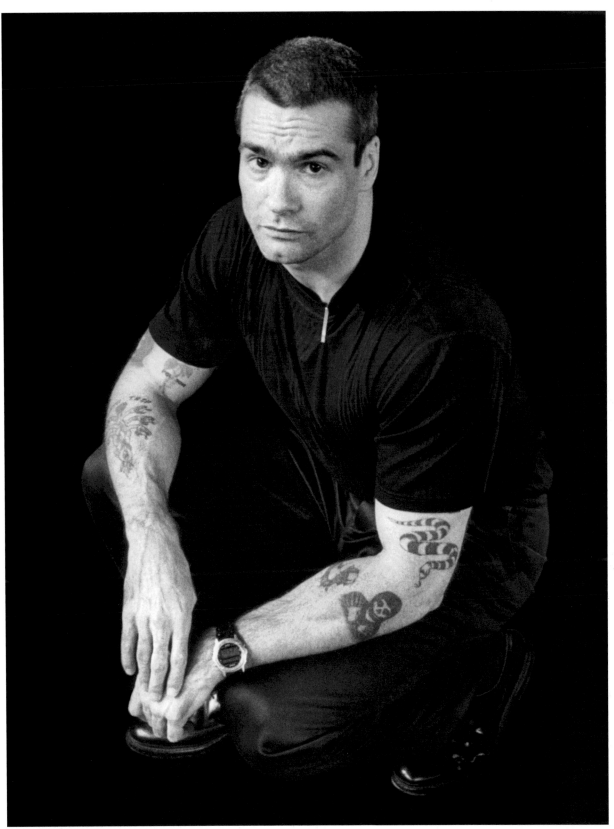

Henry Rollins, 1997

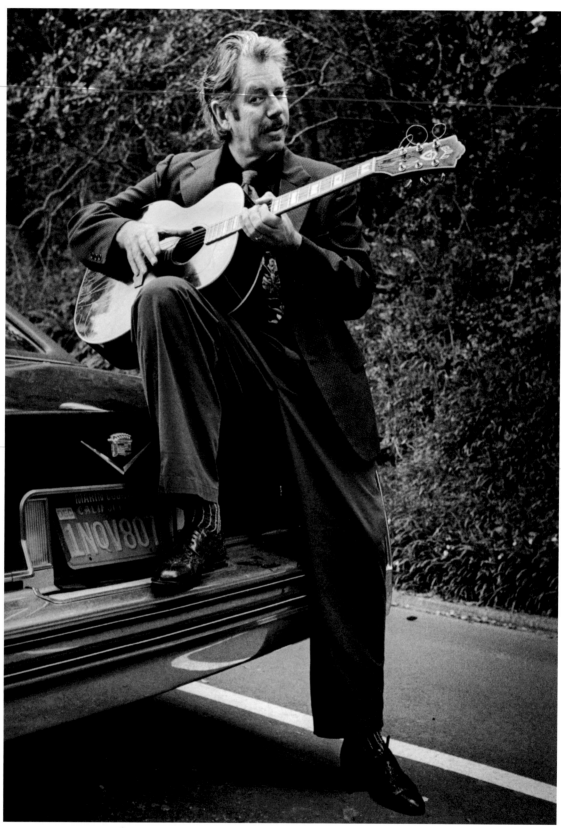

Dan Hicks, 1998

Writing Songs—

To write songs (good songs) it helps first to have an imagination. To say "she is beautiful" doesn't show much imagination, does it? But to put it like this: "She's a pork-chop dinner, with a big baked potato and a side of peas!" Now that's different.

It also helps to play an instrument to make chords on. Like a piano or guitar. If you want to back yourself up on jawharp, be my guest.

And you've got to have rhythm. Different and varied rhythms, not just one.

Singing helps, too. Just enough voice so that people can make out the melody.

Add to this: love of music, self-confidence, chops, and hubris, and my friend, you are a songwriter!

But, always be on time for your day gig because you might need it a little longer...

Dan Hicks

MILL VALLEY, CA.

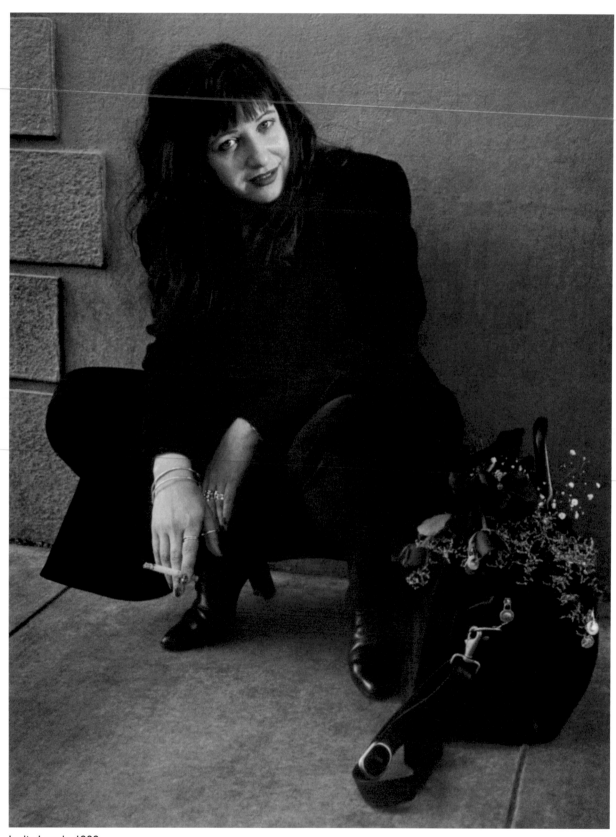

Lydia Lunch, 1999

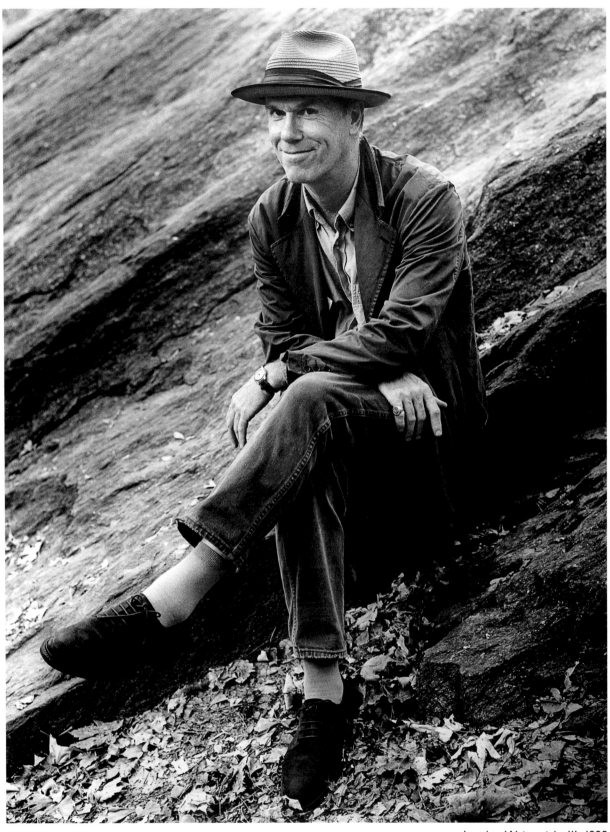

Loudon Wainwright III, 1999

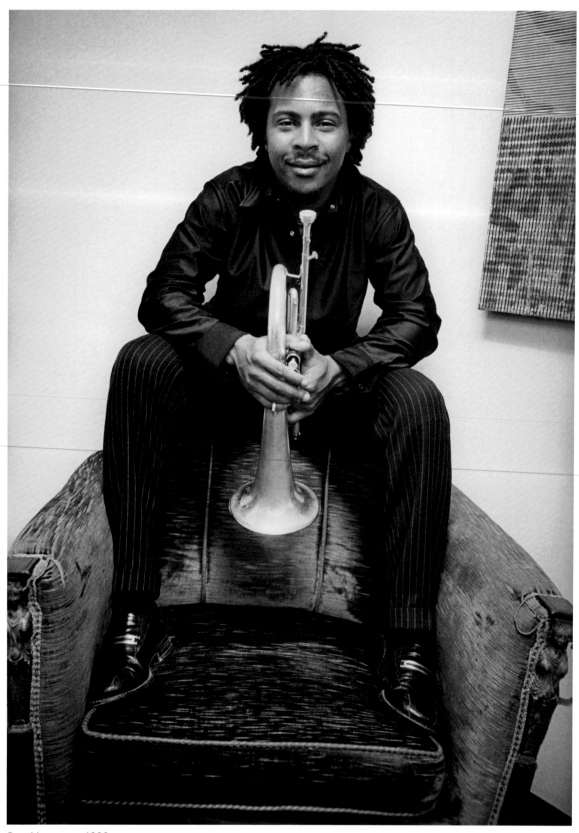

Roy Hargrove, 1999

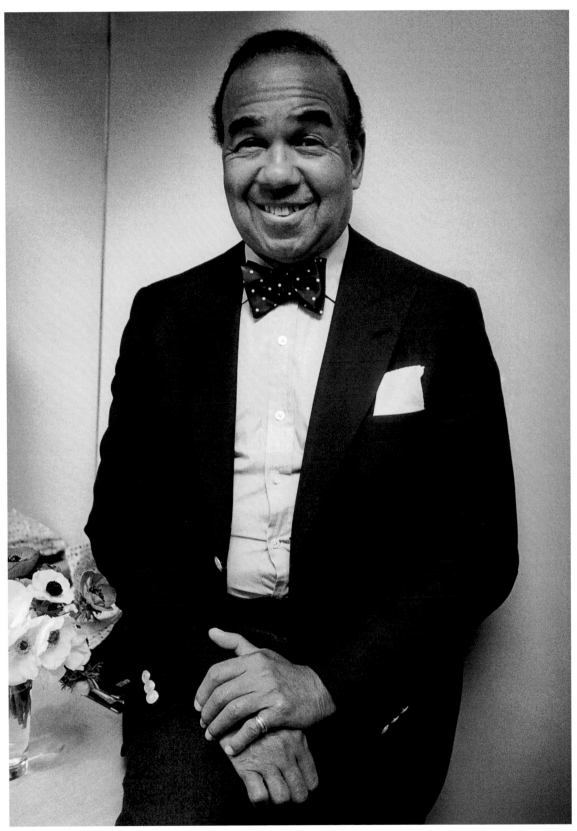

Bobby Short, 1999

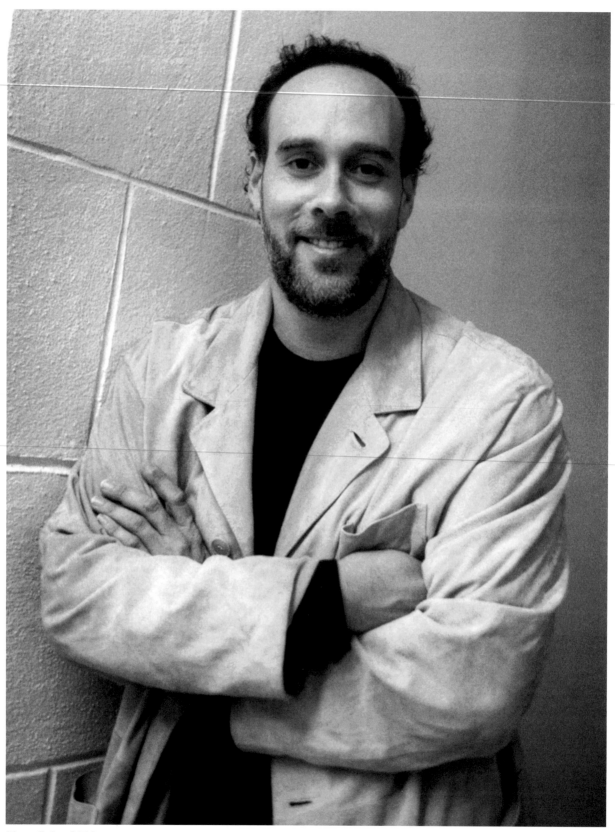

Marc Cohn, 2000

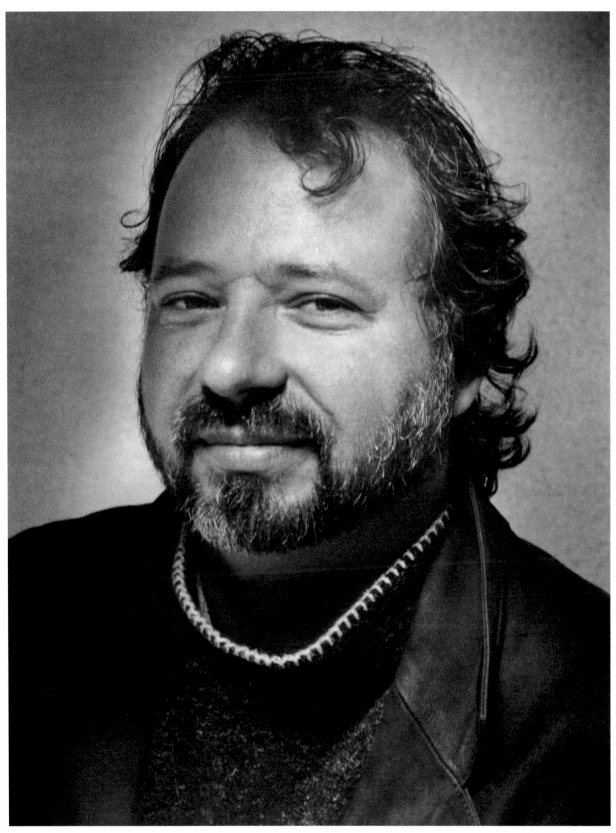

Rick DePofi, 2000

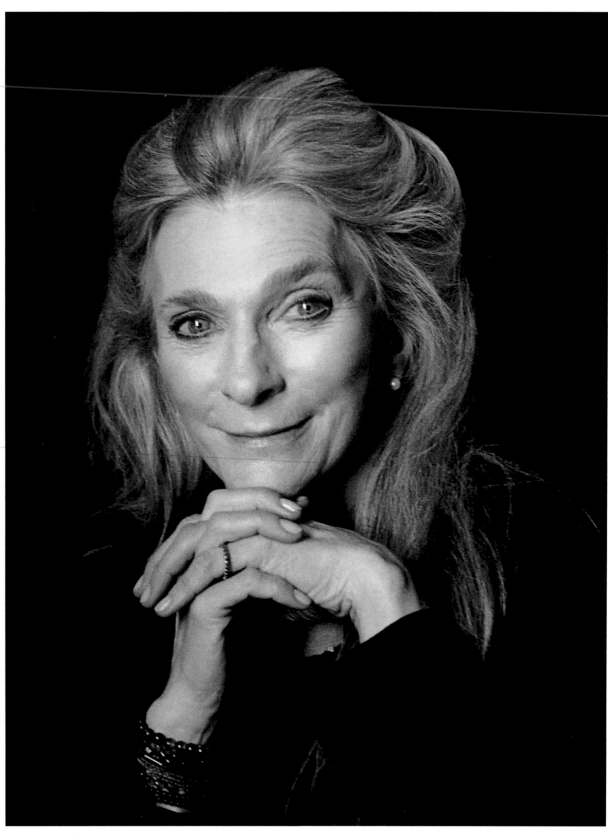

Judy Collins, 2000

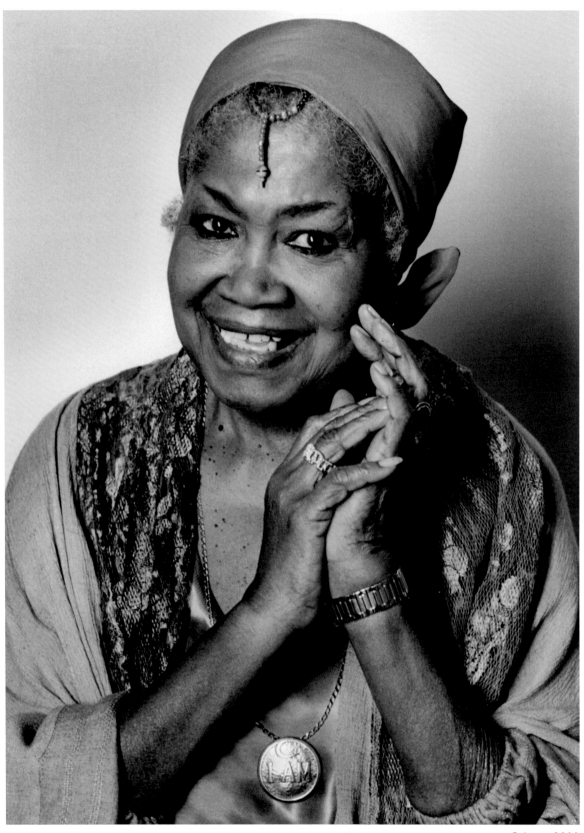

Odetta, 2000

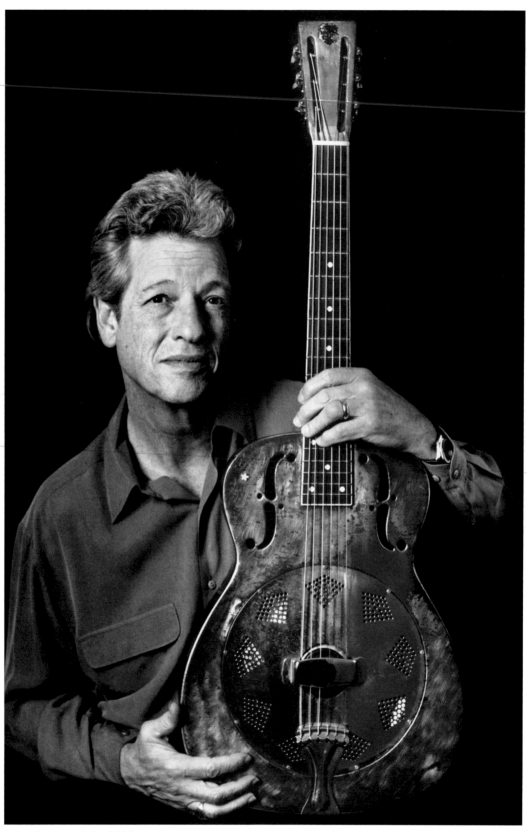

John Hammond, Jr., 2000

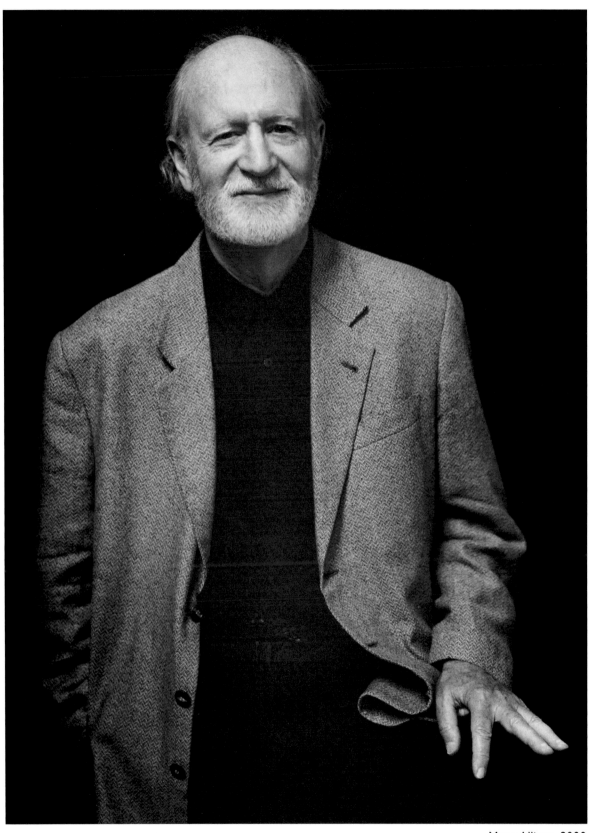

Mose Allison, 2000

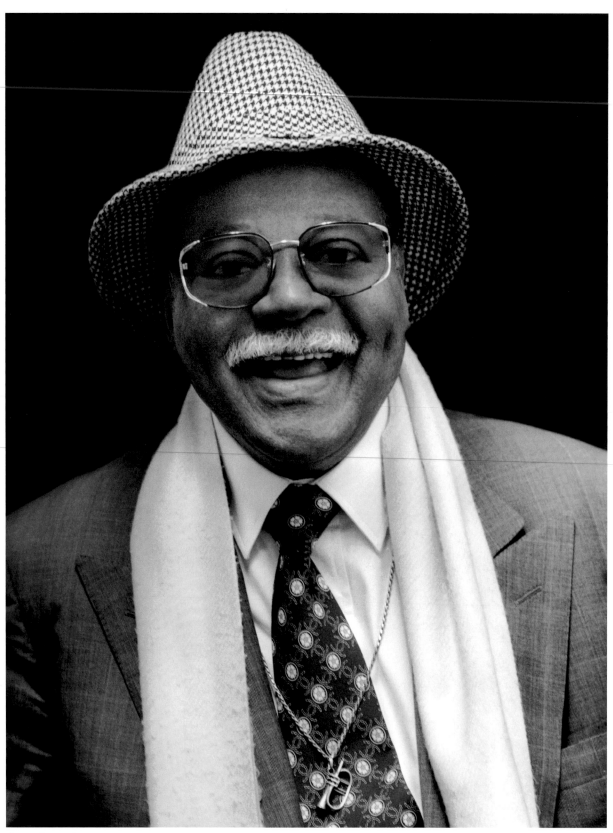

Clark Terry, 2000

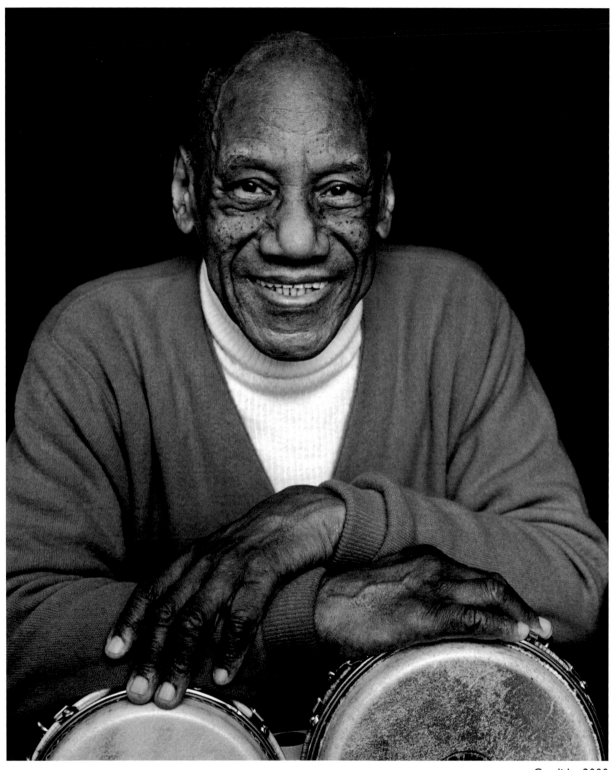

Candido, 2000

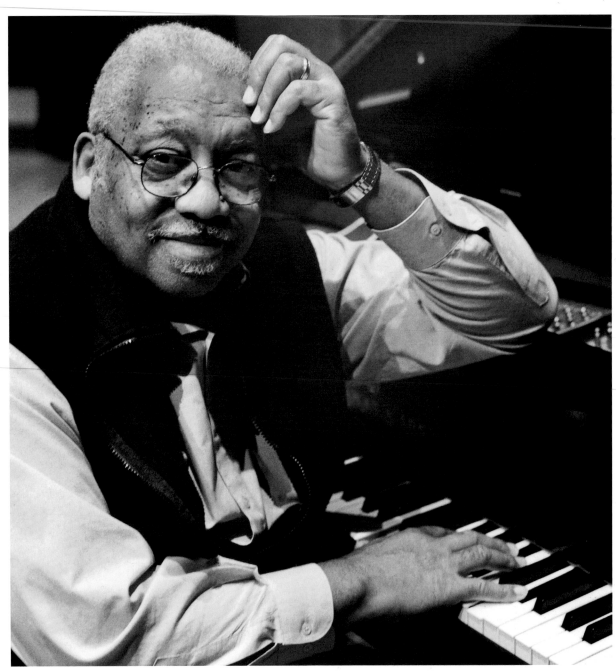

Ellis Marsalis, 2000

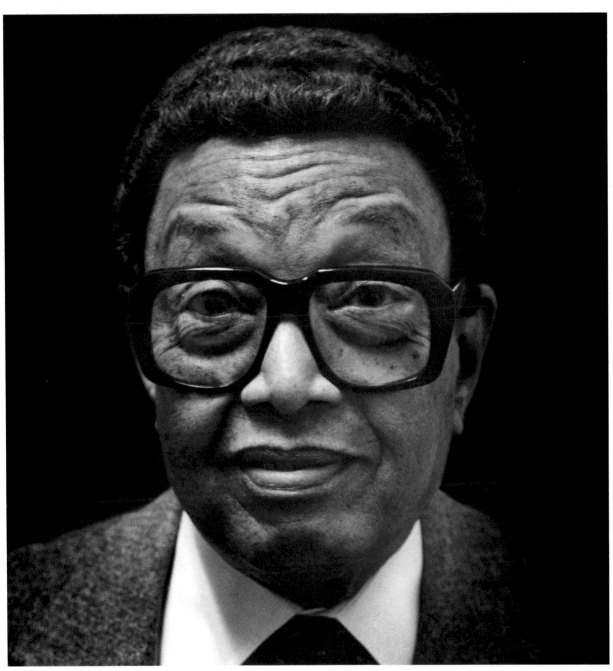

Dr. Billy Taylor, 2000

A SYMPHONY FOR WOODY

As I sit here in the delicious silence of upstate New York, in the spring of 2013, I am now listening to the recording of the Colorado Symphony Orchestra performing a stunning rendition of my *THIS LAND: Symphonic Variations on a Song by Woody Guthrie,* captured live on tape September 22nd of 2012 from Denver's Boettcher Concert Hall.

As I hear the gorgeous playing of the men and women of this great American orchestra, I realize how lucky I was to have been invited as their guest conductor for this performance and to have it documented on record. And then, I realize what a blessing it was to have been asked to compose this piece by members of Woody's own family.

As I listen to the final set of variations, all inspired by Woody's occasional trips to New York City's urban mosaic of neighborhoods, I flash back fifty-seven years to a cloudy afternoon in 1956 on the Lower East Side of New York City. That was when and where I first met Woody Guthrie.

Ahmed Bashir, a friend of Charlie Parker, Sonny Rollins, and Charles Mingus (with whom I was playing at that time), took me over to meet Woody at his friend's apartment a few blocks from mine.

Woody was lean, wiry, and brilliant, with a farmerly way that reminded me of the neighbors I grew up with on our farm in Feasterville, Pennsylvania, during the late 1930s. In the late afternoons after long hours of work, they would often congregate to chew the fat in the side room of Wally Freed's gas station, across the street from our farm. I used to get fifty cents to mow Wally Freed's lawn, and when I was done and stayed around the gas station, I never got caught while eavesdropping on all the conversations of the local farmers and out-of-work men who would commune at Wally's for their late afternoon bull sessions after their chores were done.

They always told it like it was, without wasting a word or a gesture, leaving space for you to think about what they were saying, and in spite of the grinding seemingly endless horrors of the Great Depression, they had better jokes and stories than most professional comedians or politicians. Woody had this same quality, and I felt at home with him the minute we met.

As Woody, Ahmed Bashir, and I sat swapping tales and drinking coffee at the tiny kitchen table from noon until it was dark outside, Ahmed and I spent most of the time listening to Woody's long descriptions of his experiences, only sharing ours when he would ask, "What do you fellas think about that?"

The rest of the time, we sat transfixed as he took us on his journeys with him through his stories. Woody didn't need a guitar to put you under his spell, and we could tell that when he was talking to us, it wasn't an act or a routine. Like his songs and books and artwork, everything came from the heart.

Looking back at these memorable first few hours with Woody, all these years later I still remember the excitement in his voice, as if he himself were rediscovering all the events and sharing them for the first time, as he told Ahmed and me about the incredible stories of his youth and subsequent travels.

Both Ahmed and I marveled at his encyclopedic knowledge of all genres of music, combined with literature, painting, and politics of many different cultures, all of which he wove into his narratives, delivered in a poetic country boy style that was all his own. During these descriptions of his travels and adventures around the country and overseas, he often included references to events of his early boyhood days in Okemah.

Ever since that day we first met, more than a half a century ago, I always hoped that someday I would get the chance to go to his hometown of Okemah, but with my crazy schedule I never had the opportunity to do so. In 2005, shortly after Nora Guthrie asked me to compose a full-scale symphonic composition to honor Woody's classic song *This Land Is Your Land,* I was invited to perform at WoodyFest, the annual summer festival in Okemah. I have performed there every summer since then.

In his hometown of Okemah, I was able to meet his sister Mary Jo, her late husband, and Woody's remaining old friends from long ago who were still living there. And by playing music and spending time with so many outstanding musicians who were also natives of Oklahoma, I felt that I was able to better understand Woody and his work in a deeper way.

I was now able to make a connection, since that first meeting with Woody over a half a century ago, to the ensuing years during which I have played countless times with his old friend Pete Seeger, his son Arlo, and his protégé Ramblin' Jack Elliot.

Spending time in Okemah and Tulsa made me appreciate even more the times I spent with Woody's late wife, Marjorie, in New York, and the numerous concerts I have participated in with his son Arlo and other members of the Guthrie family over the years.

All these experiences helped me when composing *THIS LAND: Symphonic Variations on a Song by Woody Guthrie.*

Kurt Vonnegut told me the last time I saw him before he left us that for my next book, "Always remember to write the way you talk."

Dizzy Gillespie would whisper when it was my turn to play a solo with his band, "Tell YOUR story."

That's what I try to do in every piece I compose.

– DAVID AMRAM
Putnam Valley, New York, 2013

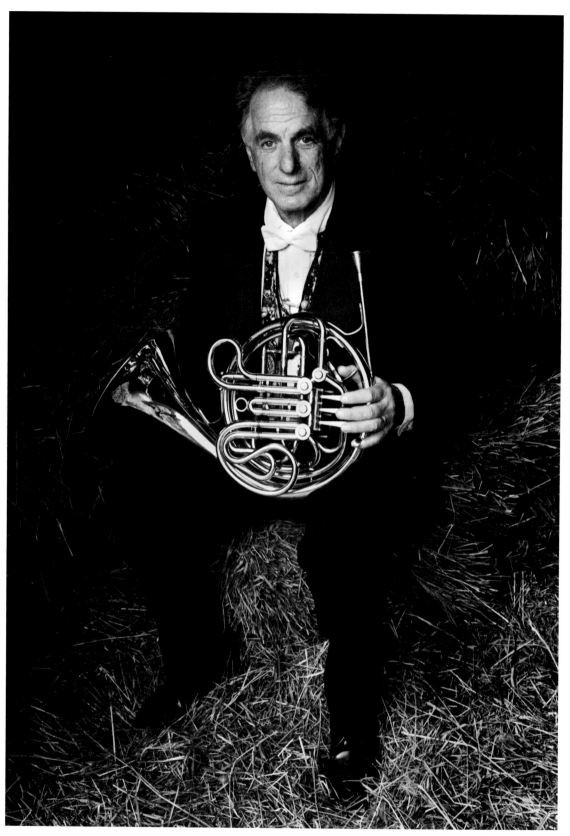

David Amram, 1999

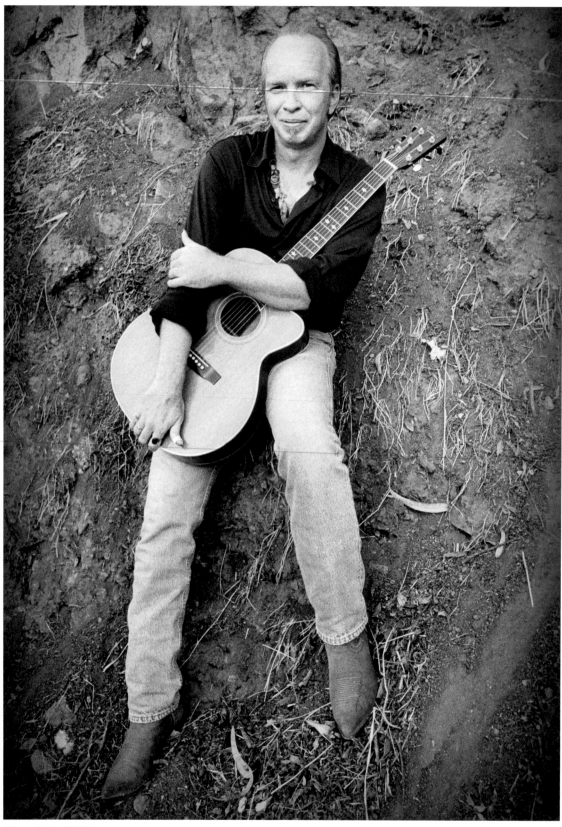

Dave Alvin, 2000

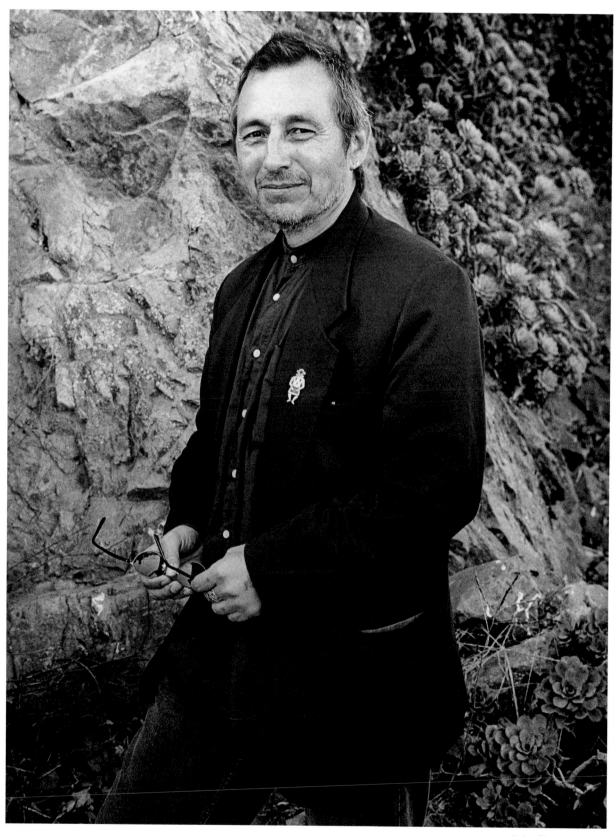

John Trudell, 2000

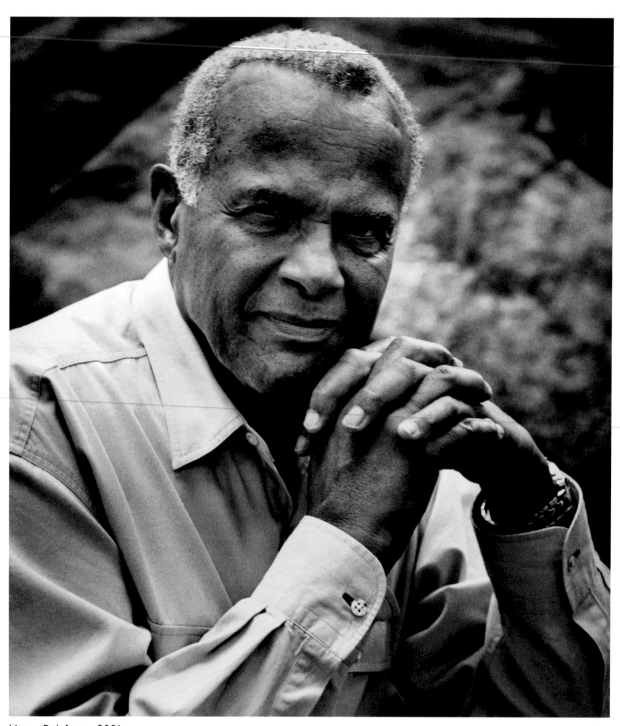

Harry Belafonte, 2001

Marian McPartland, 2001

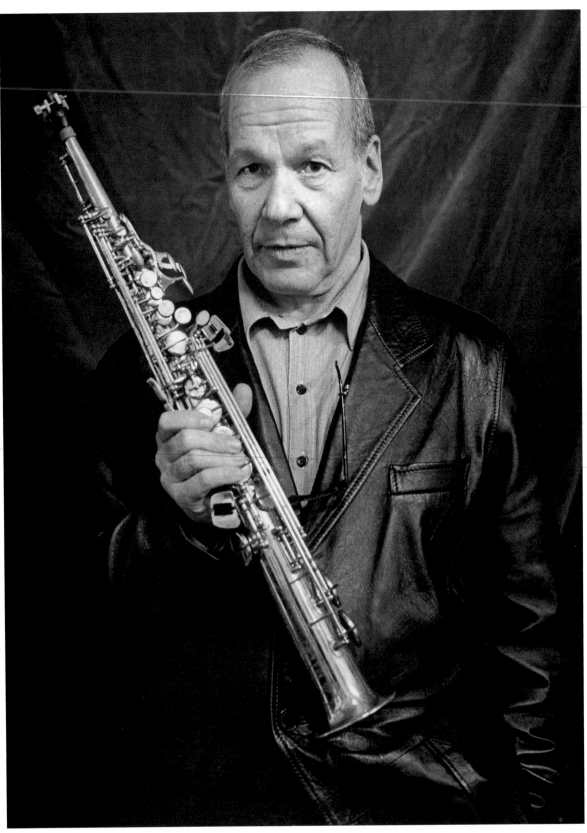

Steve Lacy, 2001

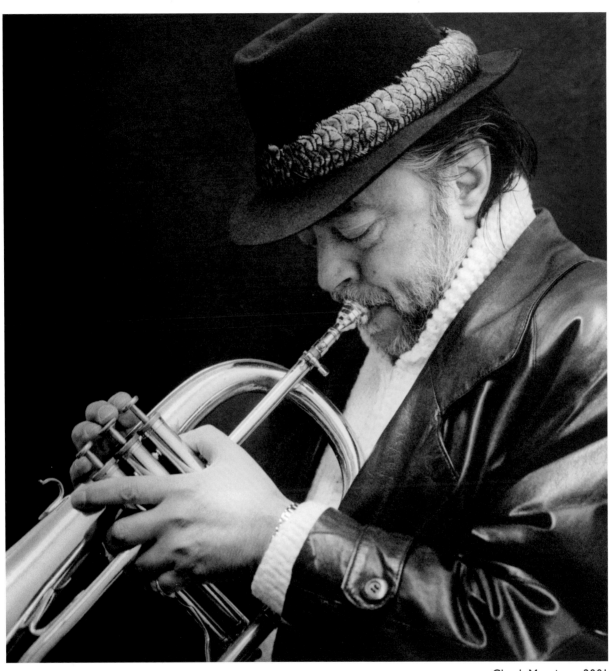

Chuck Mangione, 2001

WOODYS LAST RAMBLE

I told a friend of mine, Tom Paley, a great guitar player who knew Woody, that I'd been listening to some records of Woody's and that I was very impressed and I'd like to meet him. Tom gave me his phone number, saying, "Call him up, he's a friendly person. He'll probably invite you over." So I called Woody and told him I'd been working on some rodeos and playing guitar since '47. Woody says, "Come on over and bring your guitar. We'll knock off a couple of tunes. Don't come today, I've got a bellyache."

It turned out he had a bad case of appendicitis, so I ended up visiting him in the hospital and he could barely speak 'cause he was in a lot of pain. He said if I went over to the window and looked out, I could see his children playing on the back porch of their new apartment in Coney Island. "Go across the street and introduce yourself to my wife and she'll show you around." So I did. Marjorie showed me their new apartment and was so overjoyed to have four rooms, which was a lot larger place than their old apartment on Mermaid Avenue. I saw the kids—little Arlo was 4, Little Nora Lee, who was 1, and Joady was 3. This is 1951.

When I left I walked out on the Belt Parkway and hitched a ride in a Cadillac with a lady who was goin' out to Oyster Bay to christen her husband's new tugboat that was being launched that afternoon at high tide. She dropped me off at Whitestone Landing Bridge and I caught a ride to Westport, Connecticut, to a going-away party for a friend of mine, Cole Couper, who was in the Air Force and going out to California. He asked if I would help drive. Well, my motto has always been "Never say no." So I threw my guitar in the back of his 1937 Plymouth coupe and we headed out to the West Coast.

It took eight days because there was no interstate. After a night or two at Travis Air Force Base, I hitched to San Francisco with my guitar on my back and didn't even have an overnight bag, probably just a toothbrush. I'd just met Woody Guthrie and already started to assume the role of troubadour. I was bumming and hitching around the West Coast for three months and had some wonderful adventures, but there was really nowhere to play. I wasn't puttin' out but more or less taking it all in by lookin' and listening.

After I hitched back to New York, I called Woody. "It's Buck Elliott and I'm back on the East Coast and have been singing 'Hard Travelin'' in every bar and truck stop on Route 40." Woody said, "Come down to 120 University Place, tonight at about six o'clock, bring your guitar and we'll play couple of tunes together." I got there and he was in a closet tuning up with three or four people hanging out with him, and they were asking him for requests. He'd charge them a nickel a request. If they'd ask him for "Blue Tail Fly" he'd say, "That's a Burl Ives song and I get fifteen cents extra for Burl Ives songs." So they paid him twenty cents and he played "Blue Tail Fly." This went on for about an hour, while he was warming up, and then we went in the big room and entertained the crowd. I got up and we played the one song I really knew, "Hard Travelin'." I had learned it off his record, and when we sang it, I was amazed he couldn't remember the words. How could this be? I didn't realize the man had written over three thousand songs.

The party ended late, so he gave me a ride back to Brooklyn in his 1950 Plymouth; he called it his "Cadillac." We ended up driving right to his house and in the morning we started right up where we left off the night before, playing and drinkin' whiskey and telling stories. I ended up staying there for three years. I just couldn't get outta the door. There was just something magnetic about that guy and I'd landed into a whole new life. I slept out in the living room on a couch that was sort of a cot, and I got up about four when Arlo would start throwing things at me. We'd give the kids breakfast and then pour some kind of whiskey, soda, and ice. I was still smoking cigarettes and Woody was a chain smoker. Around the kitchen table, we would mostly play his songs and a few well-known folk songs. I just enjoyed backing him up on the guitar, and he was teaching me how to play simpler and cleaner rhythm 'cause I was a young kid trying to show him how fancy I could play. He could reminisce and tell stories 'cause he was great at that, and I loved listening to him. He was never not writing songs; he was writing songs in his sleep.

Over Marjorie and Woody's bed was a Navajo blanket and old guitar that said, "This Machine Kills Fascists." It was an old Spanish guitar and it was a wreck; Woody was hard on guitars. The neck was all bent up 'cause the guitar was made for nylon strings. It was a classical Tatay guitar. When I was with him he had the Gibson guitar and left the Tatay up on the wall. The action was so bad. In fact he had a piece of two-by-four chucked up against the back of the guitar with a piece of bailing wire that went from the tail piece around to a two-by-four that was twisted and wrapped around with a stick that was like a fence tightener. That was to keep the neck down so you could play it a little bit, but it was still pretty impossible to play and had seen its better days.

One day I asked Woody how you play "Buffalo Skinners." "It's on the record," he said. Arlo had a stack of records on the floor, old wax 78s, and he used that as kind of a stepping stone to get up on the piano stool. Some of those records got broken, but they were all very valuable 'cause they were Woody's collection. So I dug the record out and played it and listened to it about two hundred times. I couldn't figure out how he could sing in a minor key and play a C-major chord through the whole goddamn song. He made it work! That was one of Woody's mystifying tricks. I played it forever and ever and finally made up my own way to

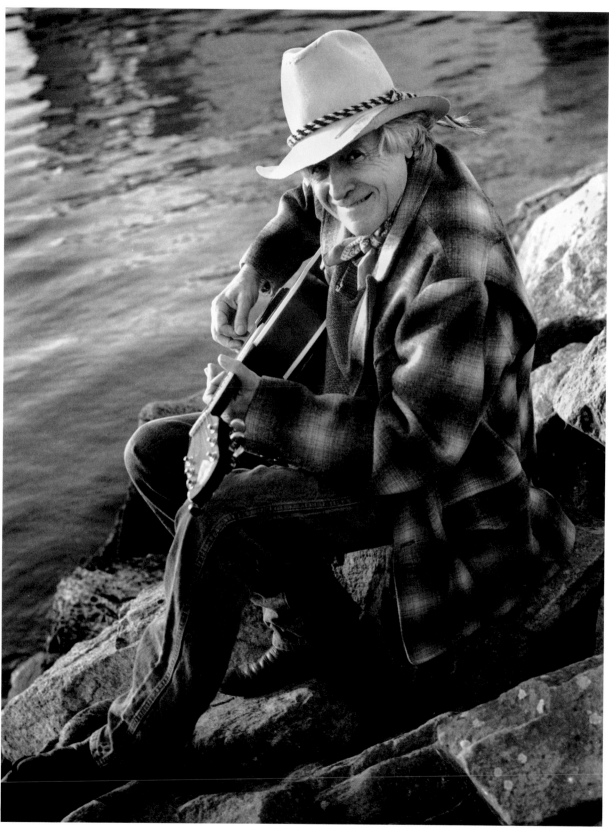

Ramblin' Jack Elliott, 2001

play that song. Years later I figured out how he did it, but my version is still not like his.

I remember one time he was going to play a gig, and when he was talking on the phone to the organizer, she asked if he could tell something about himself. He was calmly rattling off his bio: "I play guitar and write songs and Alan Lomax calls me America's greatest folksinger." I thought it was a little weird to have to say all that about yourself, but that's what you had to do if you didn't have an agent. He later did have an agent I met and he was really a nice guy, Pete Cameron. Cisco Huston came by to visit us twice and I was thrilled to meet Woody's old sidekick. You knew they had gone down the road together. They were in all kinds of fights and union battles and probably went to jail a couple of times.

It was in '53 that Woody really disappeared in a big way. We didn't know where he was for days. Finally, I received a greeting card from Florida. Woody had gone down to see Stetson Kennedy, a writer who spied on the KKK and then wrote a book about them. He was declared the number one enemy of the Klan. He was a fan of Woody's and offered blacklisted artists living spaces on his property.

When Woody arrived, Stetson wasn't home, he was in New York City. Woody was having nine arguments with Stet's wife. She didn't like Woody at all. He got the picture and after a couple of days left and decided to go to Mexico.

The Mexicans wouldn't let him in because they had information that he was a suspected Communist. He was never a member; they wouldn't have a guy like him because he was too disorganized for them. He thought the Communists had a pretty good system, though, because he was in favor of their plan on how to treat the rich and the poor. He felt workin' folks should get paid money for their labors and he was very active with Pete Seeger, who actually was a member of the Communist Party for a short while.

After Woody couldn't get into Mexico, he hitched to Oklahoma to visit friends and relatives. From there he went to California to buy land in Topanga Canyon, near his friend Will Geer, and instead fell in love with Anneke Van Kirk, who was married to a carpenter/actor. Woody felt the locals turned against him 'cause she was married, and even though he'd just put a down payment on the land, they headed back to New York City.

I was staying in the West Village when they got back and Anneke called and said that Woody wasn't doing too much and thought it would be nice if I went over and visited him. "Woody wants to go to Florida with you," she said. I'd just bought a Model A Ford in a wrecking yard somewhere on Long Island for twenty-five dollars, so right then and there we decided we'd all go south together. It took three or four days to get there. Woody spent about fifty dollars trying to get the car started 'cause it was

starting to get electrical problems. We'd stop for gas and never get it started. The Model A wasn't considered to be an antique, just an old car not worth very much. The mechanics would work on it for free 'cause they just loved workin' on Model A Fords.

We carried a cardboard carton with seven hundred typewritten pages of a book Woody was working on that hadn't been published yet called *Seeds of Man*. We stayed at Stetson's a week just camping out, but I couldn't understand why Woody was so damn grumpy. Anneke was 21, I was 22, and Woody was 42; he seemed insecure about us being so close in age and the possibility that she liked me. He didn't say anything about it, of course; he wouldn't. But after about a week of this grumpy hostility coming out of Woody, I just felt I wasn't welcome and thought it better to move on.

I gave Woody the keys to the Model A and hitched 100 miles south to catch a ride with Jack Manchack, a trucker bound for Houston. He was hauling bell peppers and let me drive his turtle-nosed White 3000 series, so I gave him my signed copy of *Bound for Glory*. Jack told me Houston was the most dangerous city in America, but that didn't mean anything to me 'cause I'd never been there. I did get shot at there, but that's another story.

After Houston, I hung out in New Orleans and wrote those goings-on in the song "912 Greens." When the heat got unbearable, I caught a ride to Winston-Salem and hitched the rest of the way to New York City. I wasn't back in New York but a day or two when Anneke called. "Woody's home talking 'bout going to California and taking you with him." So I went over to see him. His first words were, "I can see the ole hills of California just sparklin' at the end of the highway." It was something out of *Bound for Glory*. I could see he was restless to get out of that scene with the confinement of that apartment and his new baby, Lorina. We waited till Anneke got home from her job at Bellevue Hospital and went over to my place at 414 West Tenth.

That weekend hit and we were playing music in Washington Square and passin' around the hat. We gathered up a bunch of money, about twelve dollars, and went to the San Remo Bar. I'd met Allen Ginsberg, Gregory Corso, and all those writers, and my girlfriend, Helen Parker, at that café on Bleeker and McDougal. But Woody was anxious to get to California, and just then my New Orleans buddy Billy Faier had gotten a drive-away car to San Diego, a nice new Buick. It was perfect timing. He loaded me and Woody and Brew Moore, a tenor sax player from Mississippi, in the car, and off we went.

The bebop man drank a lot of wine and didn't see eye to eye with Woody. He stayed in the front seat with Billy. It took four days of fast driving to get to California, where Woody planned to stay on the land again in Topanga Canyon. When we got there, Woody decided we would camp on his property. Woody was really beat, so I got him set up in his wall tent forty feet up on this

cliff overlooking the ocean. About sunset, I left and went down to Will Geer's to look up my old friend Frank Hamilton, who'd been in New Orleans with me just a few months before.

It got later and later and just too dark to climb up that cliff where Woody was camped. So the next morning I went looking for him and he was gone, disappeared. He'd hitchhiked up to Olympia, Washington, then found himself in jail for vagrancy in Montana. After that he hitched back to New Jersey, where they threw him in the hospital and put him in a bathtub, for about a week, to get the road dirt off him. That was the end of Woody's free-ramblin' life. He lived the next thirteen years in institutions. First in New Jersey for about five years, and then back over in Brooklyn State Hospital, where I started visiting him in '51 when he first went there for testing, for what eventually took him out, Huntington's chorea.

– RAMBLIN' JACK ELLIOTT
Marshall, California, March 2013

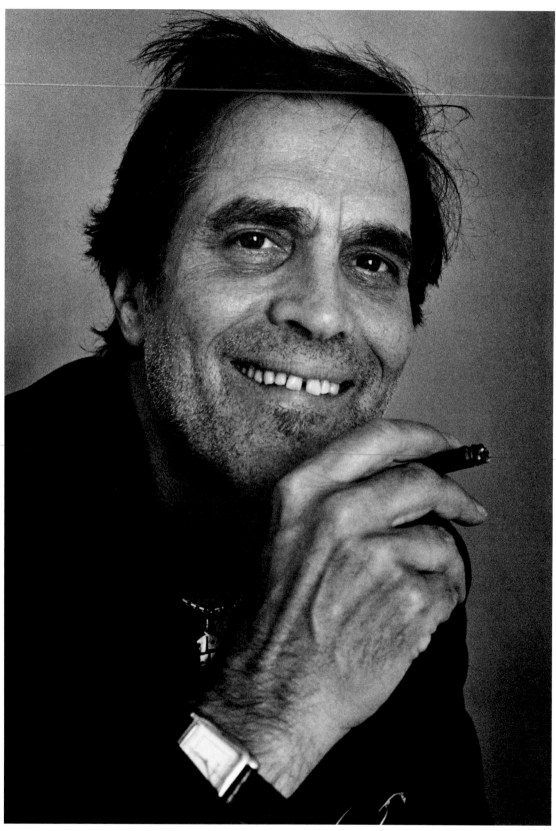

Eric Andersen, 2001

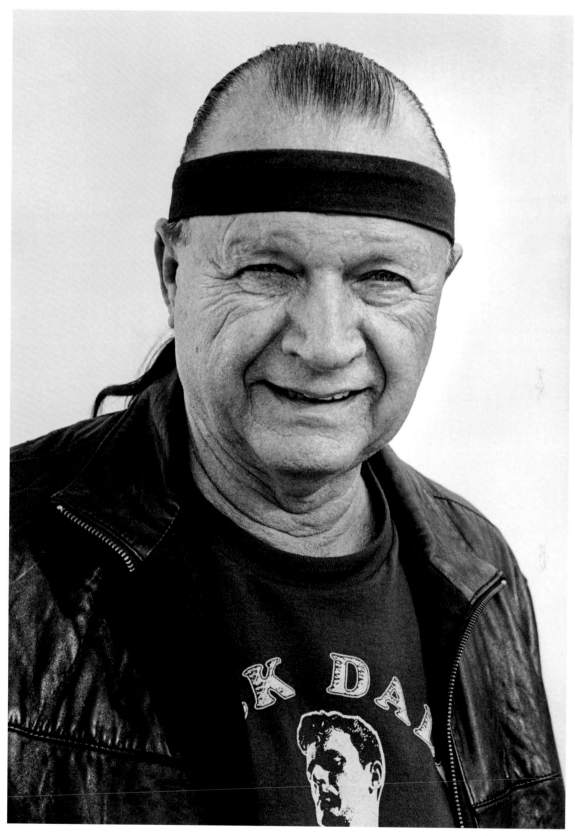

Dick Dale, 2001

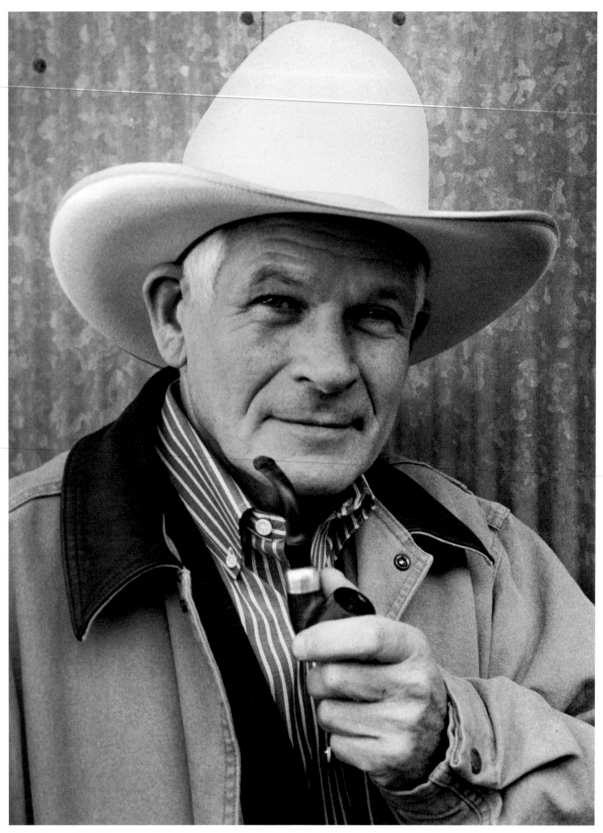

Don Edwards, 2002

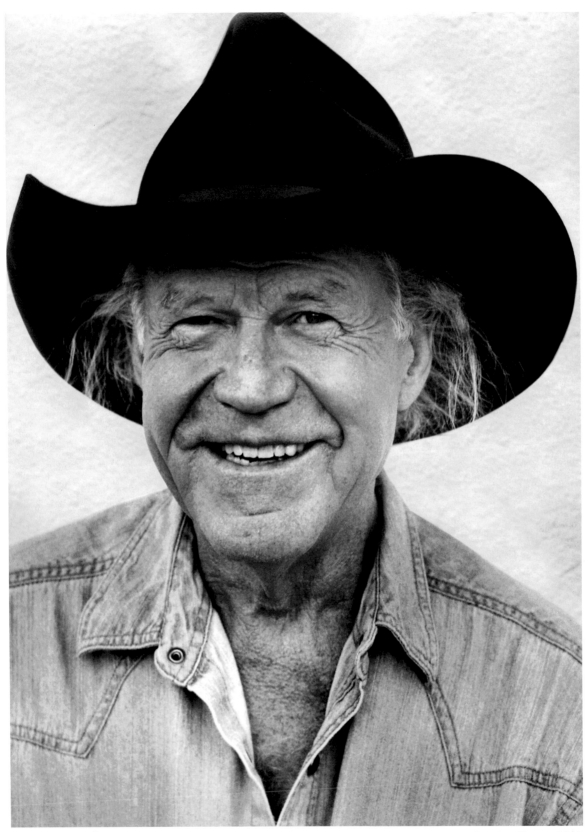

Billy Joe Shaver, 2002

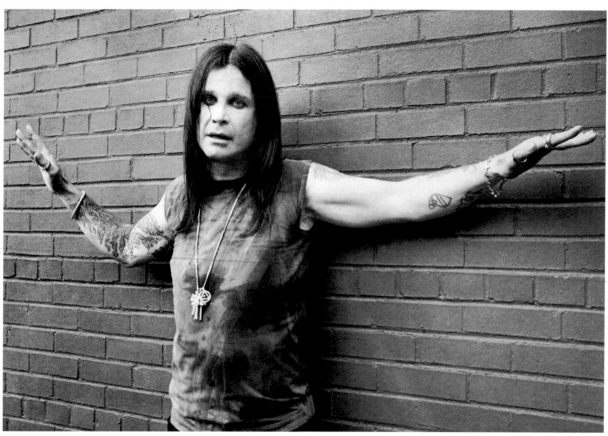

Ozzy Osbourne, 2002

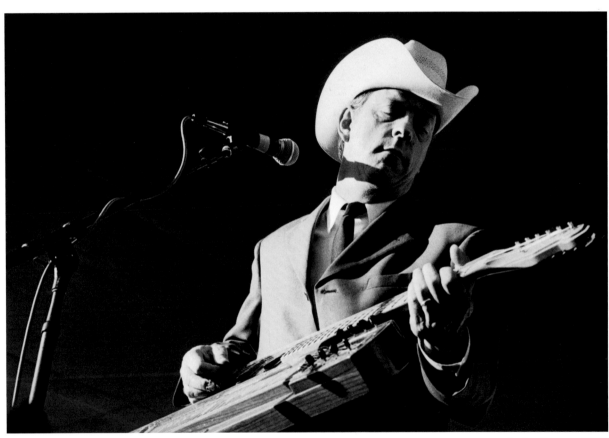

Junior Brown, 2002

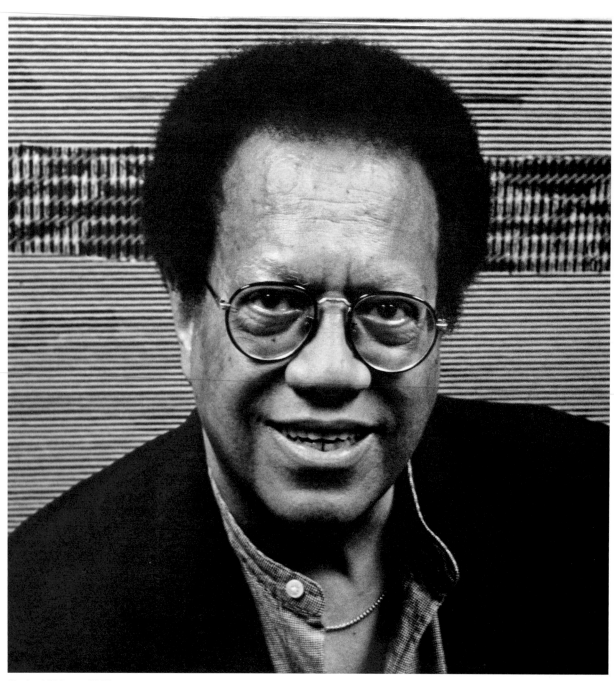

Cedar Walton, 2002

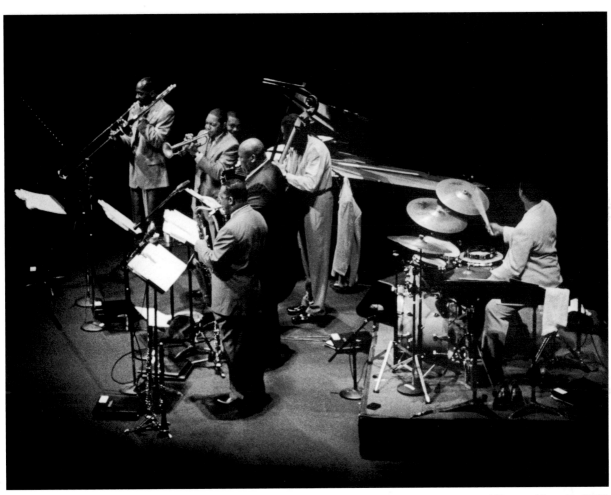

Wynton Marsalis, 2002

Poncho Sanchez, 2004

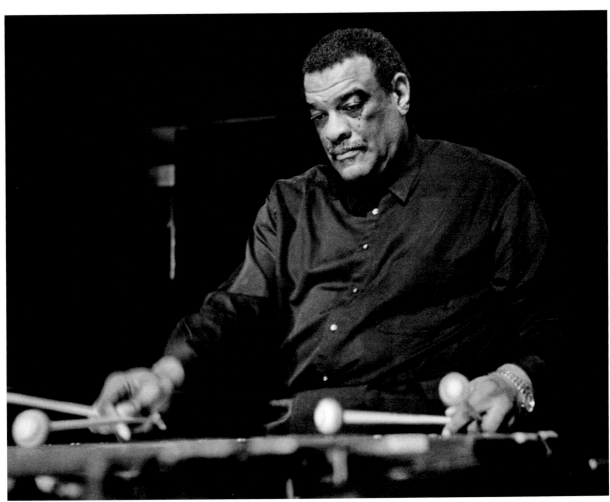

Joe Chambers, 2005

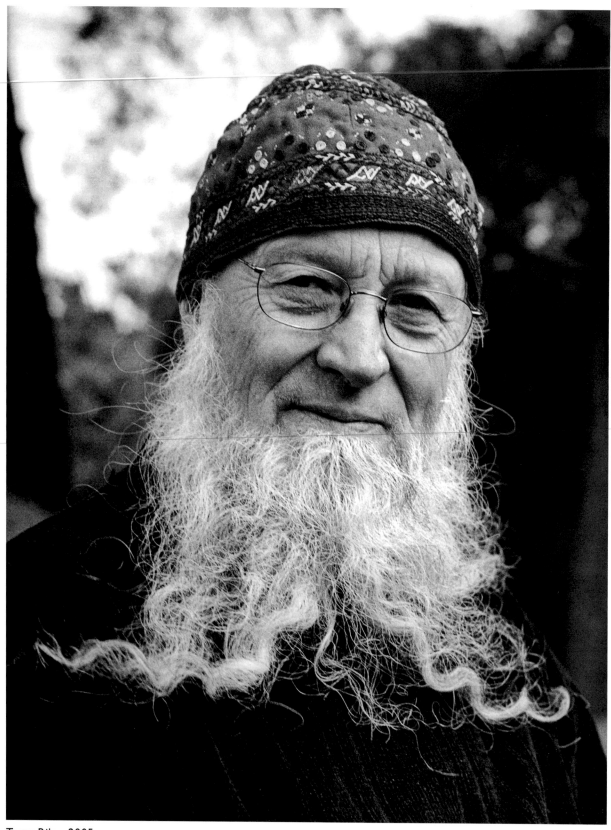

Terry Riley, 2005

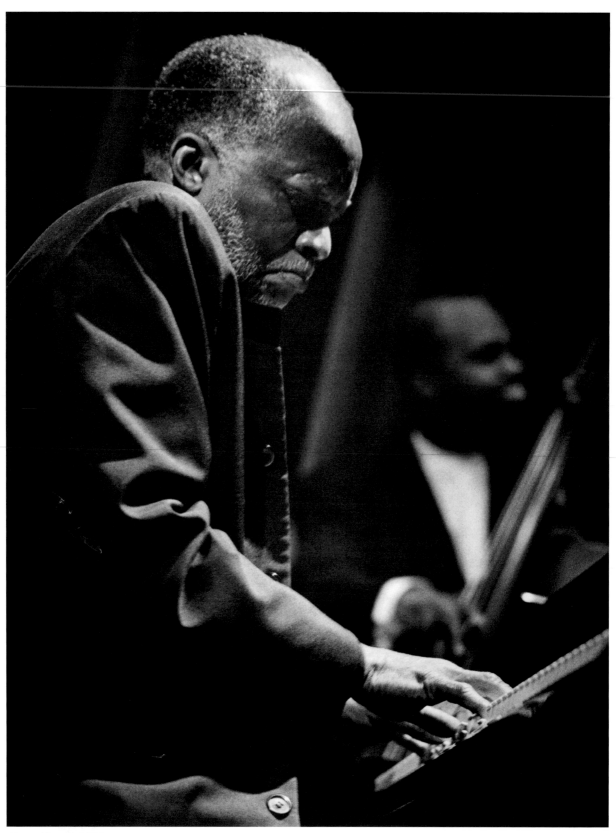

Ahmad Jamal, 2006

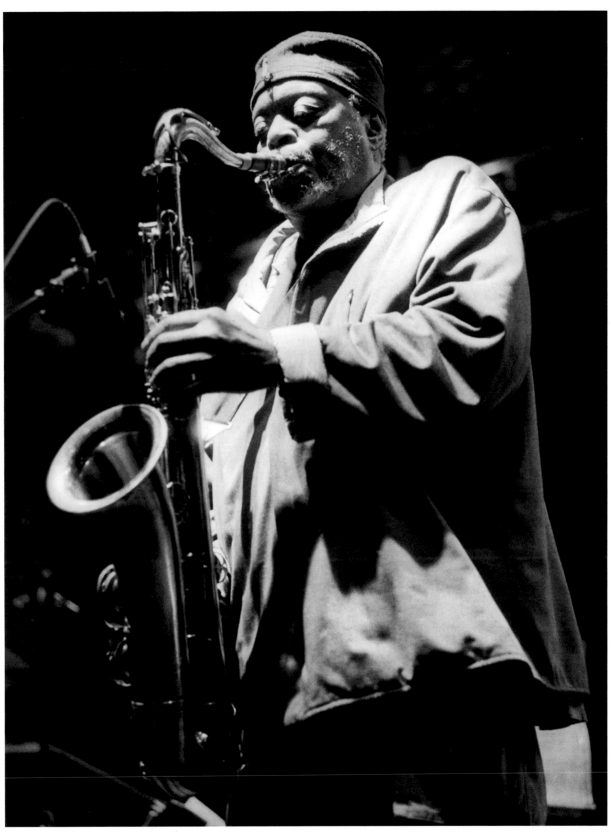

Dewey Redman, 2006

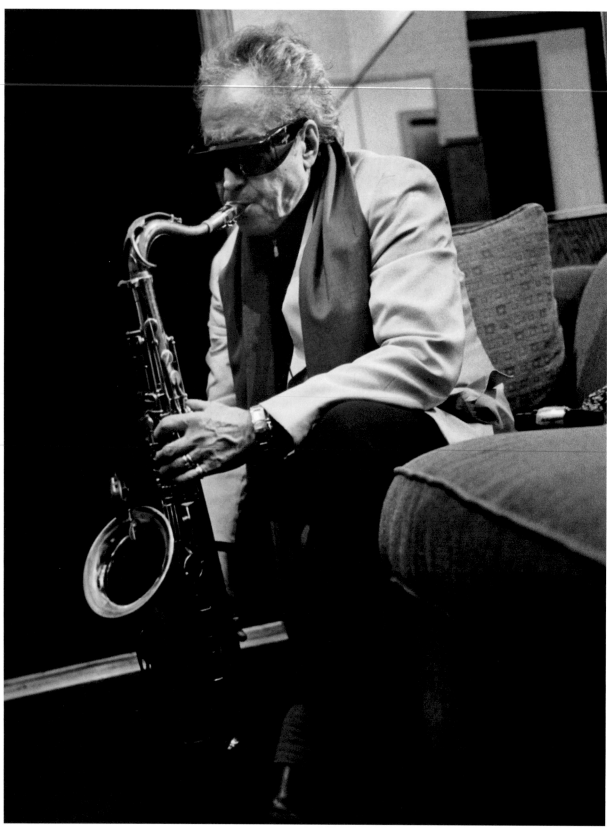

Gato Barbieri, 2006

Branford Marsalis, 2006

IN FOCUS OUT OF LUCK

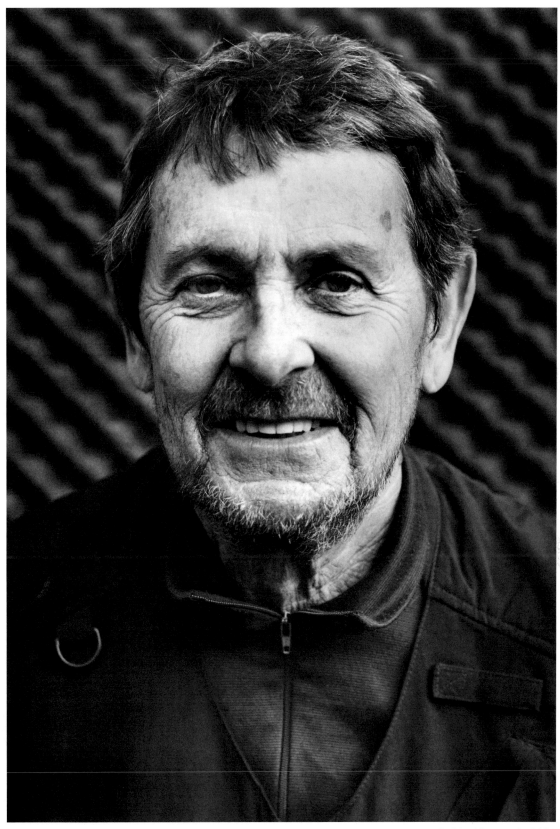

Bobby Neuwirth, 2006

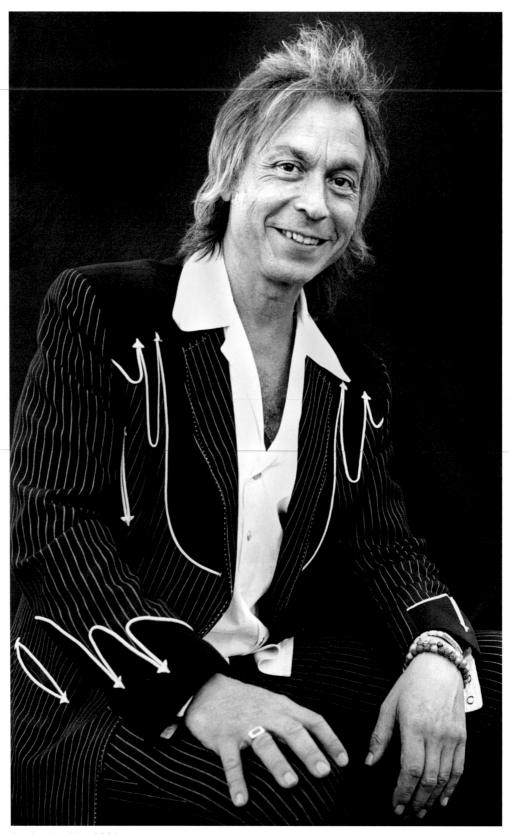

Jim Lauderdale, 2006

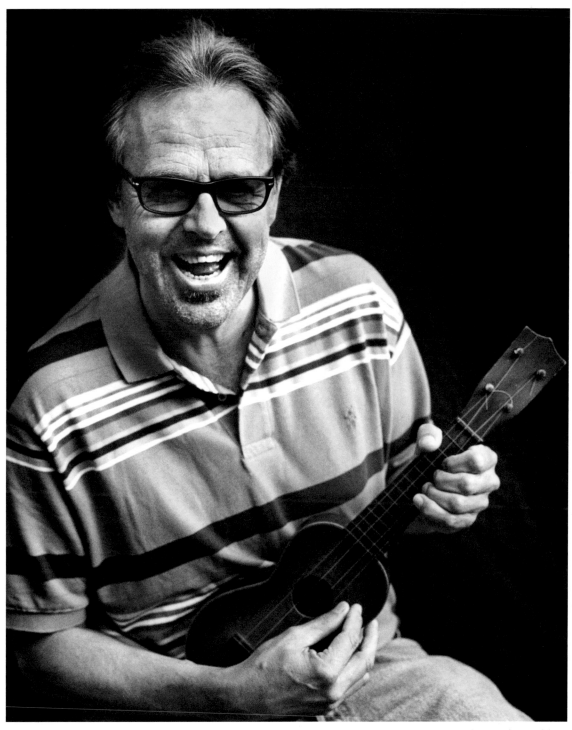

Steven Souls, 2006

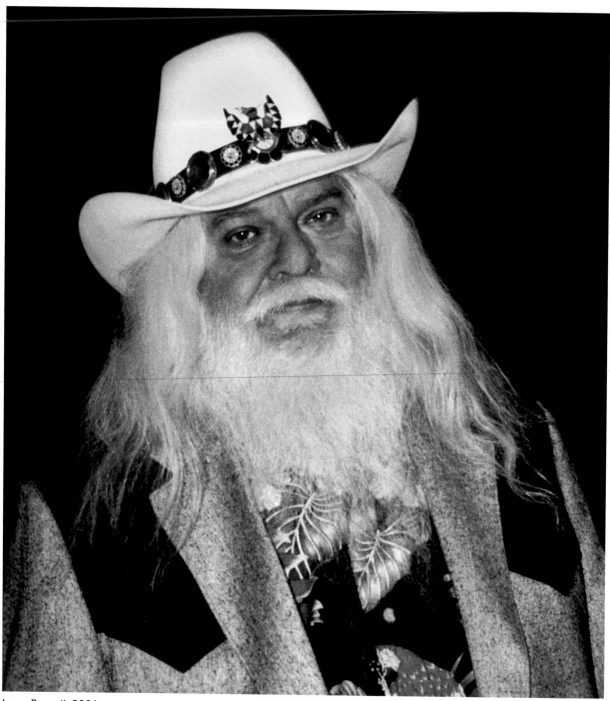

Leon Russell, 2006

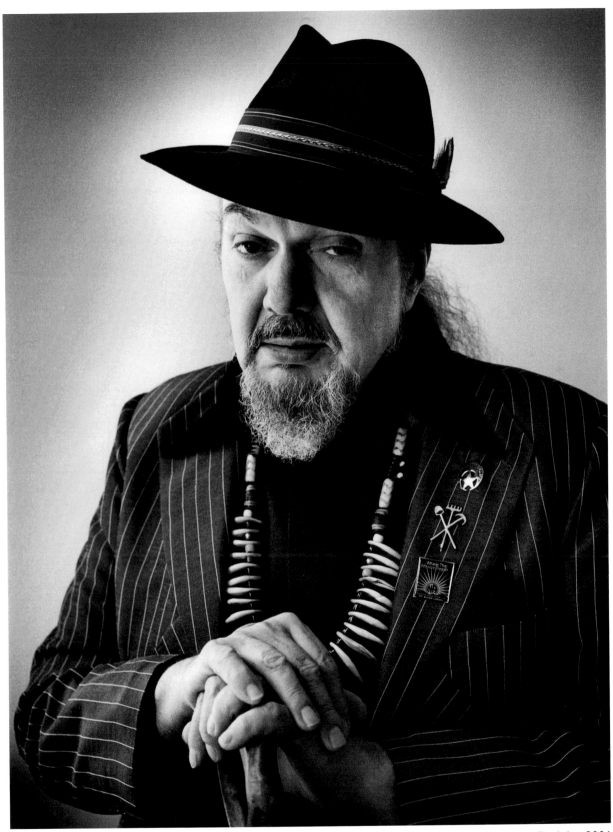

Dr. John, 2006

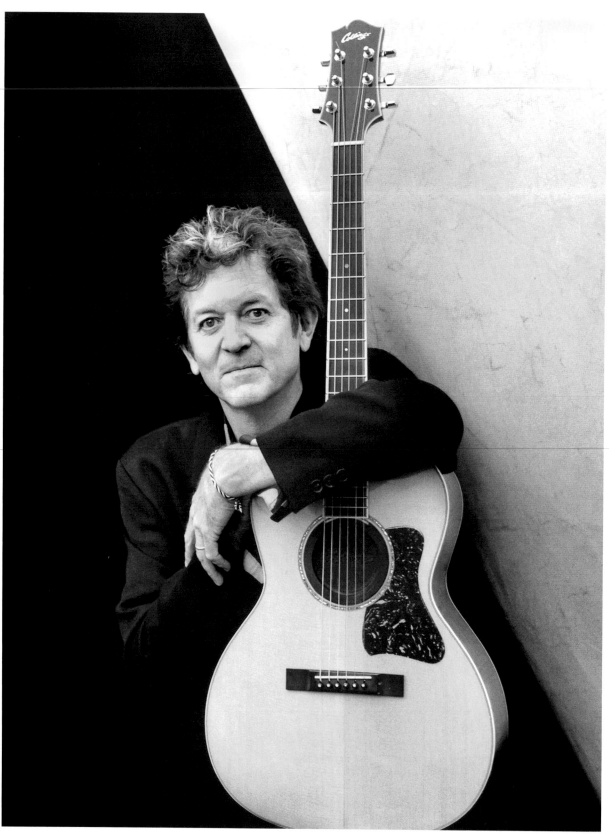

Rodney Crowell, 2006

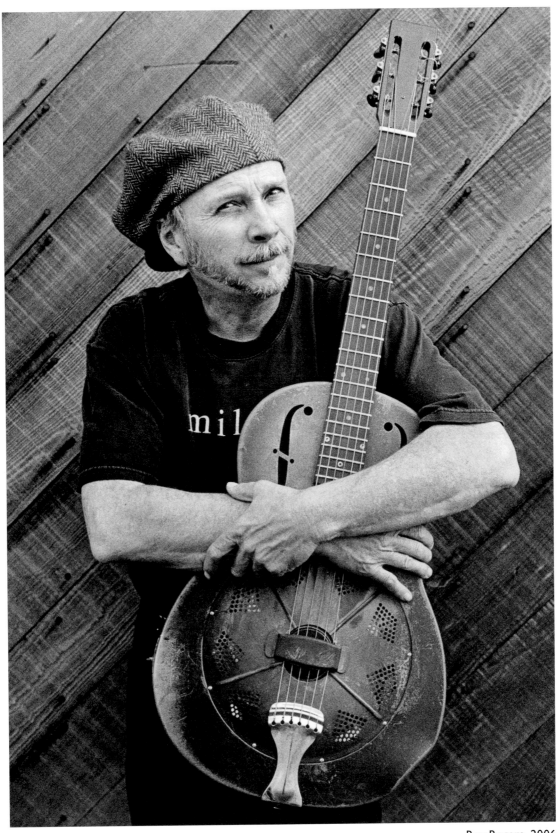

Roy Rogers, 2006

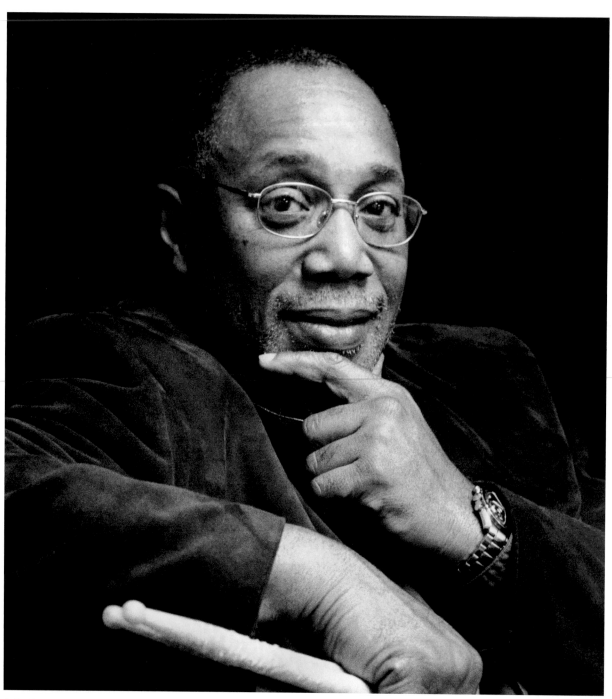

Billy Cobham, 2006

TIME IS MY FRIEND

When attending New York's High School of Music and Art, I was blessed to spend most of those days in the shadows of my peers: Jimmy Owens, Larry Willis, Eddie Gomez, Richard "Tee" Tenright, and many more. They were either a year ahead of me or in my graduating class. With them as my role models, I found myself living through their personal experiences and participating in conversations and discussions within that small group of colleagues. We kept track of what records to listen to, who was performing where, and what was generally in fashion. We were always listening to Miles, Art Blakey, Monk, Coltrane, Newk, and Dizzy. Arrangers and orchestras like Orchestra U.S.A., Gunther Schuller, Gil Evans, Manny Albam, Duke Ellington, Basie, and Stan Kenton were always hot topics. The ideas stuck with me and helped define the percussion specialist that I wanted to be. I remember attending a Saturday afternoon rehearsal of Orchestra U.S.A. where the drummer in the band was Connie Kay (Modern Jazz Quartet). I was about 16 years old and had been invited to join the youth band sponsored by Orchestra U.S.A. We were there to learn from the orchestrations of Dizzy Gillespie, Gil Evans, Frank Foster, and others. I remember Barry Altschul and Elvin Jones's nephew competing with me for time at the drum set in support of the band. The idea behind this musical game was that whoever made a mistake lost a shot at the next tune and would have to give up the drummer's chair for the rest of the three-hour session. I felt a tremendous necessity to produce under pressure and in real time. It was one of the first defining moments for me in determining my fate and future.

As much as there is competition and the quest to be the "alpha" in most performance environments, human nature reminds us that at some point the group performance is only as strong as its weakest player. There has to be a camaraderie in place if everyone is to enjoy the fruits of his or her labor, both as part of the group and then as individuals. In performance, the more short-term accomplishments are made, the stronger the bond and commitment within the group. So, some bands feed off of this idea and stay together for a very long time. Yet the same can be said for a band that might not stay together for an infinite amount of time but puts in an intense effort, like the Mahavishnu Orchestra, which put the band ahead of personal achievements. At the end of the day, it does depend on the individuals involved and how they interact.

I approach each performance as a "stand-alone" musical personality. I come with an open mind (as much as I can) and an open heart to receive, in total, what is being offered from that particular musical environment. For example, playing music influenced by Miles Davis as opposed to music performed by the M.O. The concept is related, yet different, in that the material performed by the M.O. was more set up with themes that were founded upon a set of musical disciplines. This put us on a very different path than when performing within the musical environment of Miles. Sometimes these inherently diverse paths meet, as when a Mahavishnu theme was performed with Miles on Miles's *Jack Johnson* album. Without exception, it is the music that dictates my approach to performing with various combinations of musicians . . . and it's not just the types of ensembles but also the combination of who is performing with me in the band, the type of music being performed, and how comfortable I might be working within that musical context. Personally, when performing the music of others, I try to be an instrument to be directed or conducted by them, to help fulfill their dream as to how they would like their music to be presented. As the leader of my own band, I try to combine the music that I've written with musicians who will approach my music with the same creative spirit that I would have if I were approaching theirs.

— BILLY COBHAM
New York City, June 2013

Emmylou Harris, 2007

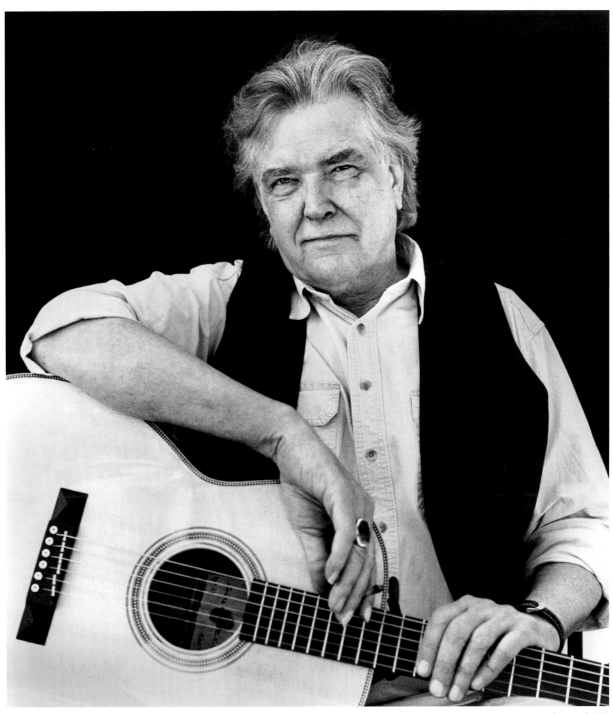

Guy Clark, 2007

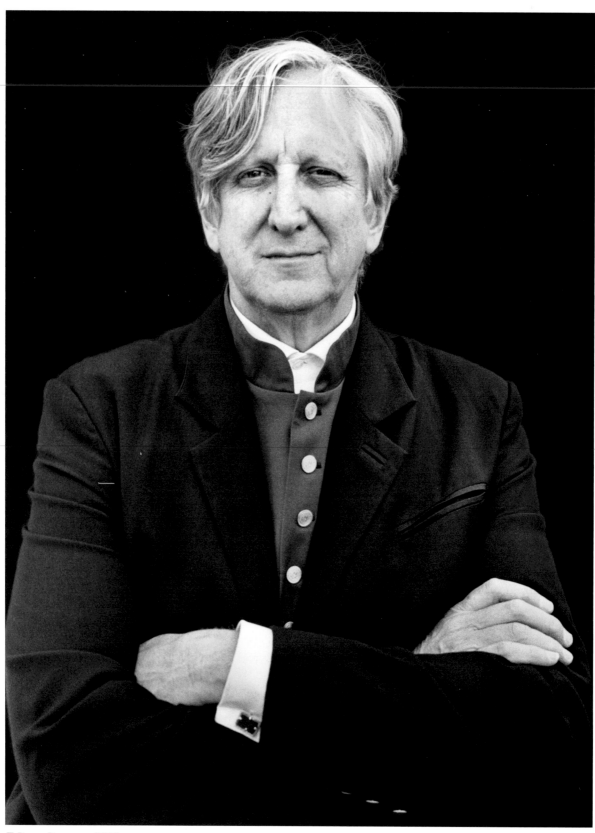

T Bone Burnett, 2007

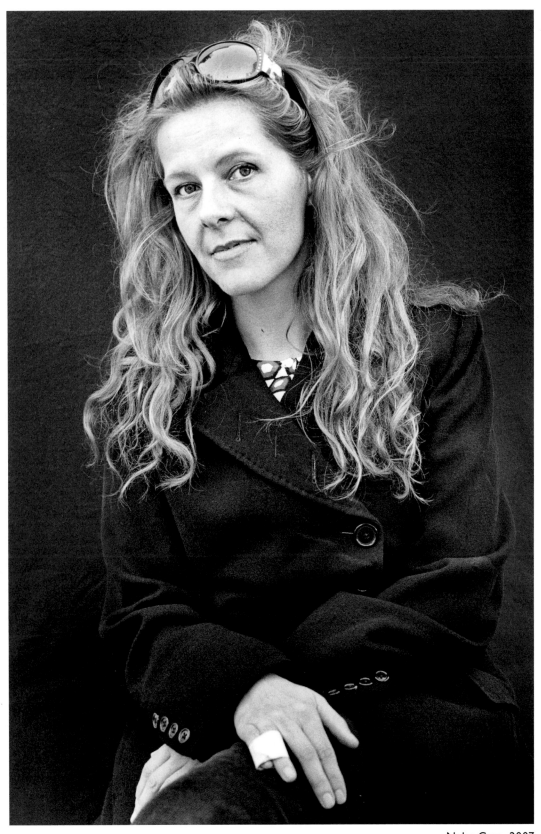

Neko Case, 2007

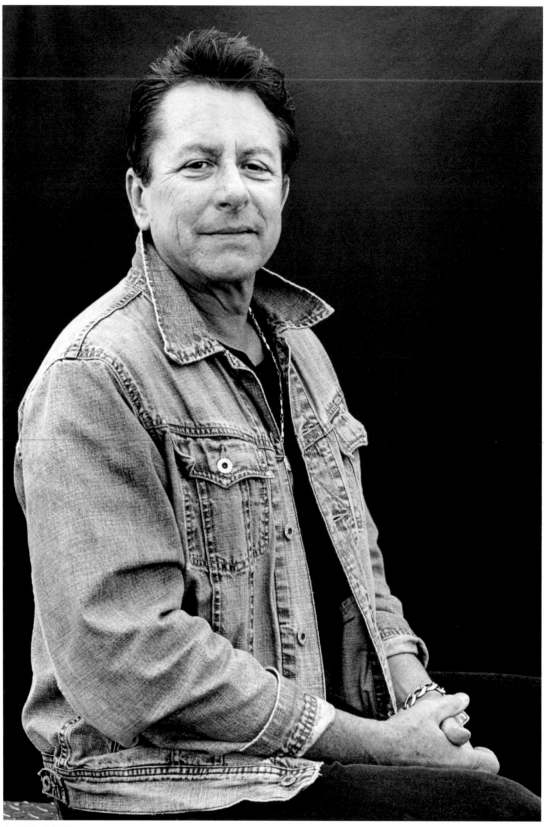

Joe Ely, 2007

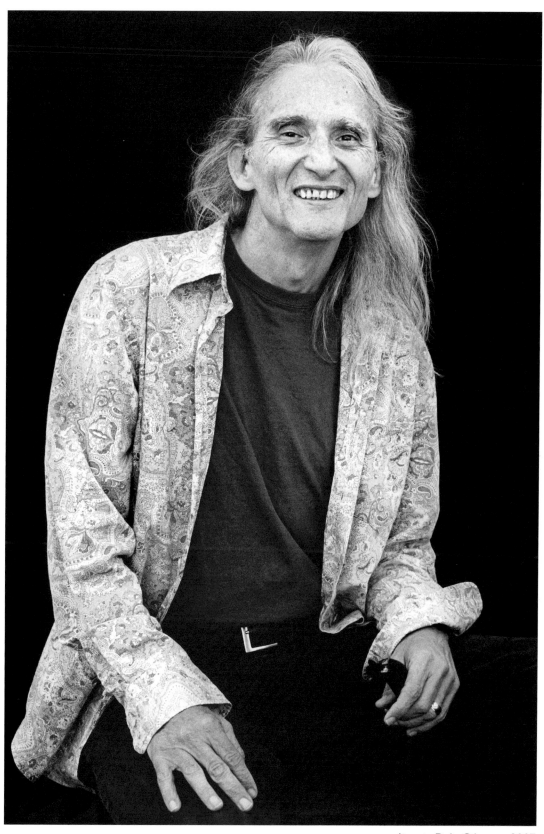

Jimmie Dale Gilmore, 2007

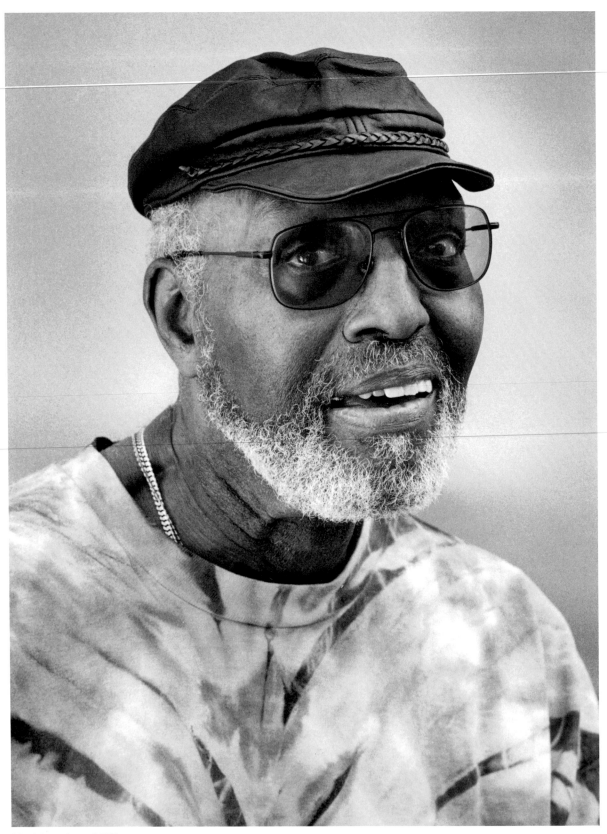

Merl Saunders, 2007

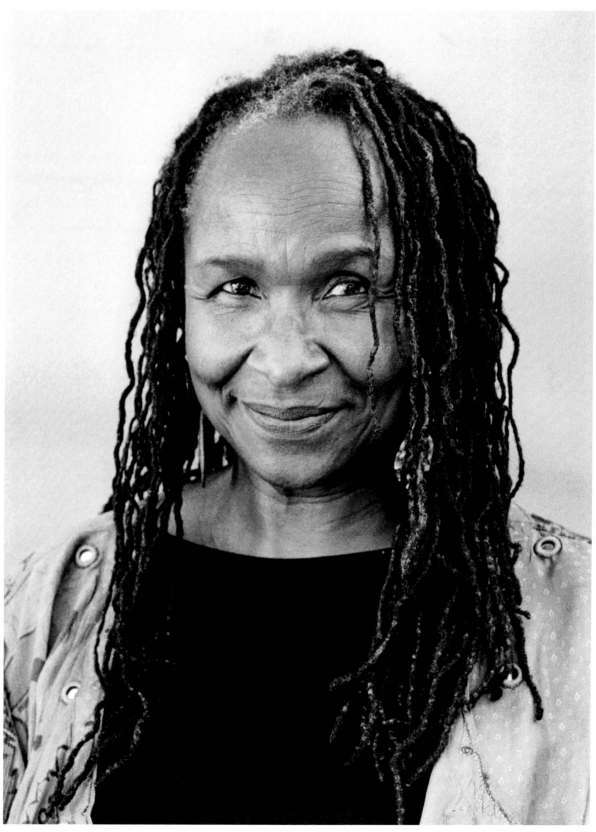

Annie Sampson, 2007

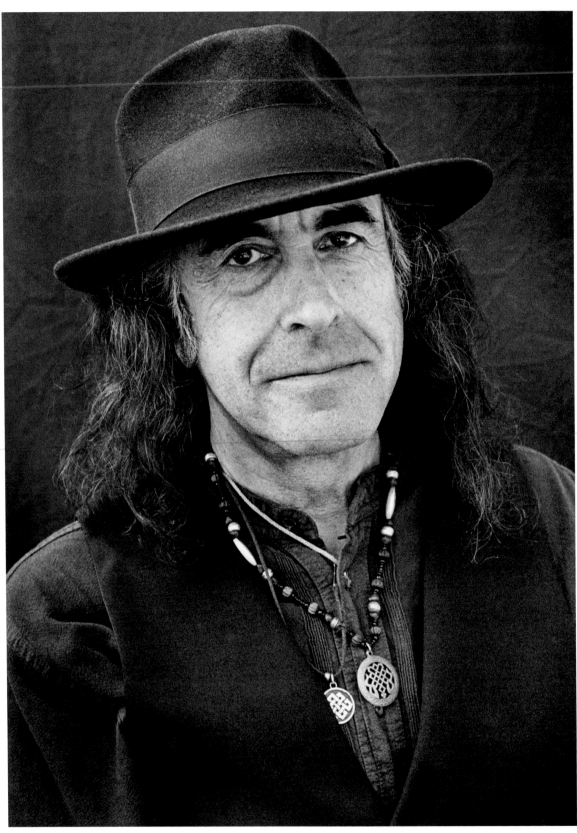

Pete Sears, 2007

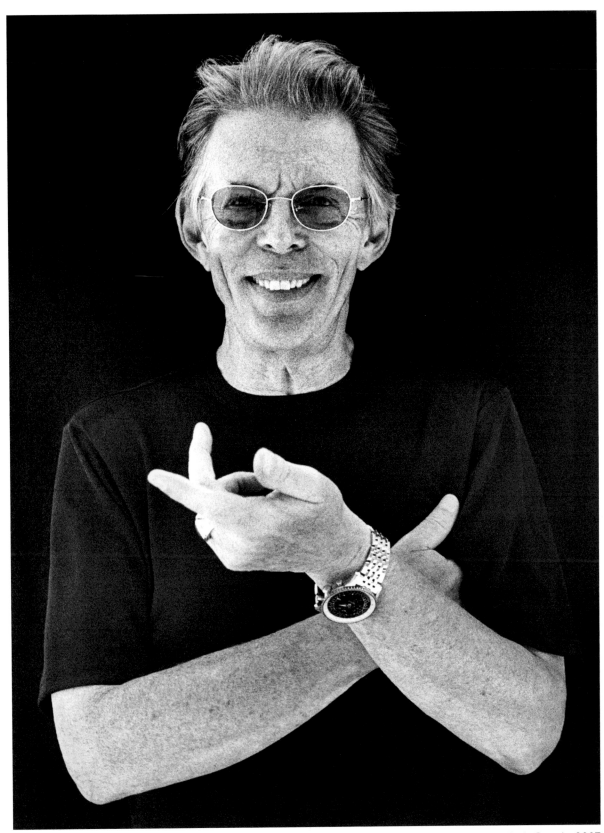

Jack Casady, 2007

Gillian Welch, 2007

Bruce Hornsby, 2007

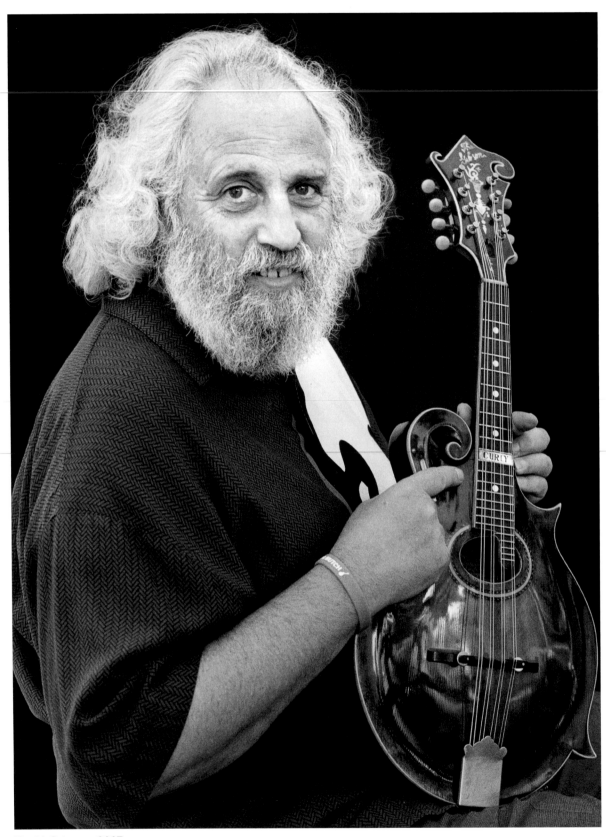

David Grisman, 2007

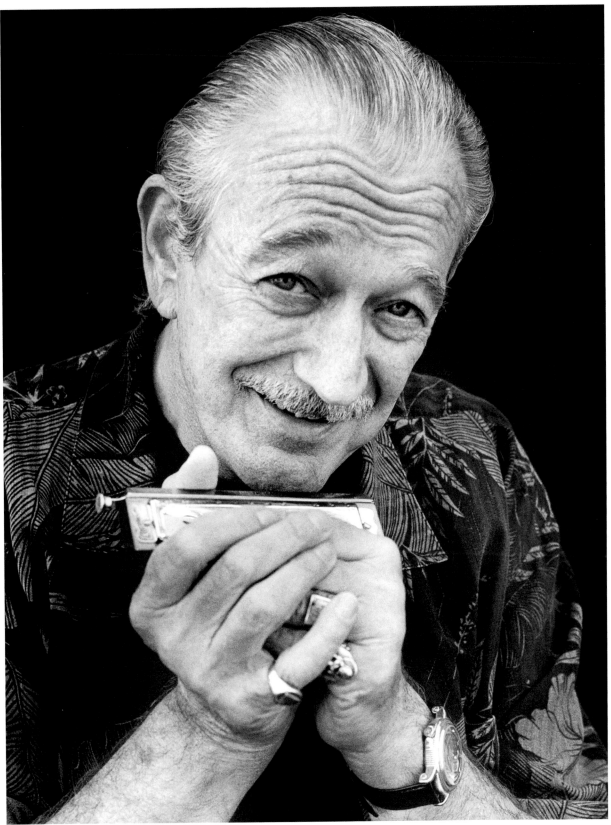

Charlie Musselwhite, 2007

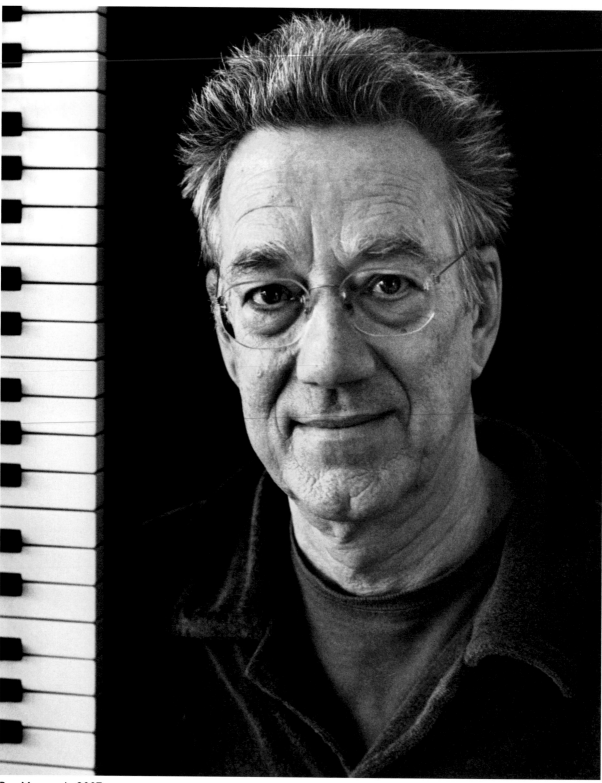

Ray Manzarek, 2007

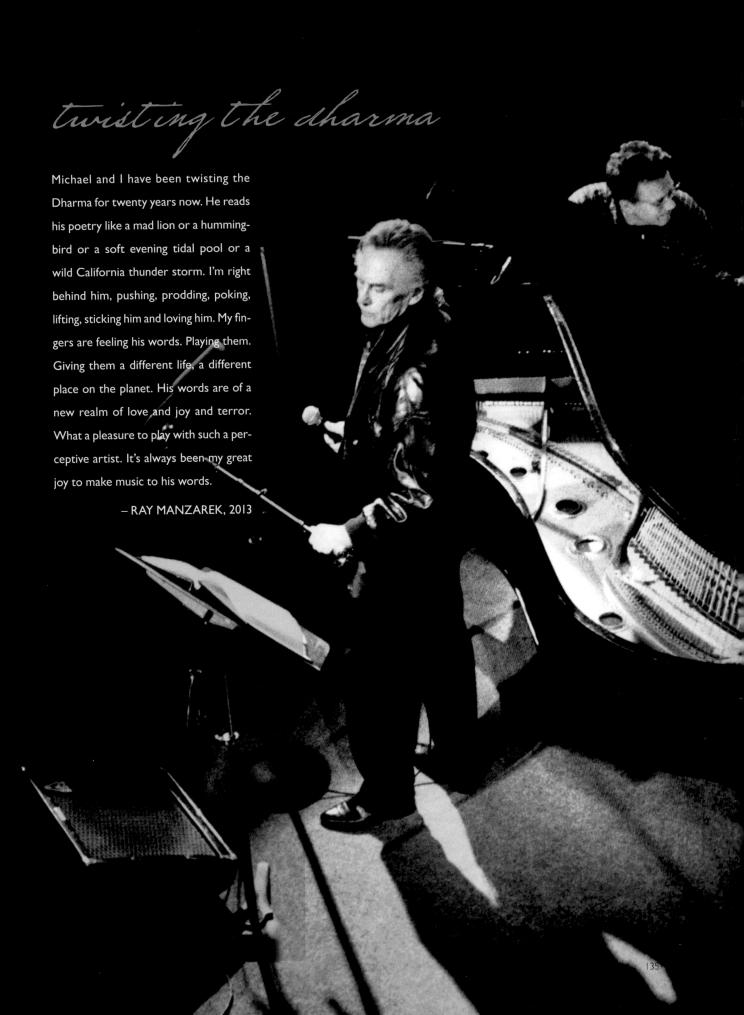

twisting the dharma

Michael and I have been twisting the Dharma for twenty years now. He reads his poetry like a mad lion or a hummingbird or a soft evening tidal pool or a wild California thunder storm. I'm right behind him, pushing, prodding, poking, lifting, sticking him and loving him. My fingers are feeling his words. Playing them. Giving them a different life, a different place on the planet. His words are of a new realm of love and joy and terror. What a pleasure to play with such a perceptive artist. It's always been my great joy to make music to his words.

— RAY MANZAREK, 2013

Charlie Louvin, 2007

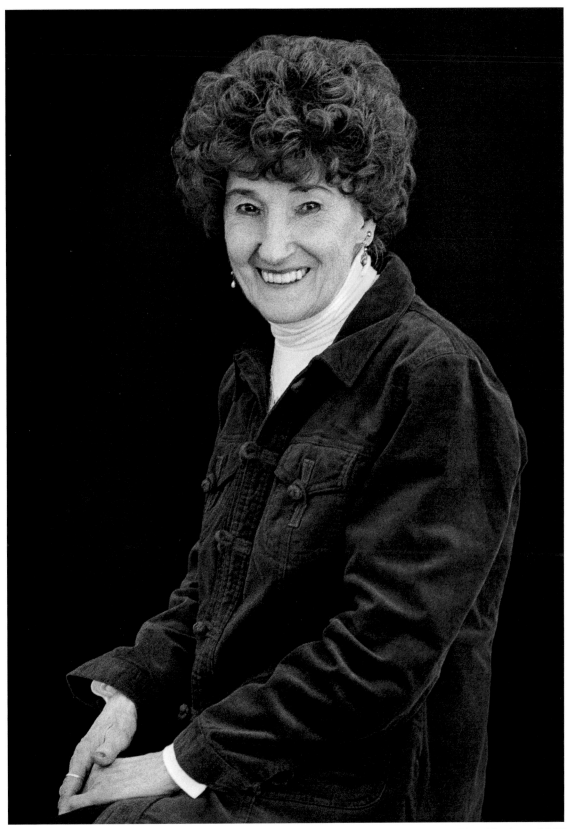

Hazel Dickens, 2007

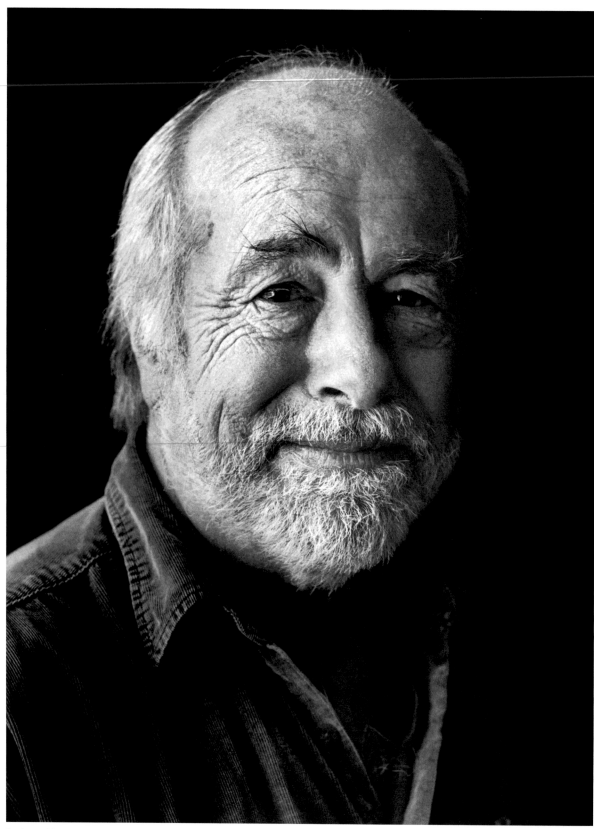

Robert Hunter, 2007

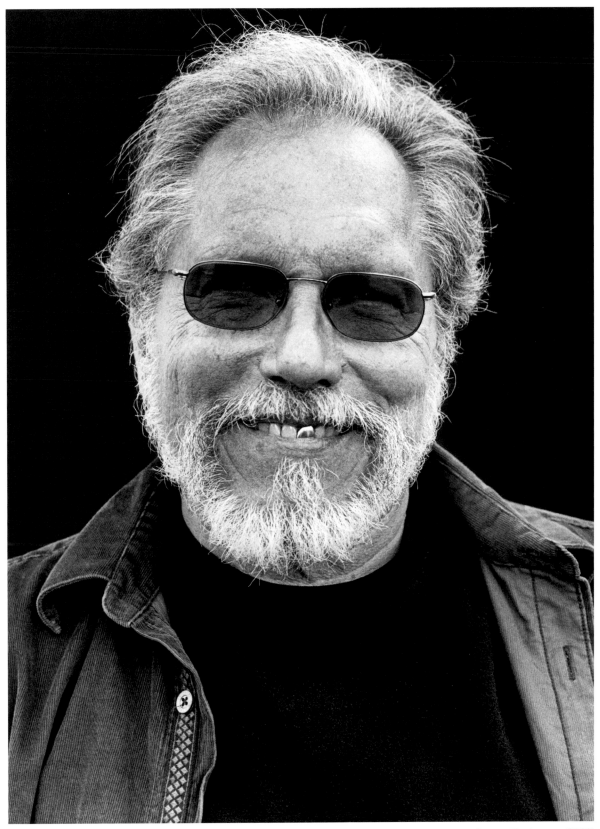

Jorma Kaukonen, 2007

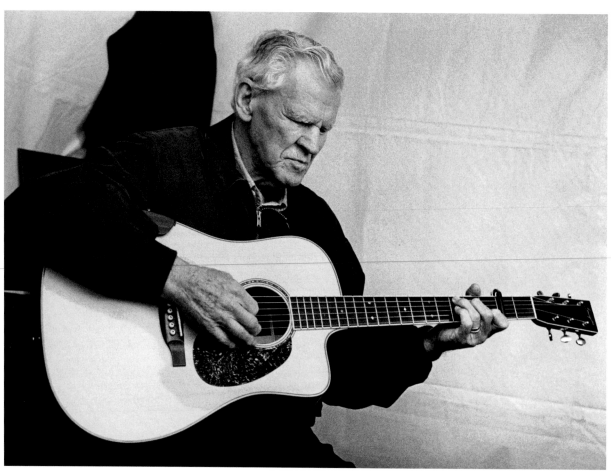

Doc Watson, 2007

Earl Scruggs, 2007

Buddy Miller, 2007

John Cohen, 2007

Ricky Skaggs, 2007

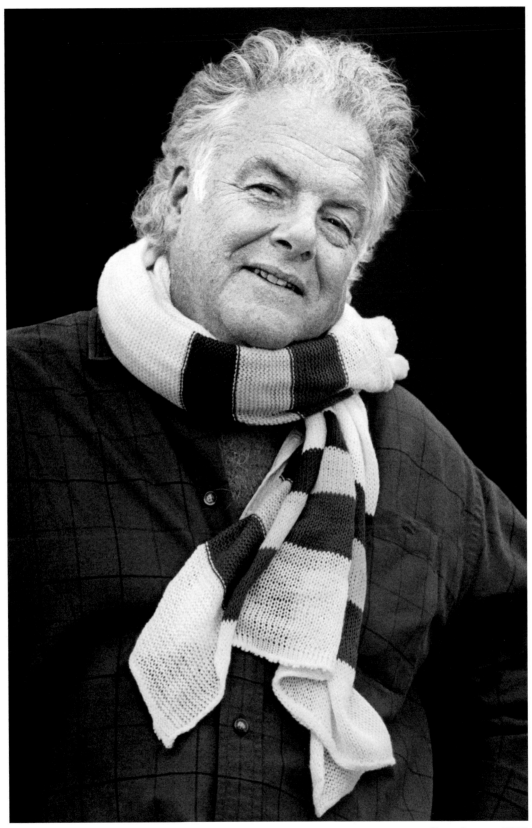

Peter Rowan, 2007

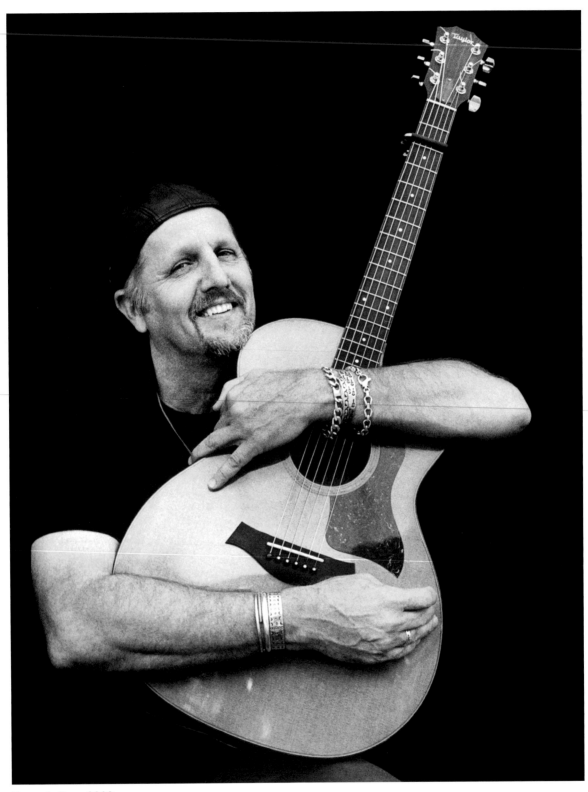

Jimmy LaFave, 2008

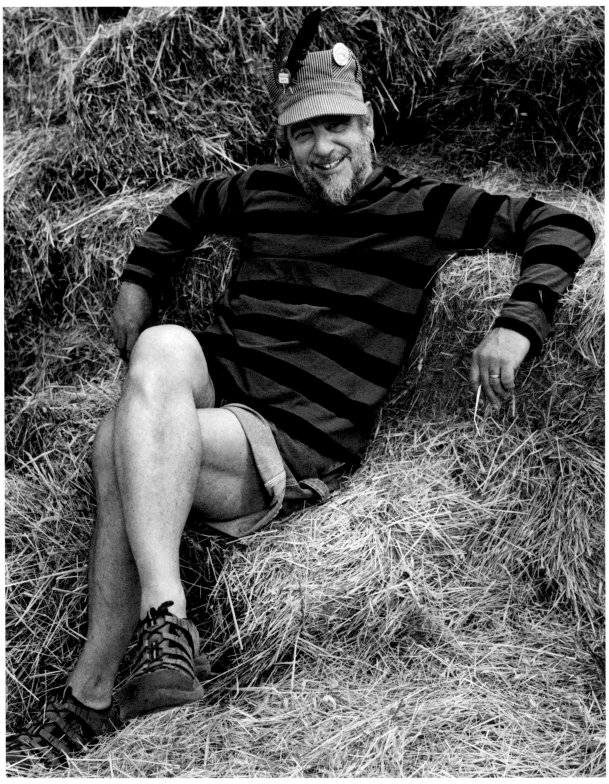

Greg Brown, 2008

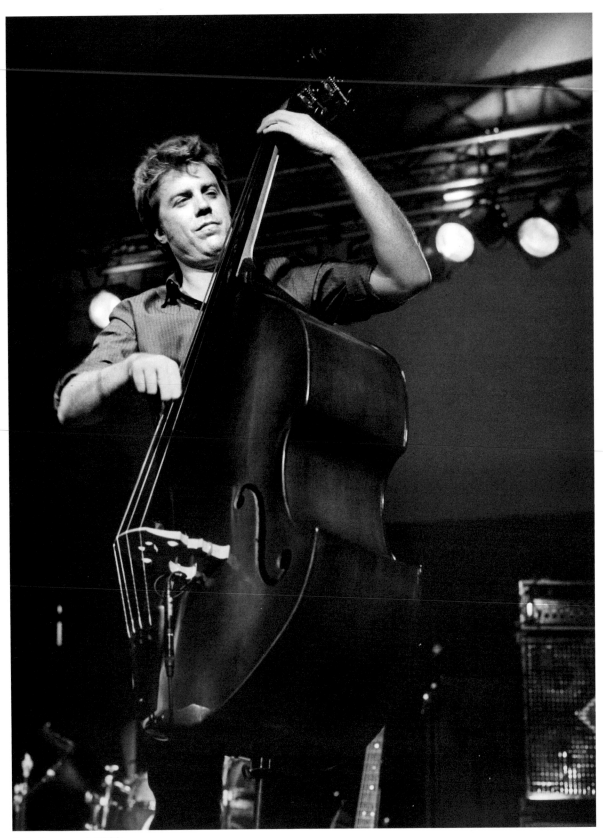

Kyle Eastwood, 2008

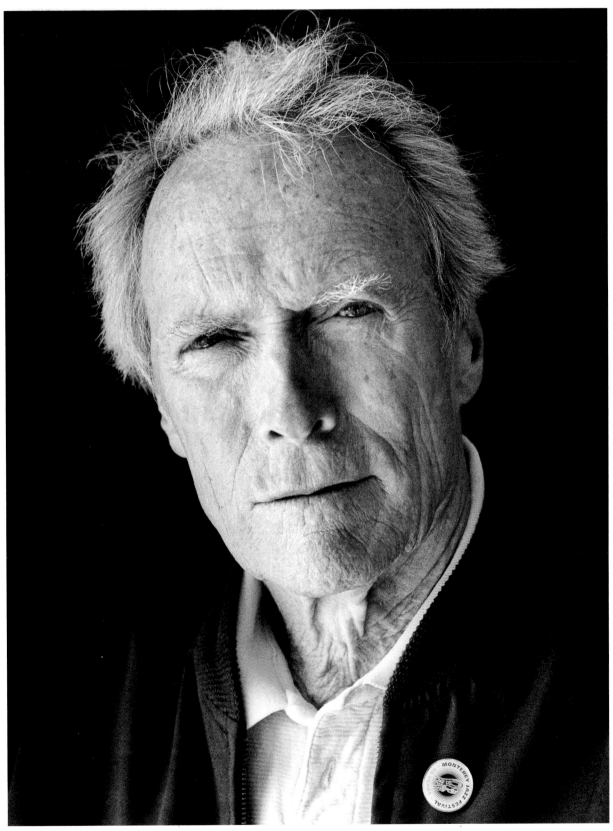

Clint Eastwood, 2008

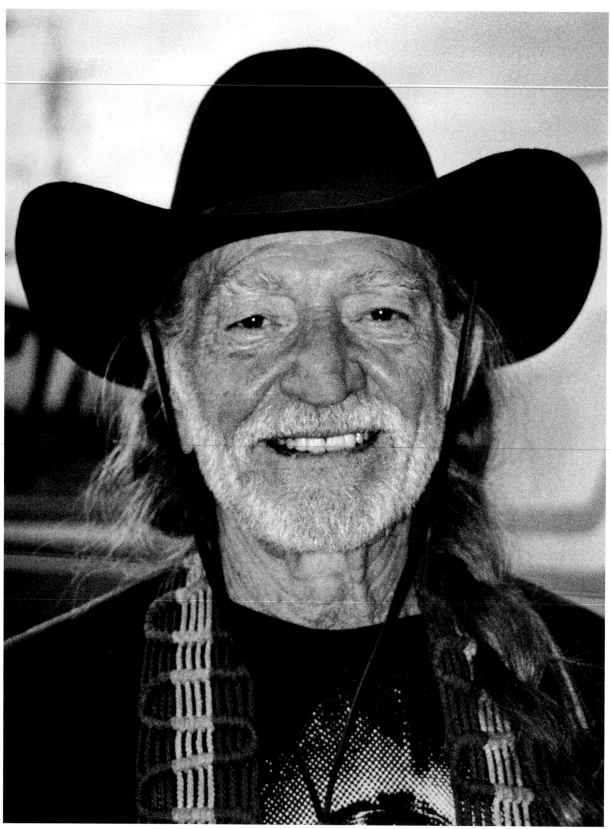

Willie Nelson, 2008

Paula Nelson, 2008

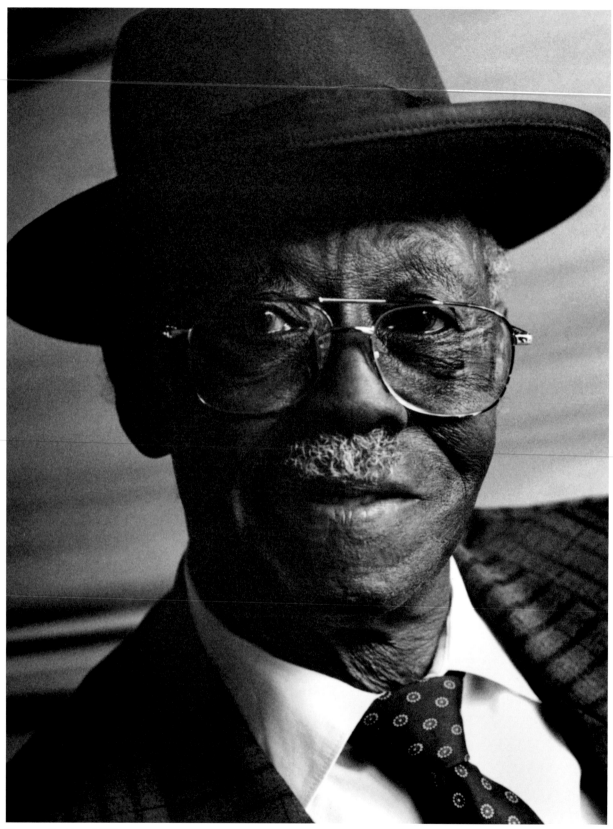

Pinetop Perkins, 2008

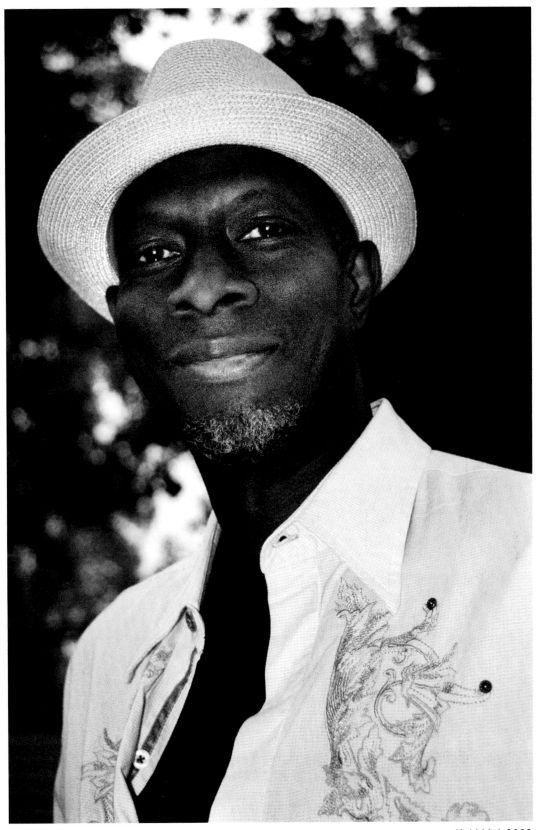

Keb' Mo', 2008

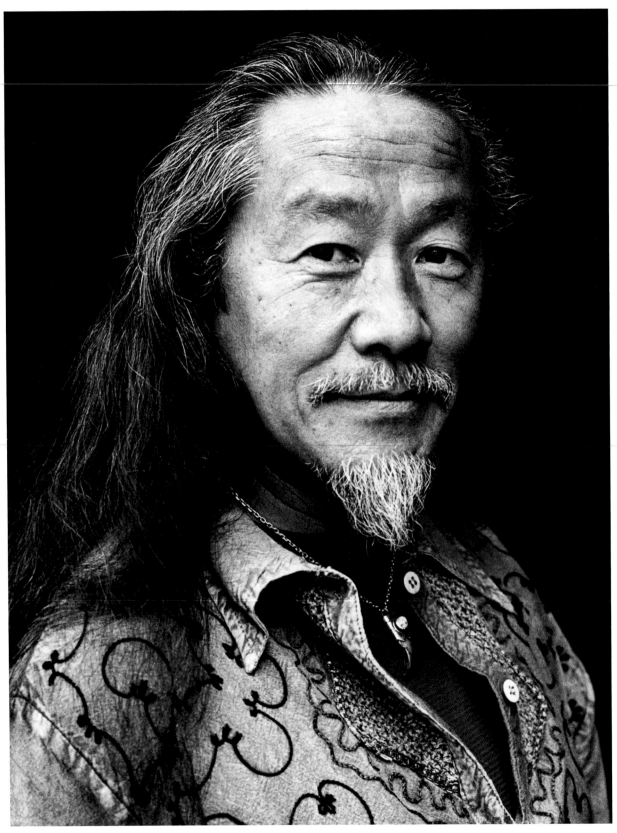

Kitaro, 2008

Pieta Brown, 2008

John Gorka, 2008

Bo Ramsey, 2008

CLOSING
OF THE
FILLMORE
WEST

In 1970, while still living in New England where we grew up, my brother Chris and I met up with David Grisman (former co-founder with our brother Peter of their Boston-area group, Earth Opera), who became our music producer. With his advice, we all moved to what one conservative East Coast journalist called "the weird rootless world of California," specifically Marin County for us, whereupon David introduced us to his friend Jerry Garcia from the Grateful Dead. David had recently recorded mandolin on the Dead's track "Friend of the Devil" from the band's more acoustic-oriented *American Beauty* album. Soon Jerry was playing his unique style of steel guitar with us, along with drummer Bill Kreutzmann. And on July 4, 1971, at the closing of Fillmore West, Chris and I were invited to open for the Dead, with Garcia and Kreutzmann backing us along with David Grisman. Bill Graham gave us a warm introduction. We played all our own original songs that night, which no one had ever heard before, but the crowd was very appreciative and roaring with approval, thanks in no small part to Garcia and Kreutzmann playing with us. Garcia had a great laugh, as he could see our minds were blown by being up there on stage with all this crazy-good vibe energy coming from the audience. A lot of those songs we performed that night soon got recorded on our first Columbia record, as we were signed by music mogul Clive Davis. What a rush, our first time on an iconic West Coast stage!

<div align="right">

– LORIN ROWAN
Mill Valley, California, March 2013

</div>

Chris & Lorin Rowan, 2008

Kevin Bacon, 2008

Johnny Rivers, 2008

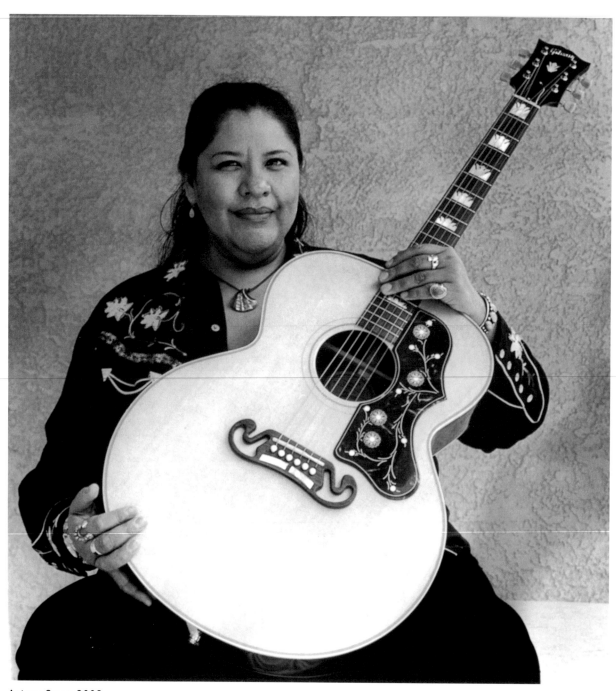

Arigon Starr, 2008

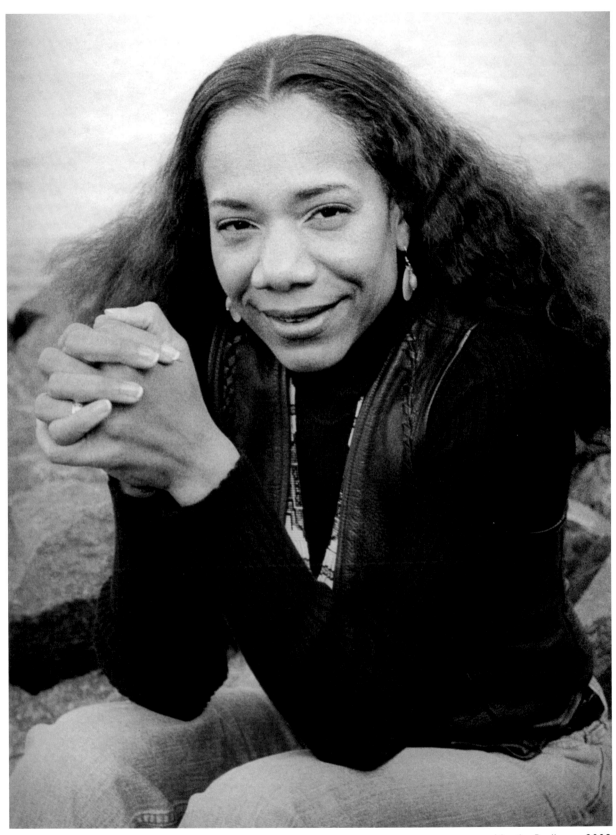

Martha Redbone, 2008

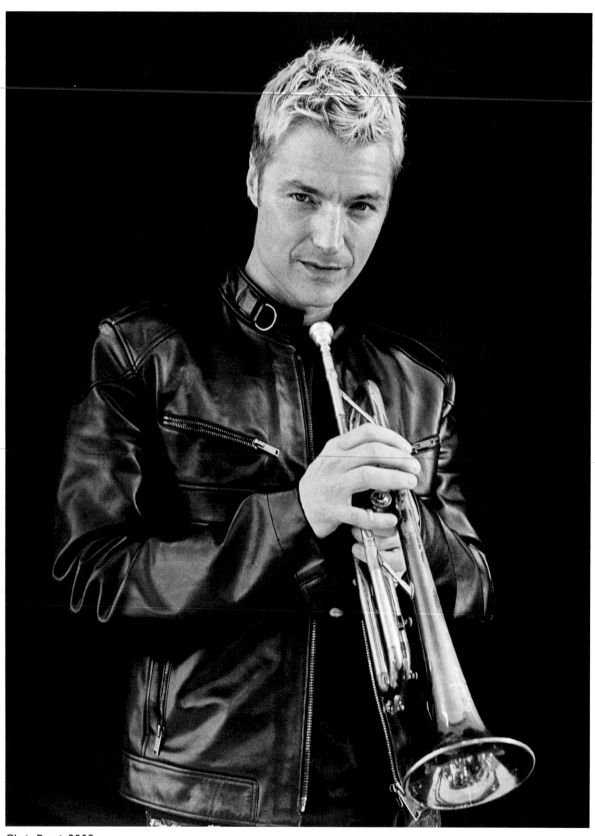

Chris Botti, 2008

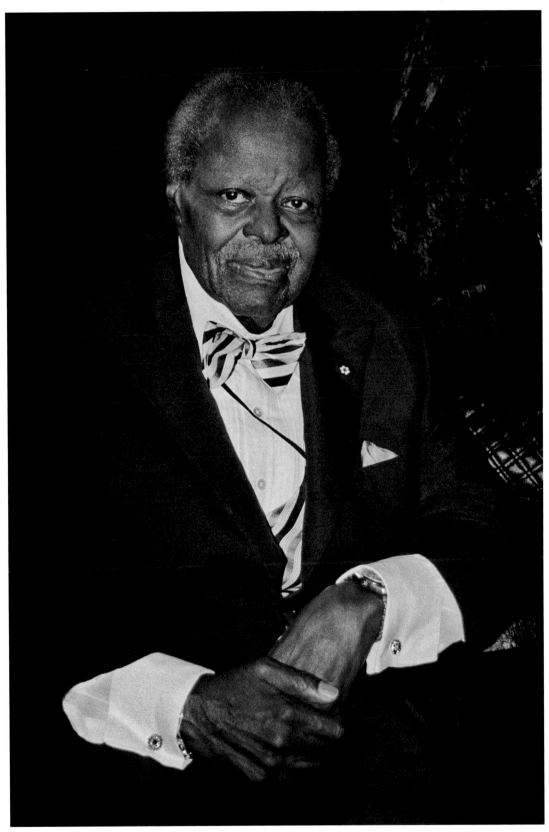

Oscar Peterson, 2008

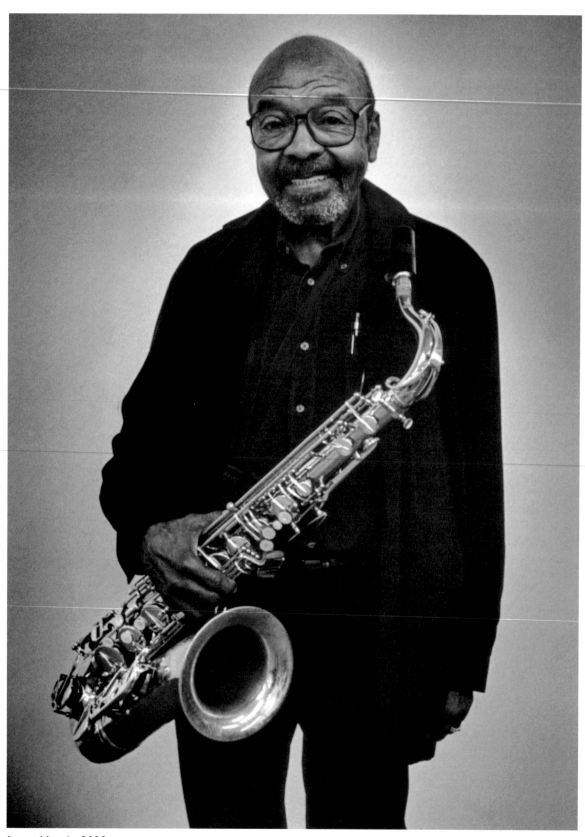

James Moody, 2008

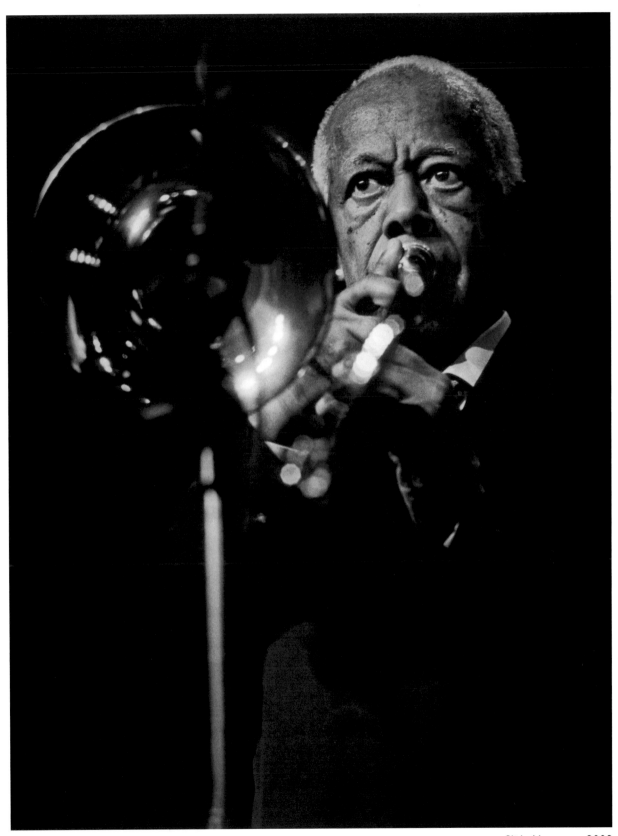

Slide Hampton, 2008

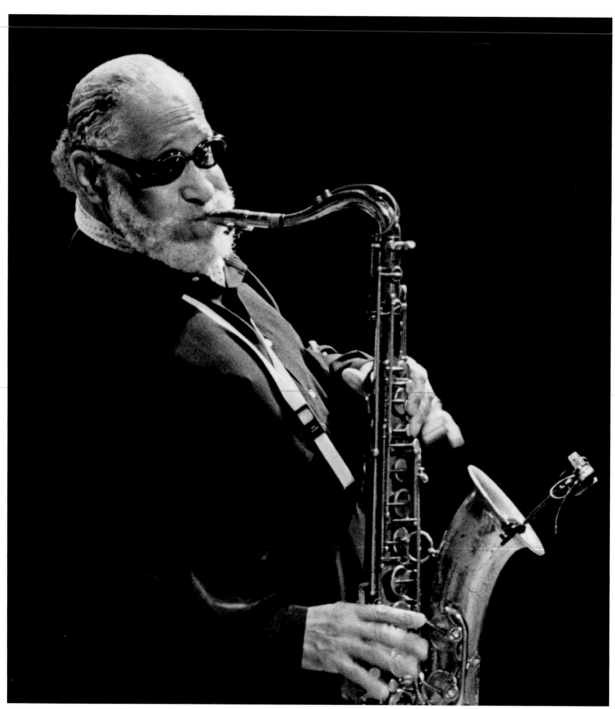

Sonny Rollins, 2008

Eartha Kitt, 2008

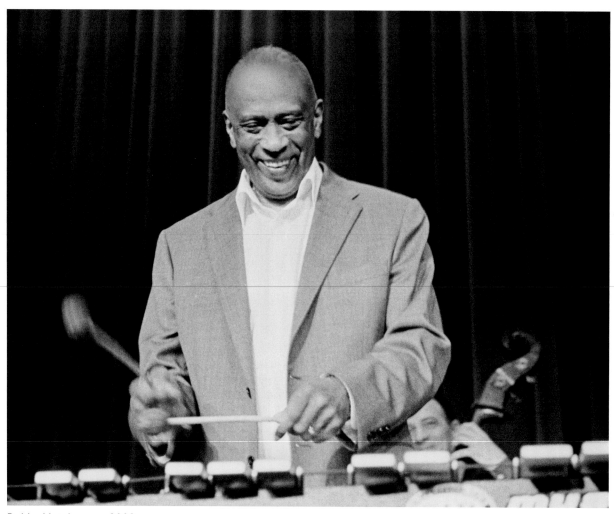

Bobby Hutcherson, 2008

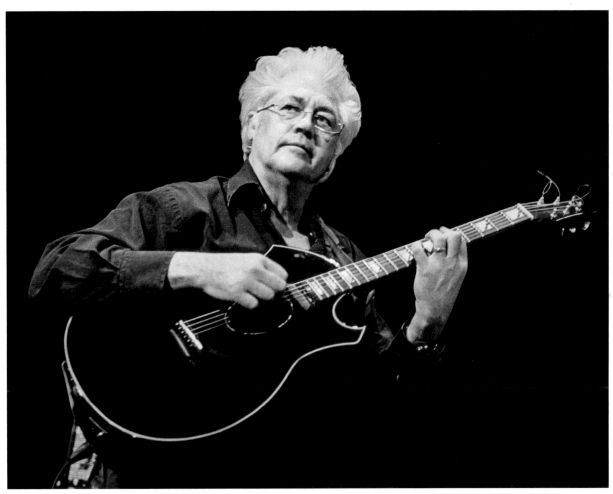

Larry Coryell, 2008

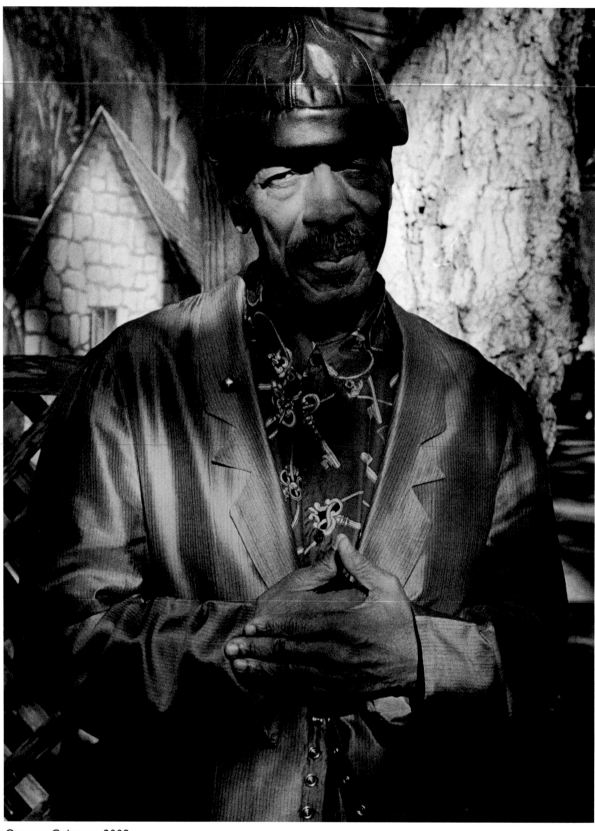

Ornette Coleman, 2008

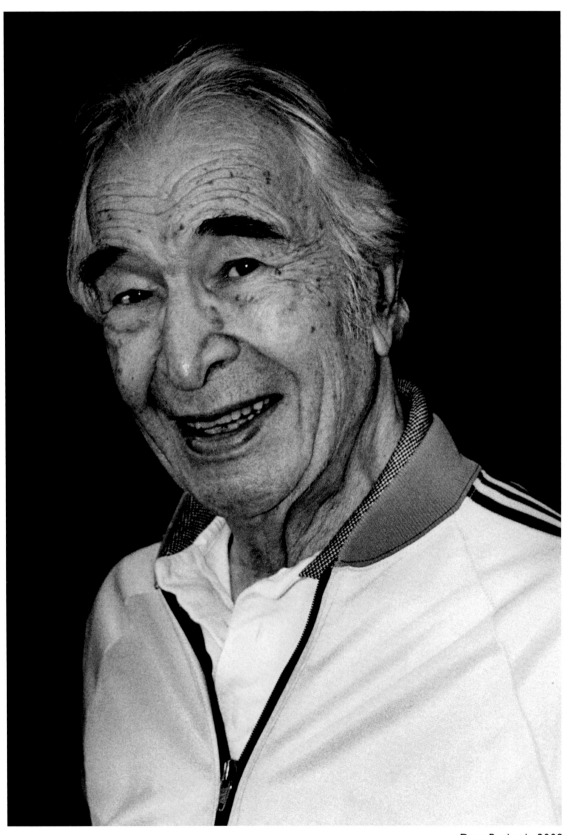

Dave Brubeck, 2008

Diane Reeves, 2008

Kurt Elling, 2008

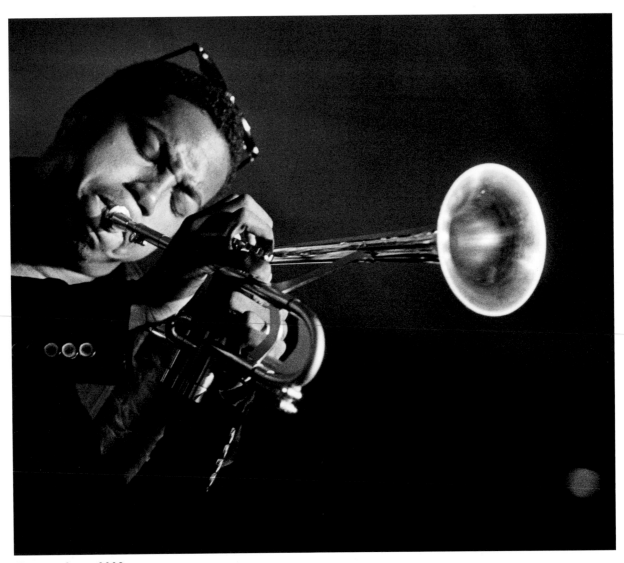

Christian Scott, 2008

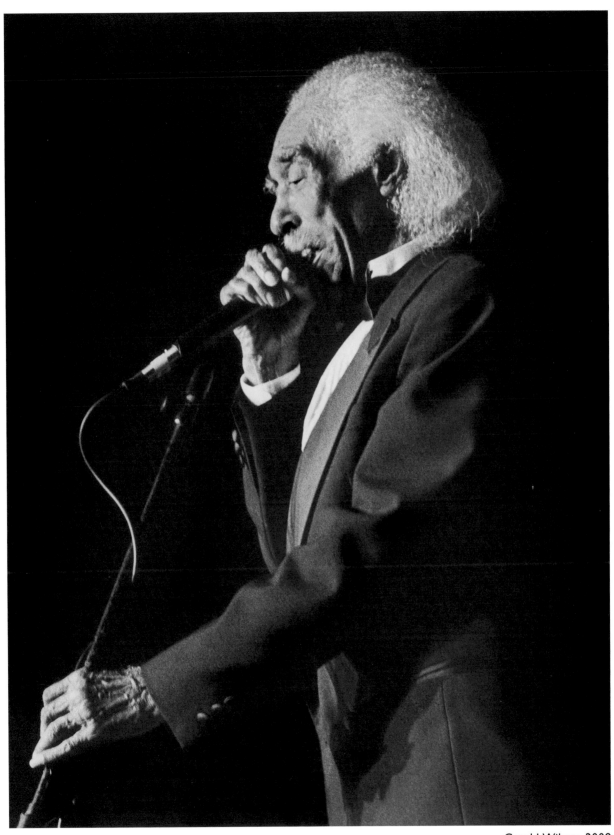

Gerald Wilson, 2008

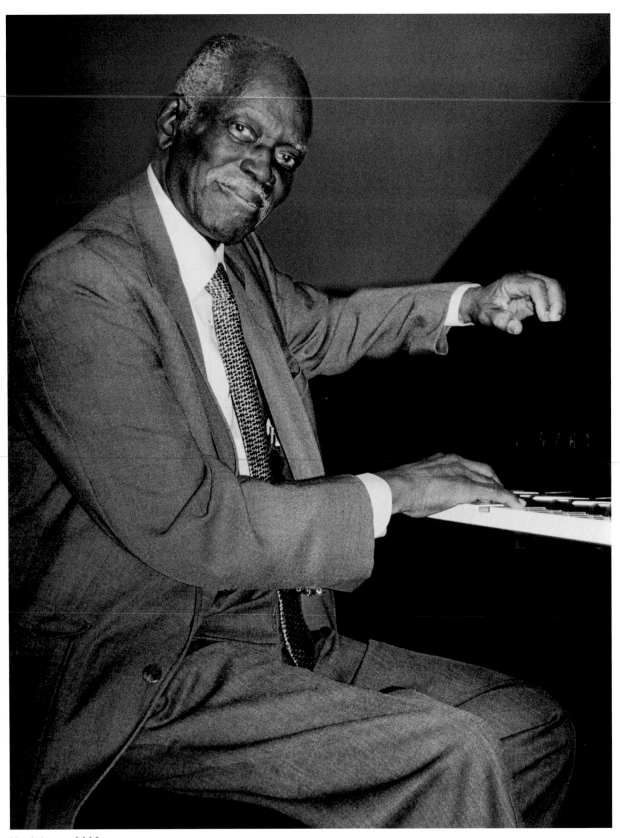

Hank Jones, 2008

Nancy Wilson, 2008

Wadada Leo Smith, 2008

KosMic Music 10

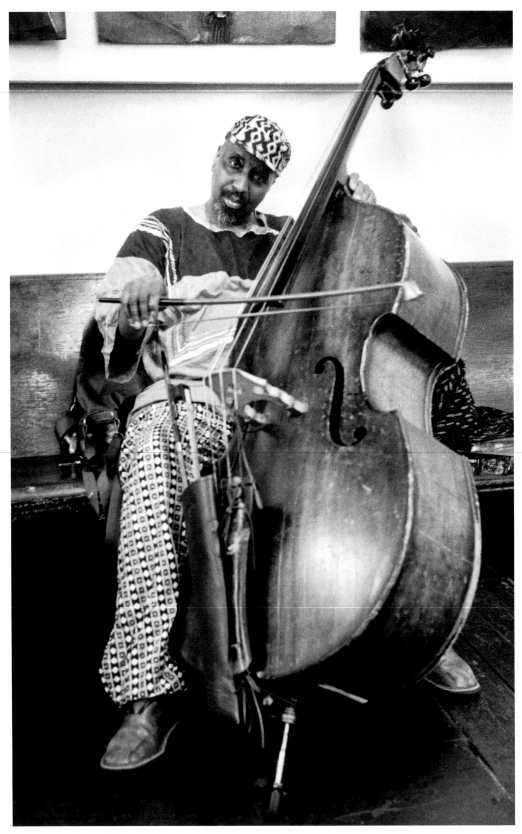

William Parker, 2008

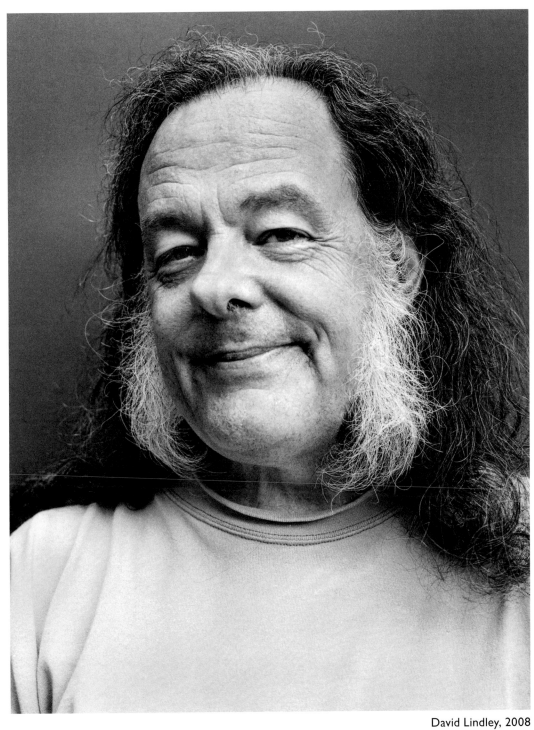

David Lindley, 2008

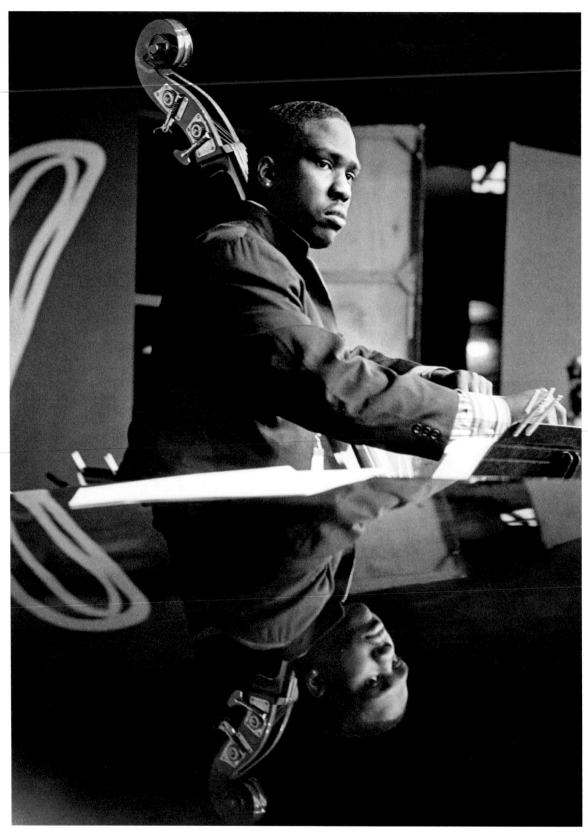

Derek Hodges, 2008

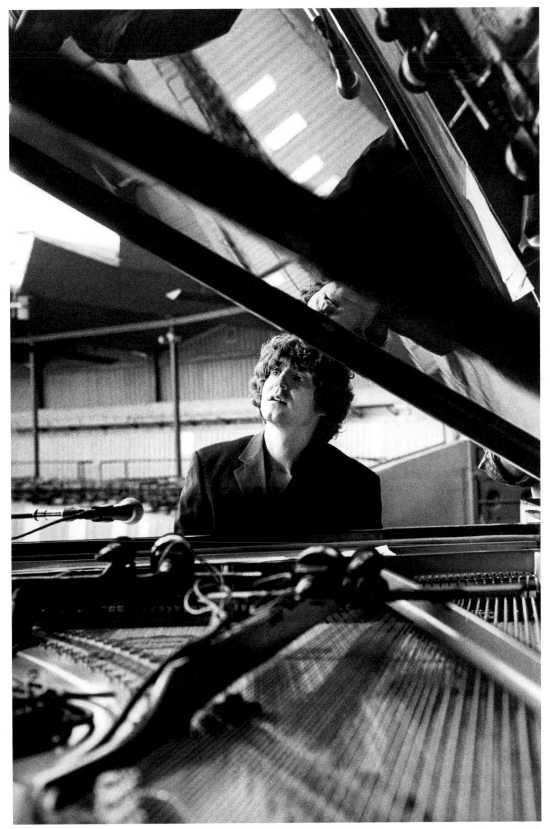

Benny Green, 2008

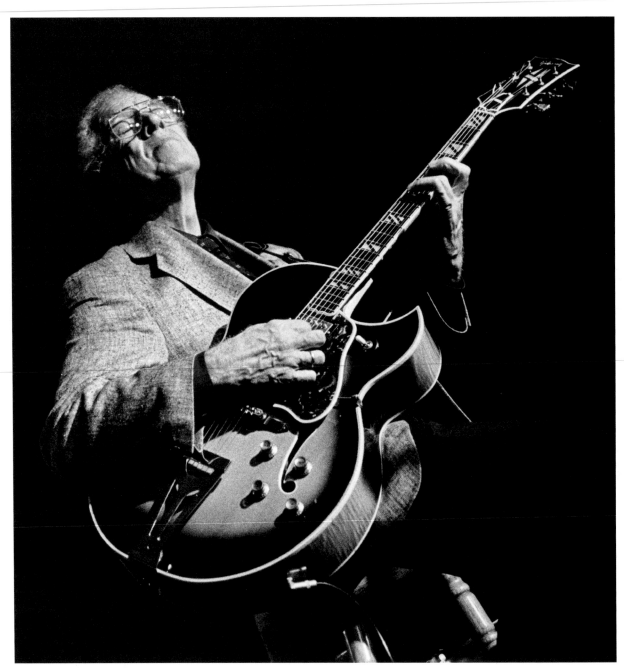

Kenny Burrell, 2008

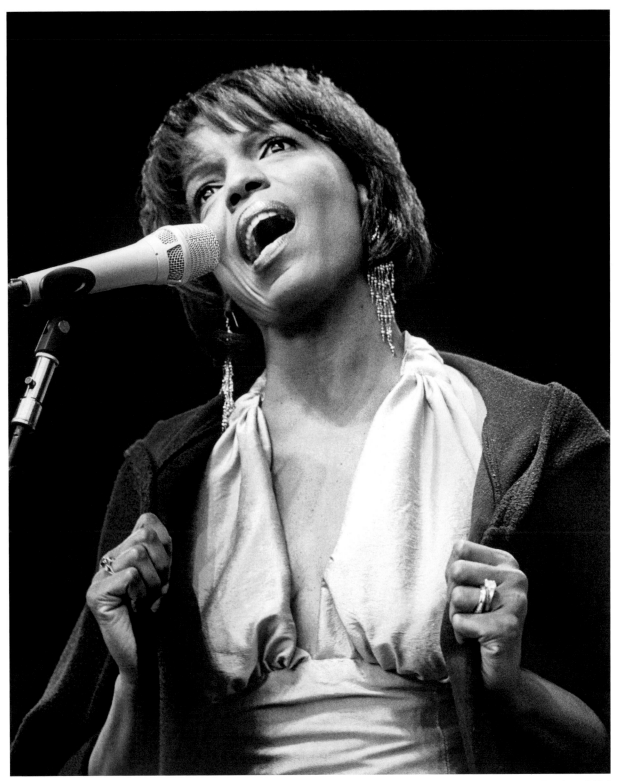

Nnenna Freelon, 2008

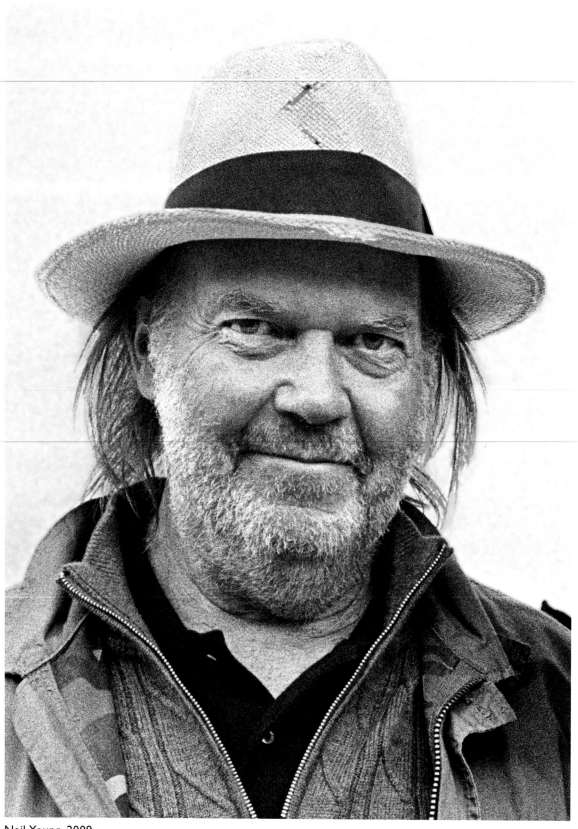

Neil Young, 2009

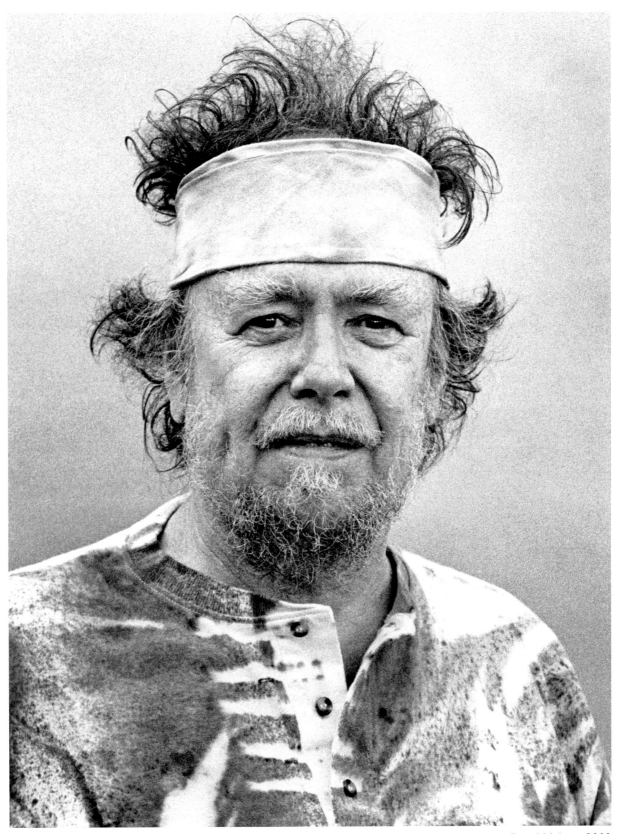

David Nelson, 2009

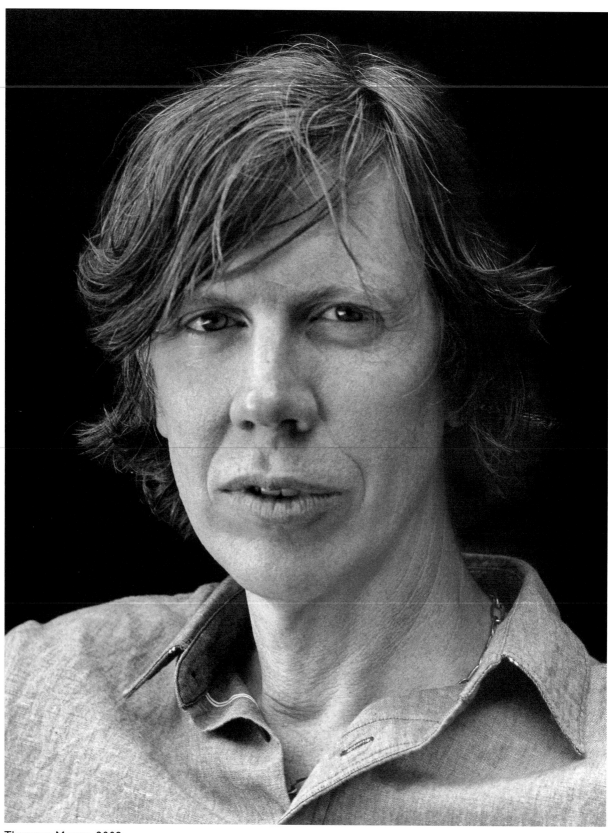

Thurston Moore, 2009

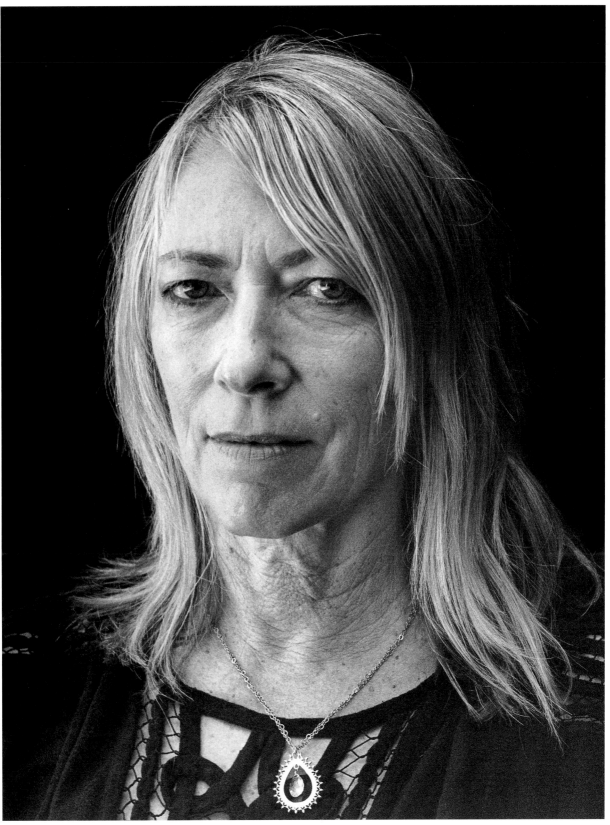

Kim Gordon, 2009

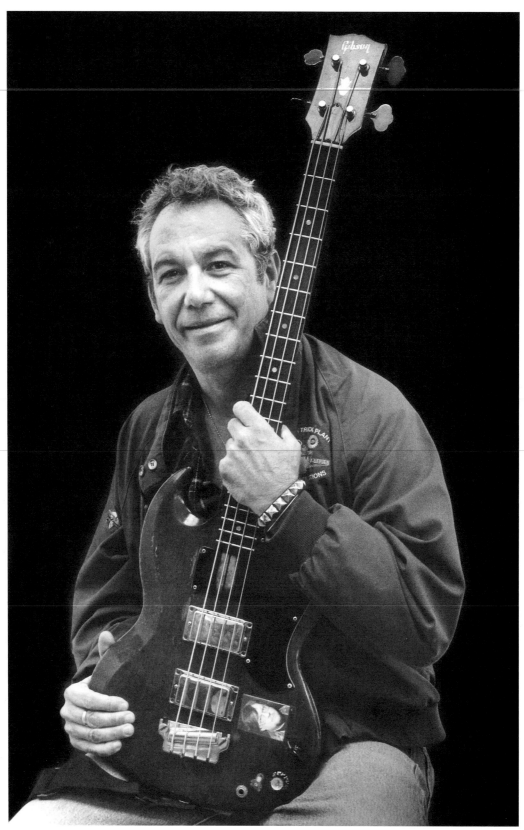

Mike Watt, 2010

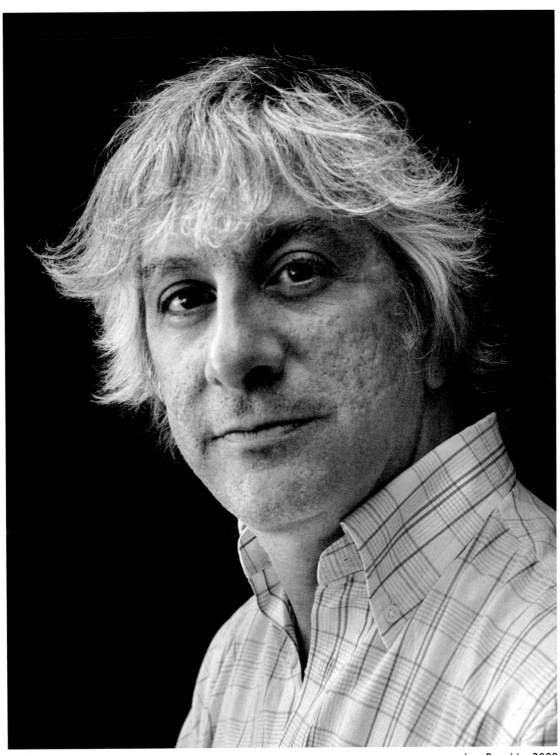

Lee Ranaldo, 2009

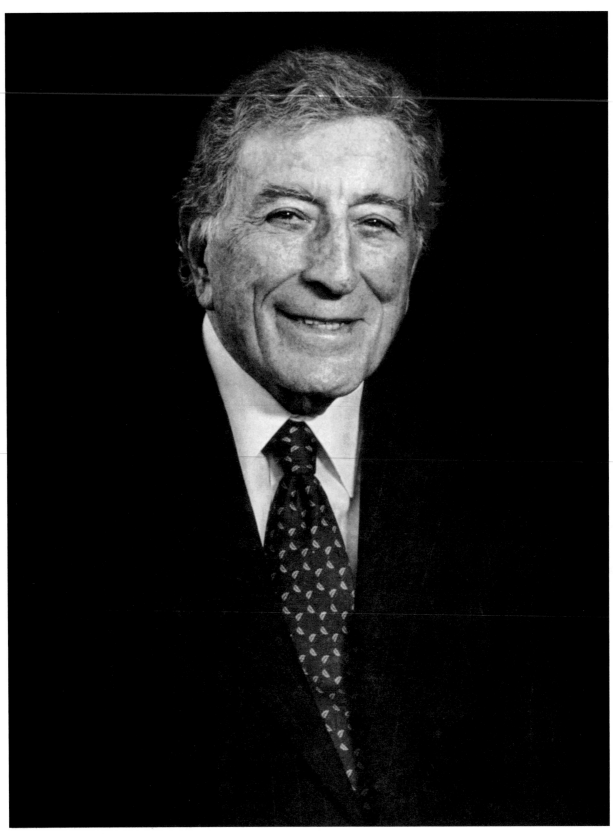

Tony Bennett, 2010

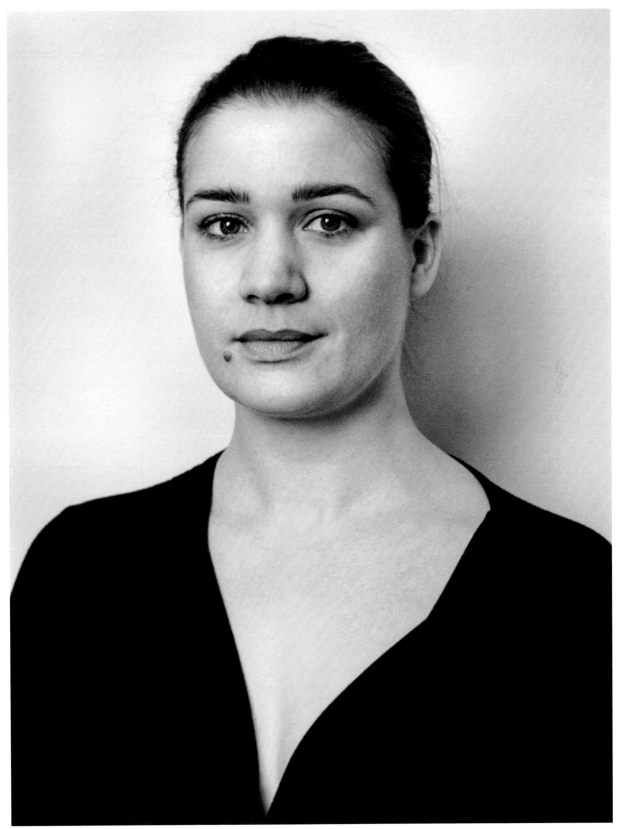

Maude Maggart, 2010

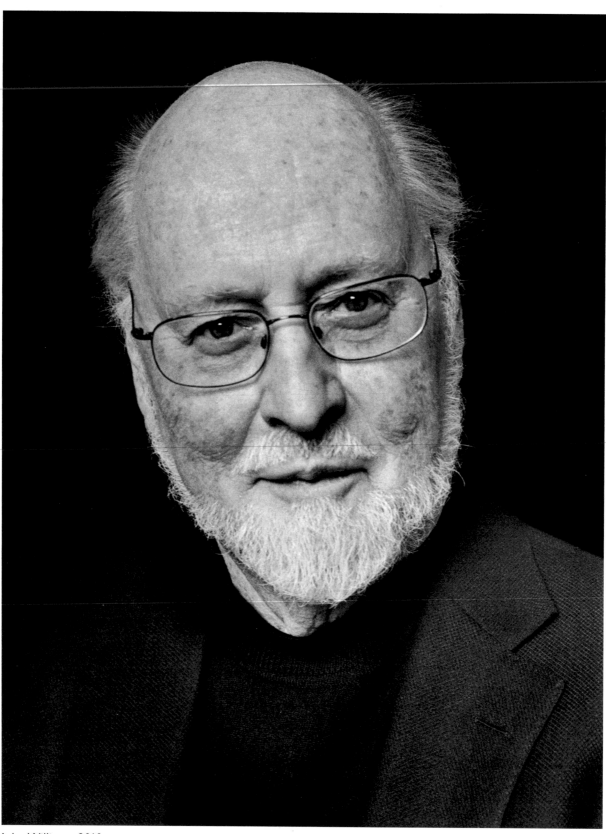

John Williams, 2010

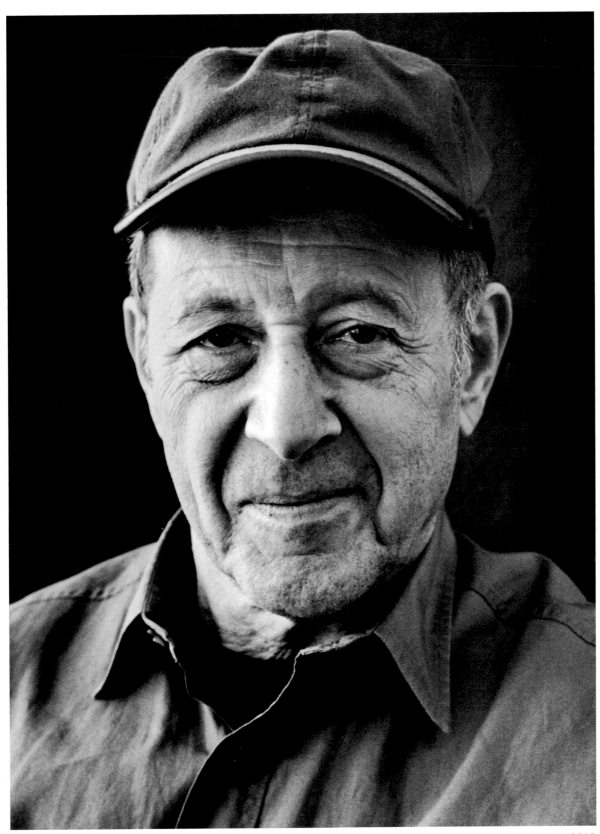

Steve Reich, 2010

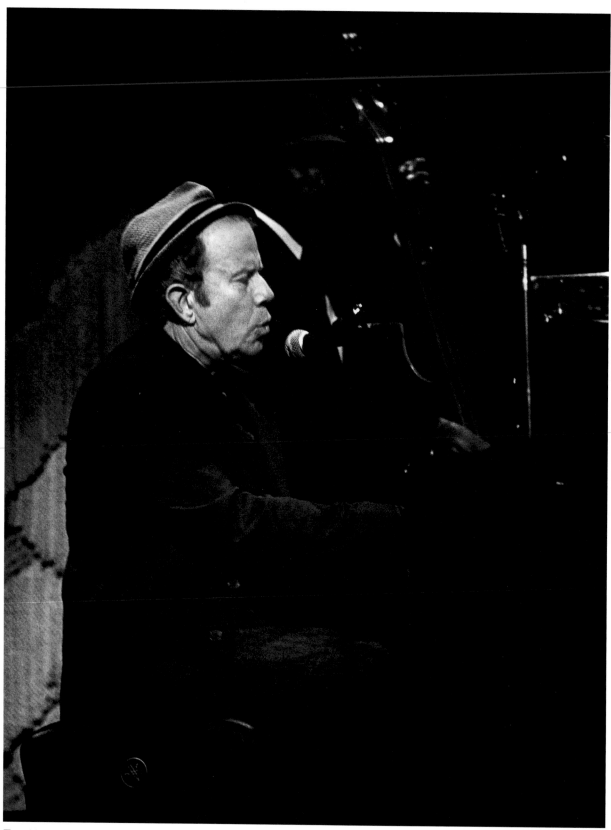

Tom Waits, 2010

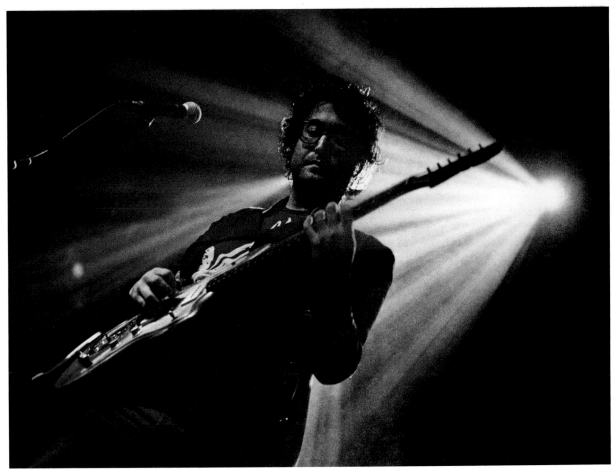

Sean Lennon, 2010

Steve Martin, 2010

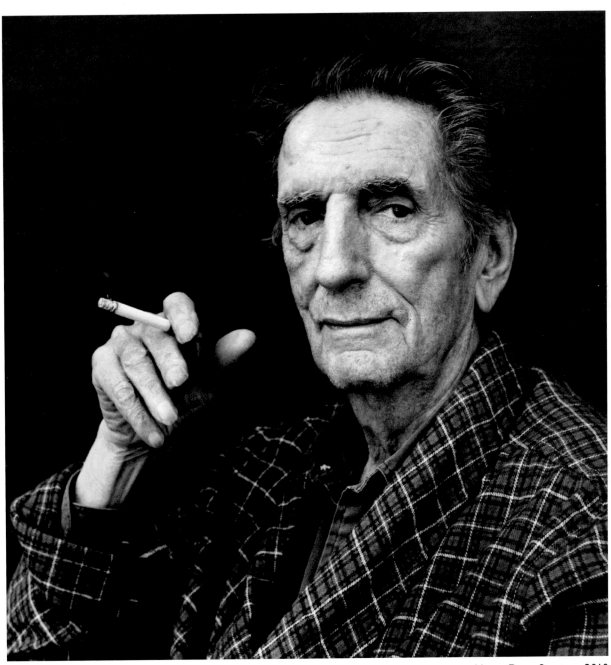

Harry Dean Stanton, 2010

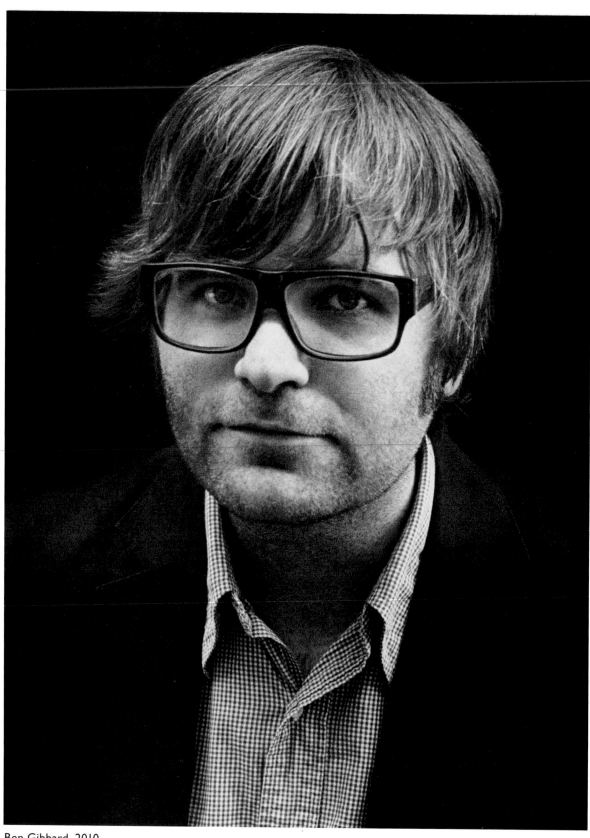

Ben Gibbard, 2010

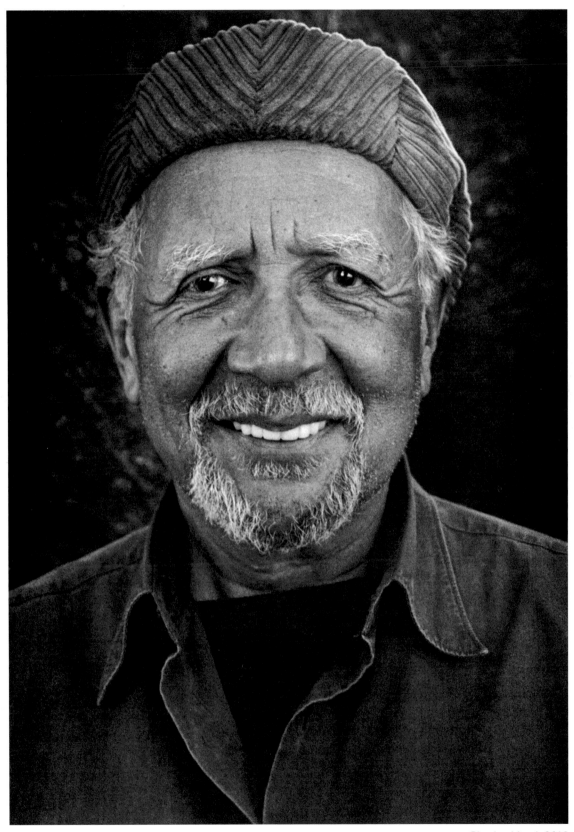

Charles Lloyd, 2010

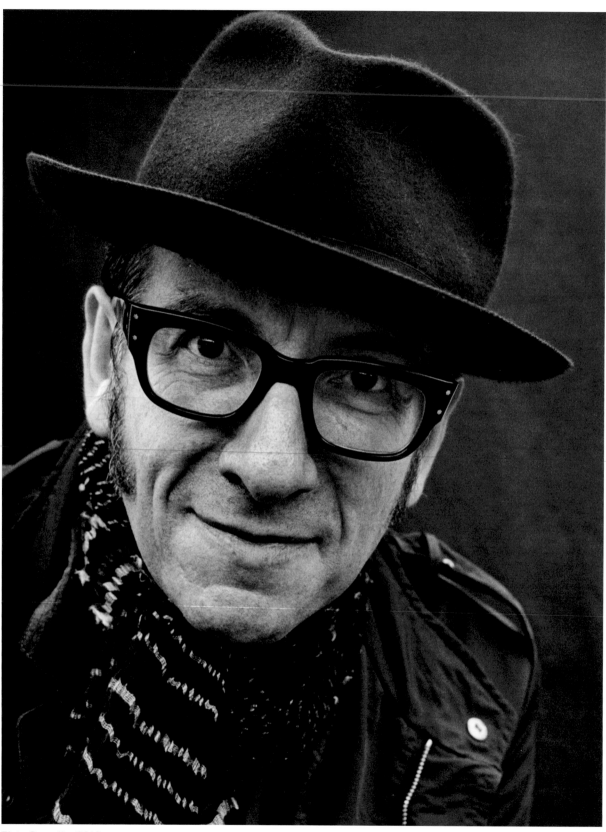

Elvis Costello, 2010

Randy Newman, 2010

777

nothing is true, everything is permitted.

john zorn

John Zorn, 2011

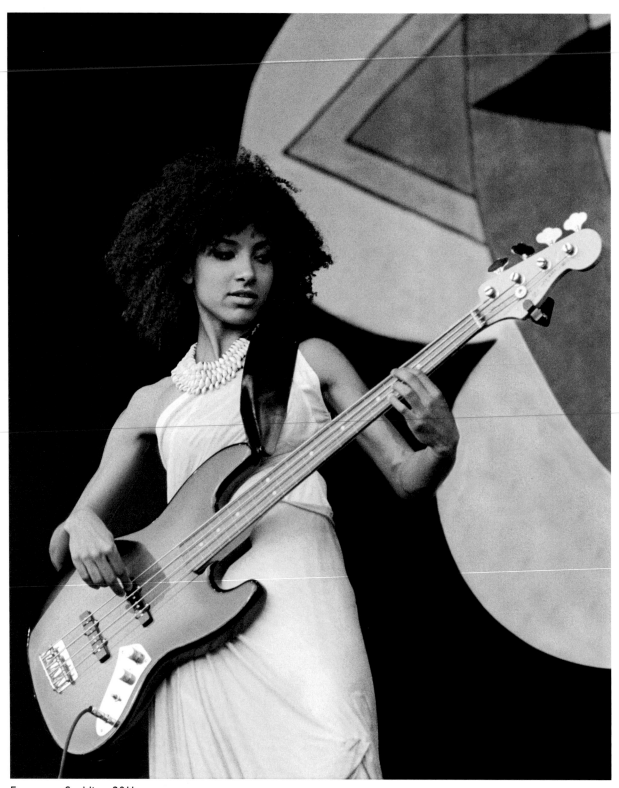

Esperanza Spalding, 2011

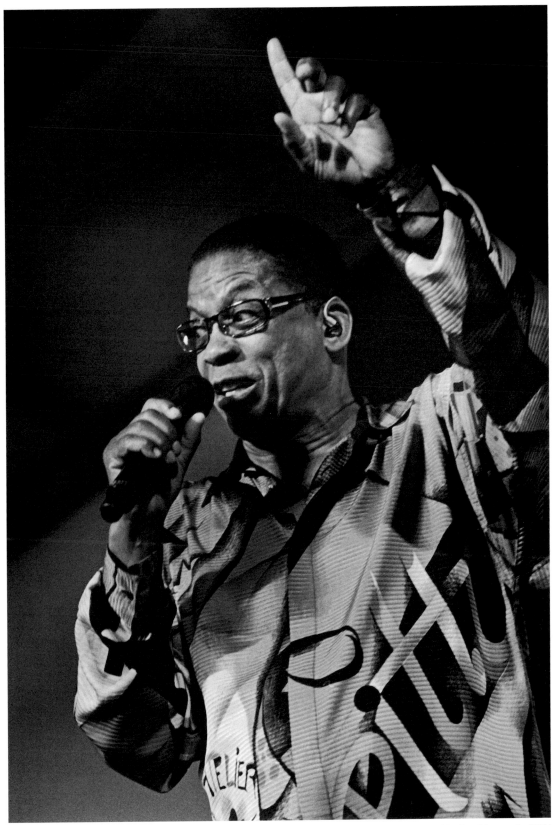

Herbie Hancock, 2011

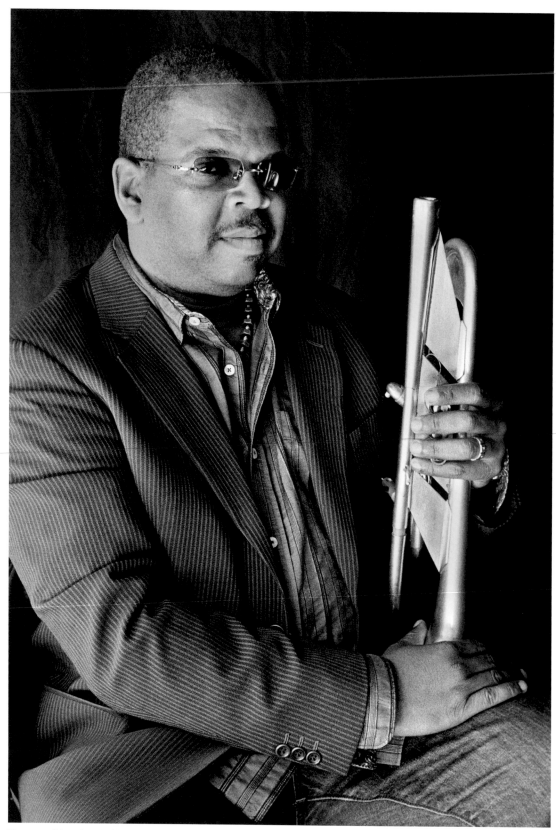

Terence Blanchard, 2011

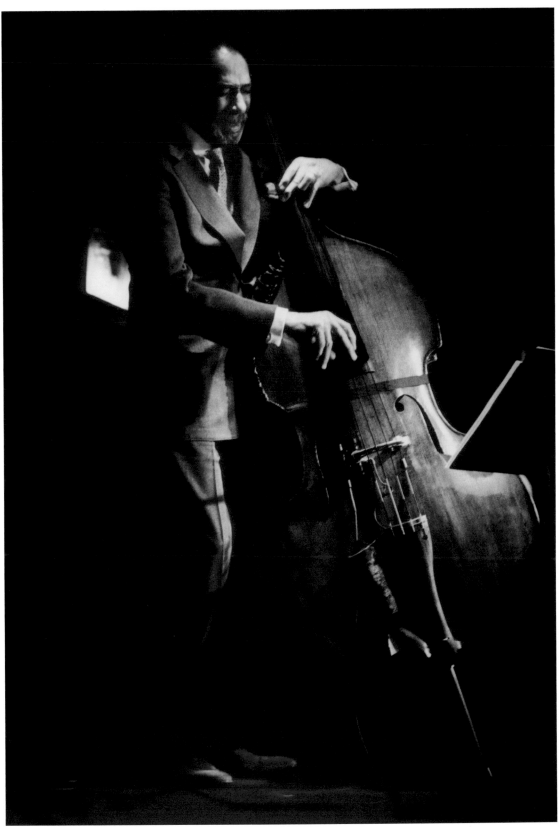

Ron Carter, 2011

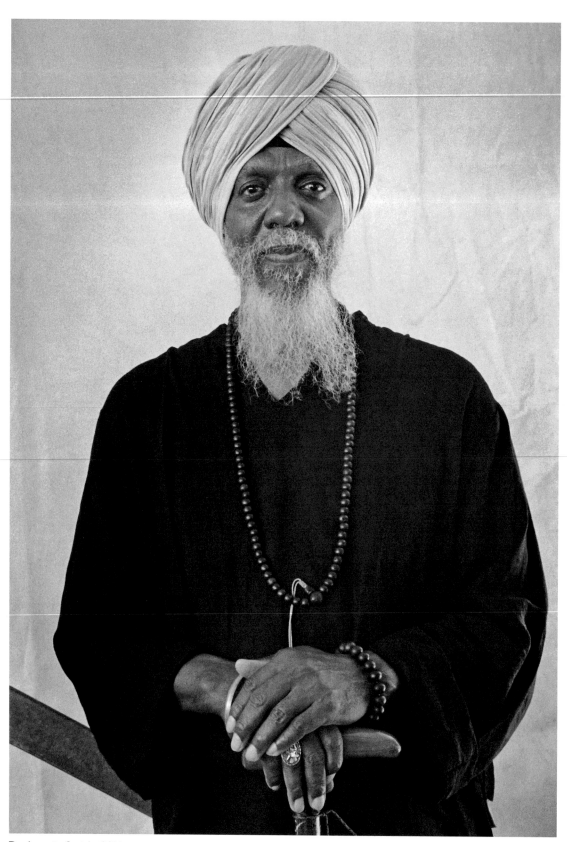

Dr. Lonnie Smith, 2011

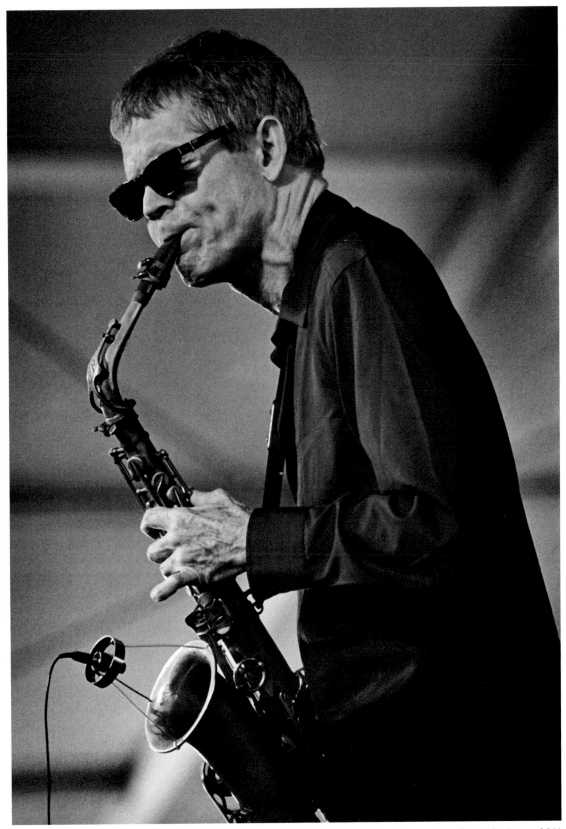

David Sanborn, 2011

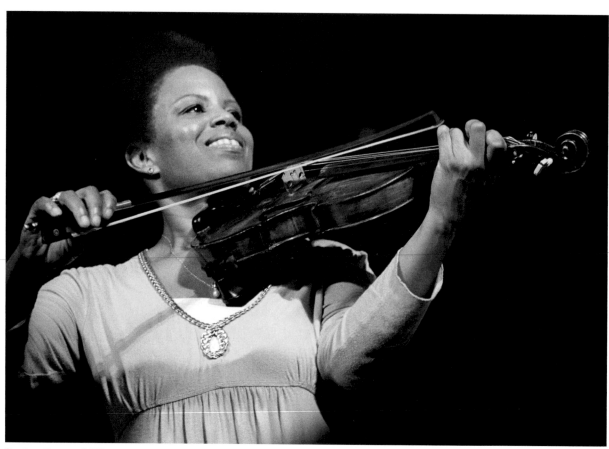

Regina Carter, 2011

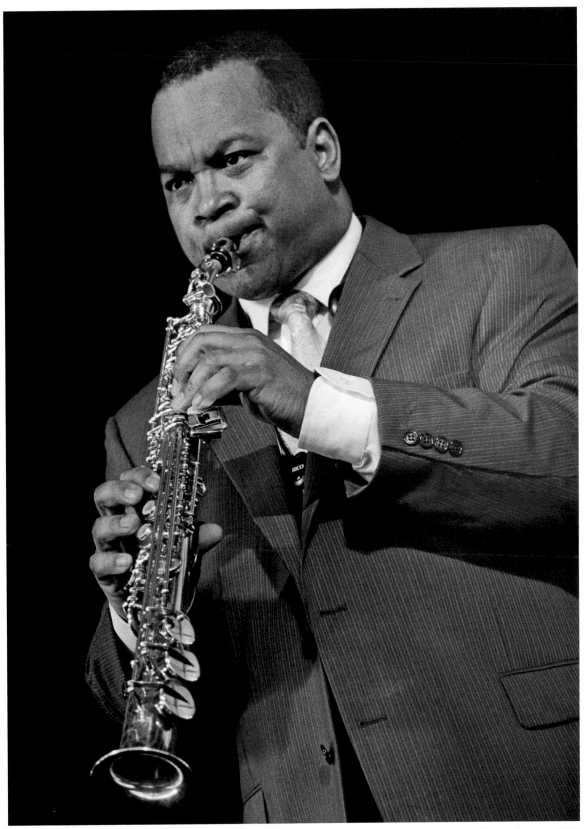

Victor Goines, 2011

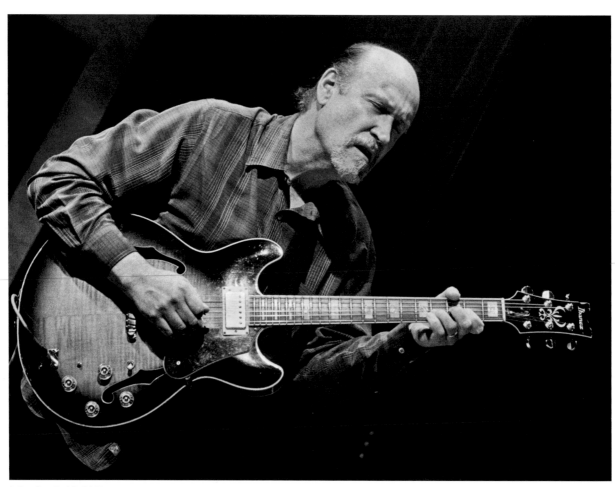

John Scofield, 2011

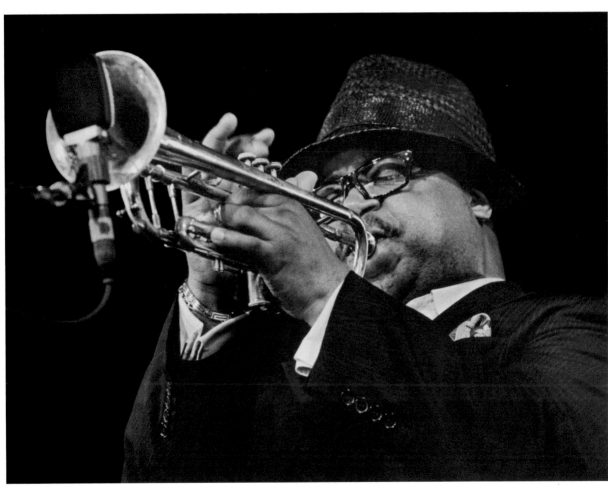

Nicholas Payton, 2011

Trombone Shorty, 2011

John Boutté, 2011

Pete Fontain, 2011

Jimmy Buffet, 2011

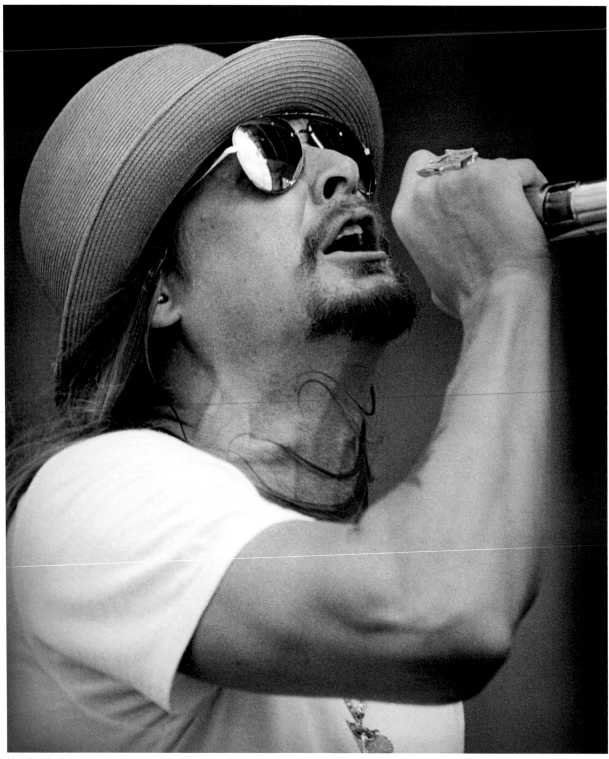

Kid Rock, 2011

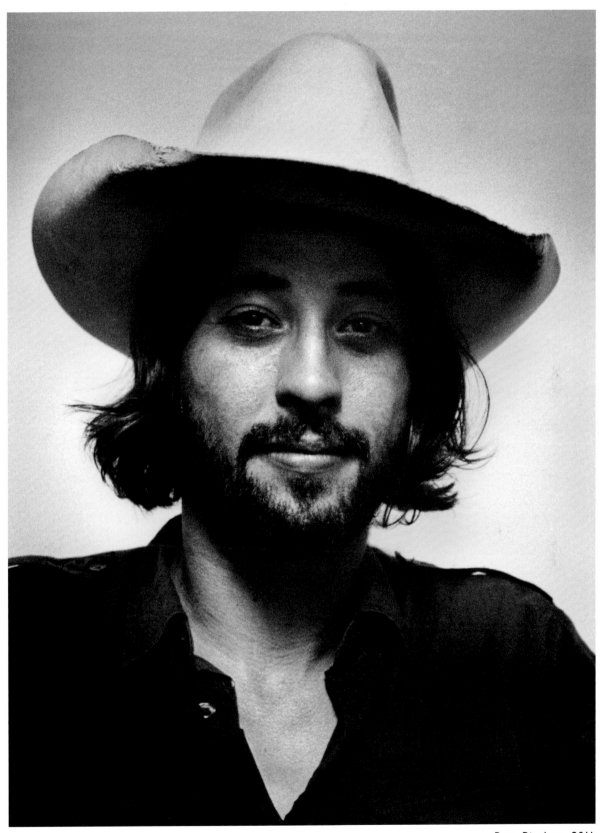

Ryan Bingham, 2011

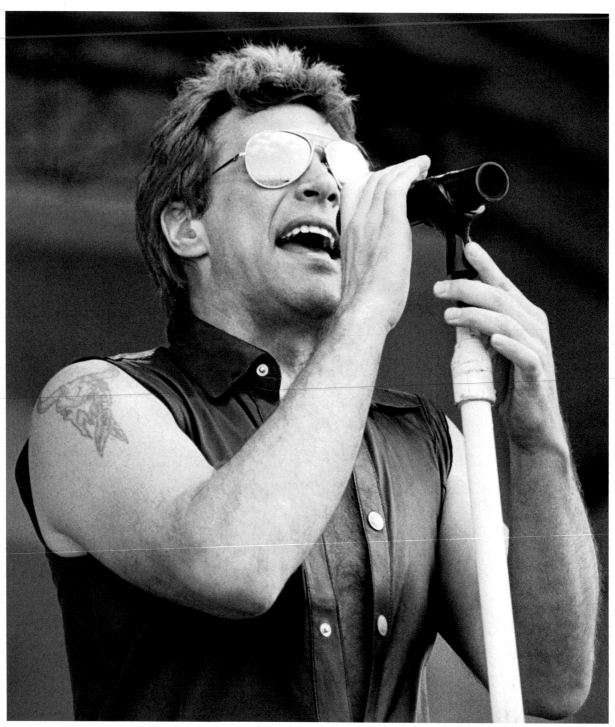

Jon Bon Jovi, 2011

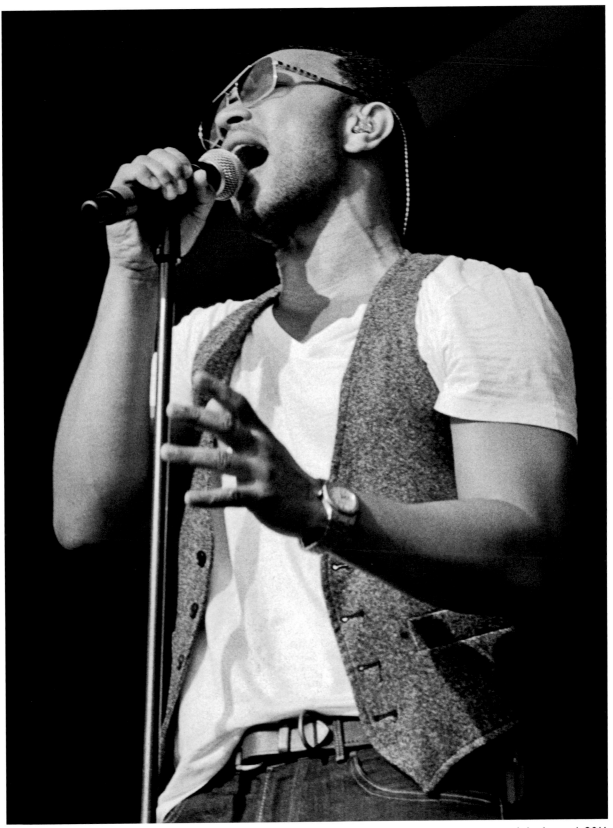

John Legend, 2011

Merle Haggard, 2011

Kris Kristofferson, 2011

Ralph Stanley, 2011

Steve Earle, 2011

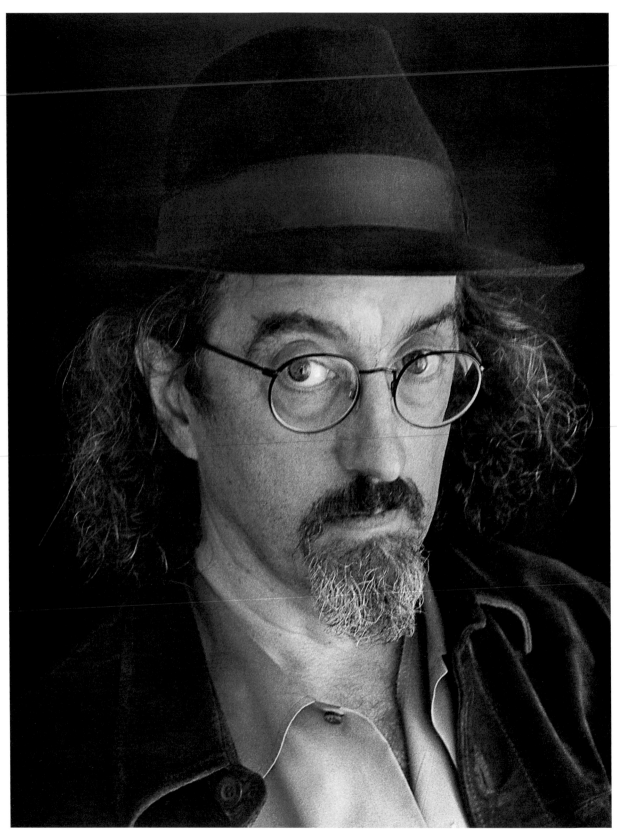

James McMurtry, 2011

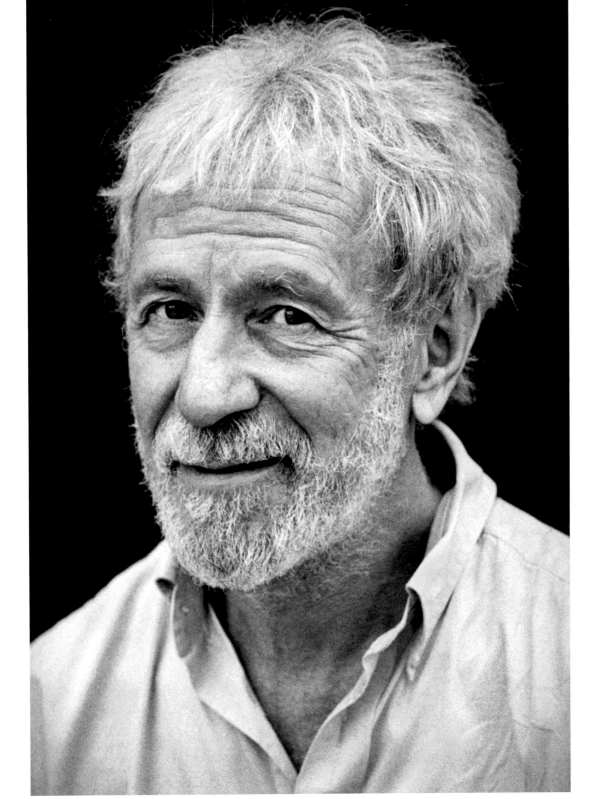

Jesse Winchester, 2011

The Long Way Home

Cash • Leventhal

dark highways and the country roads
don't scare you like they did
The woods and winds now welcome you
to the places you are hid.

You grew up and you moved away
across a foreign sea
and what was kept was what was left
was what you gave to me

you thought you'd left it all behind
You thought you'd up and gone
But all you did was figure out
how to take the long way home

The Southern rain was heavy
almost heavy as your heart
a cavalcade of strangers came
to tear your world apart

the bells of old St. Mary's
now the clang of Charcoal Hill
and you took the old religion from
the woman on the hill

You thought you'd left it all behind
you thought you'd up and gone
But all you did was figure out
how to take the long way home.

Rosanne Cash

2013

Rosanne Cash, 2012

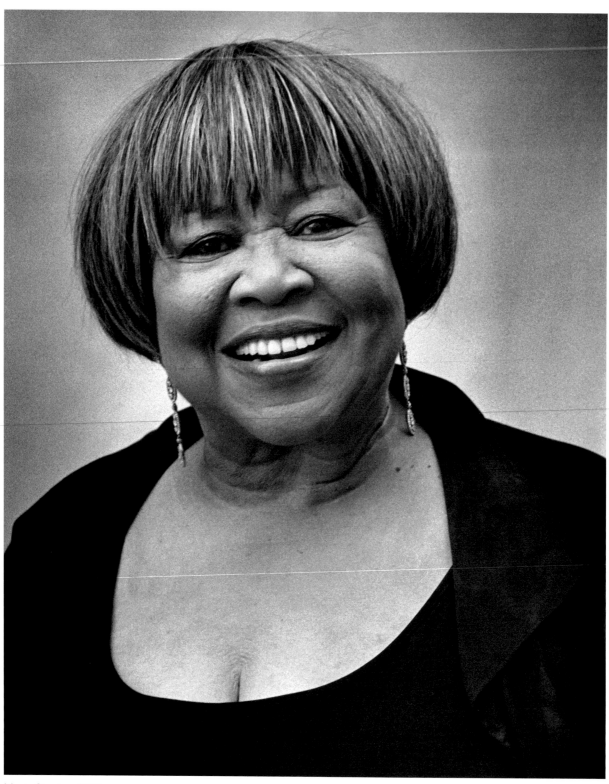

Mavis Staples, 2012

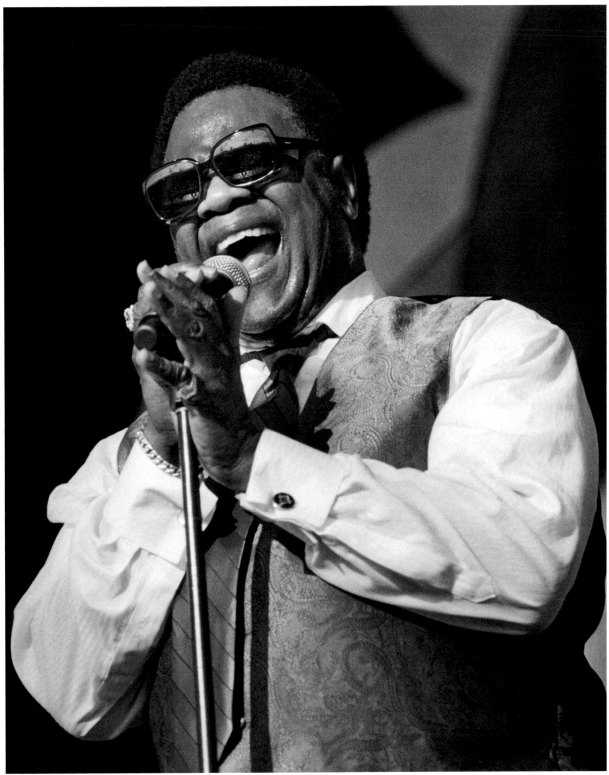

Al Green, 2012

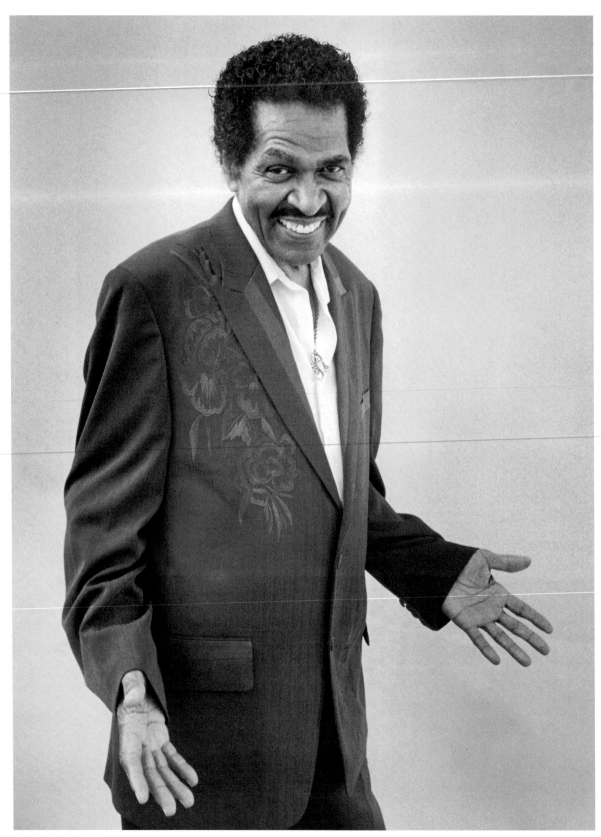

Bobby Rush, 2012

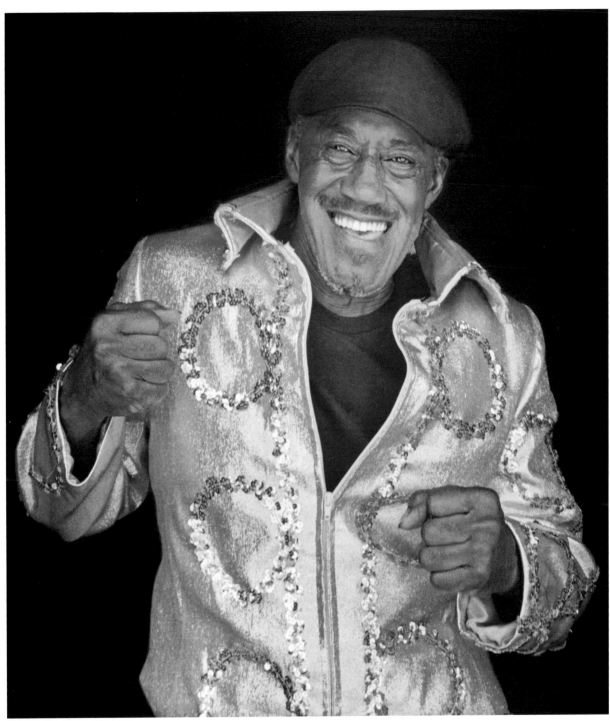

Ironing Board Sam, 2012

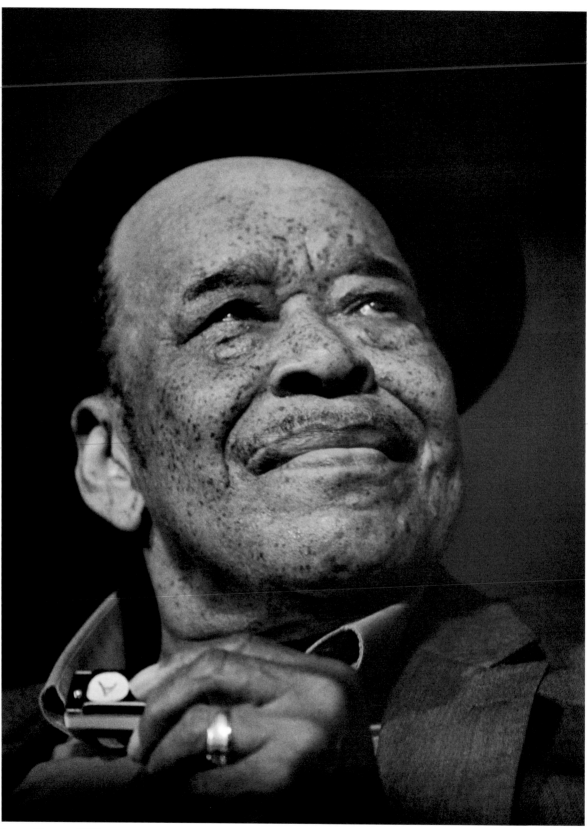

James Cotton, 2012

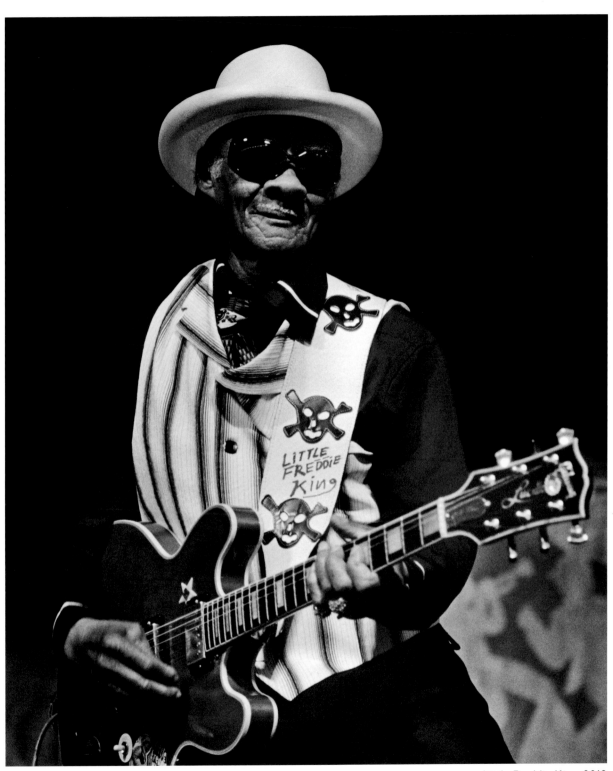

Little Freddie King, 2012

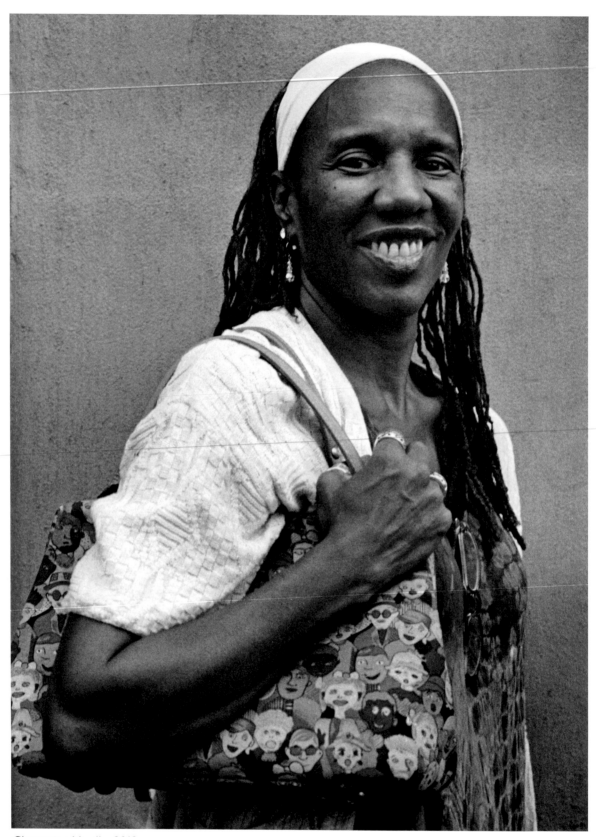

Charmaine Neville, 2012

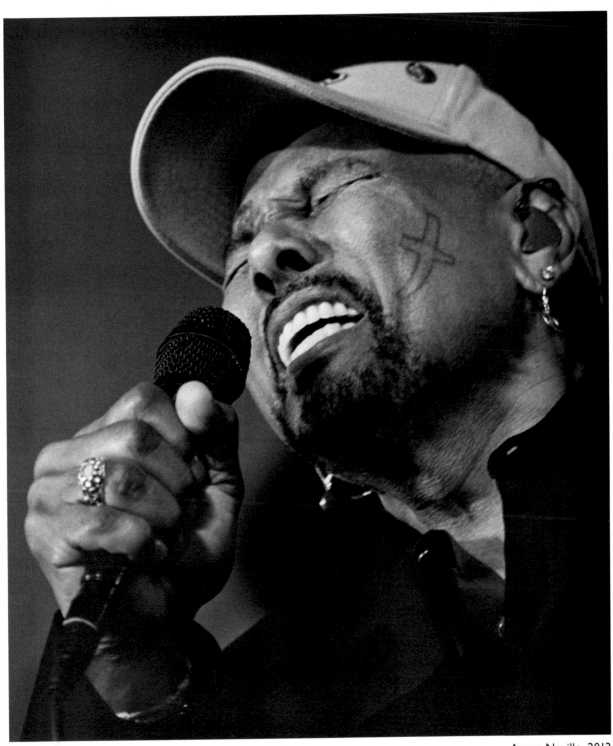

Aaron Neville, 2012

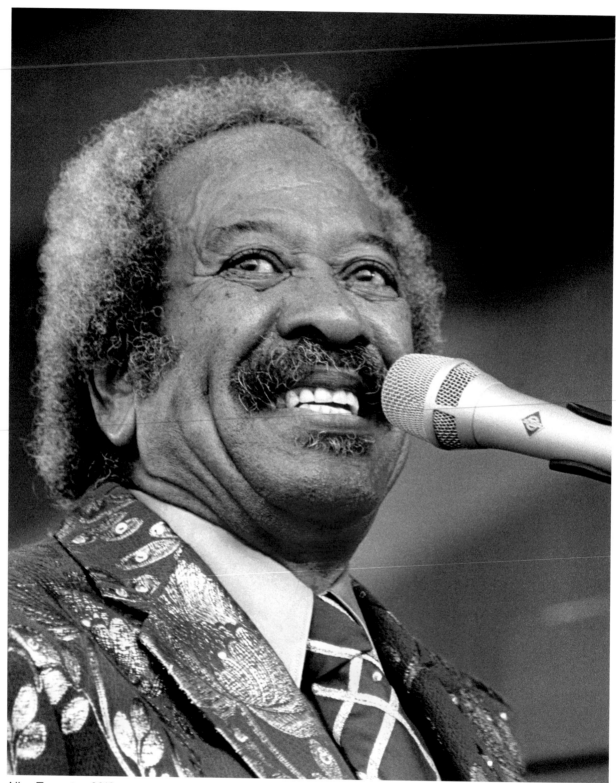

Allen Toussaint, 2012

Irma Thomas, 2012

Bonnie Raitt, 2012

George Wein, 2012

Buckwheat Zydeco, 2012

Zac Brown, 2012

Shawn Colvin, 2013

Robert Earl Keen, 2013

Lisa Marie Presley, 2013

Narada Michael Walden, 2013

Mark Mothersbaugh, 2013

Dont shoot
Peek a Boo
What we do
Goin under
Fresh
Thats good

----------------------transition to blue hats-------------------

Girl u want
Whip it

--------------------carl sagan video-------------------

Uncontrollable urge
Mongoloid
Jocko Homo
Smart patrol / Mr.DNA
Gates of steel

...enchore..................................

Freedom of choice
beautiful world

choose your mutations (CAREFULLY!

mark -o- Devo

INDEX

CHRISTOPHER FELVER's distinctive visual signature is a lasting contribution to the legacy of our national cultural community. His previous books are *The Late Great Allen Ginsberg*; *Seven Days in Nicaragua Libre*; *The Poet Exposed*; *Ferlinghetti Portrait*; *Angels, Anarchists & Gods*; *The Importance of Being*; and *Beat*. His photographs are distributed worldwide, collected by museums and university libraries, and have been featured in international exhibitions at the Center Georges Pompidou in Paris, the Whitney Museum in New York, the National Theatre in London, and the Torino Biennale Internazionale. The Gallery of Art in Washington, D.C., the New York Public Library, and the Museum of Fine Art in Boston have presented retrospectives of his films: *John Cage Talks About Cows*, *Cecil Taylor: All the Notes*, *West Coast: Beat & Beyond*, *Taken by the Romans*, *Donald Judd's Marfa Texas*, *Tony Cragg: In Celebration of Sculpture*, and *Ferlinghetti: A Rebirth of Wonder*. Felver's unparalleled body of work captures with integrity the cultural icons of the late twentieth century.